

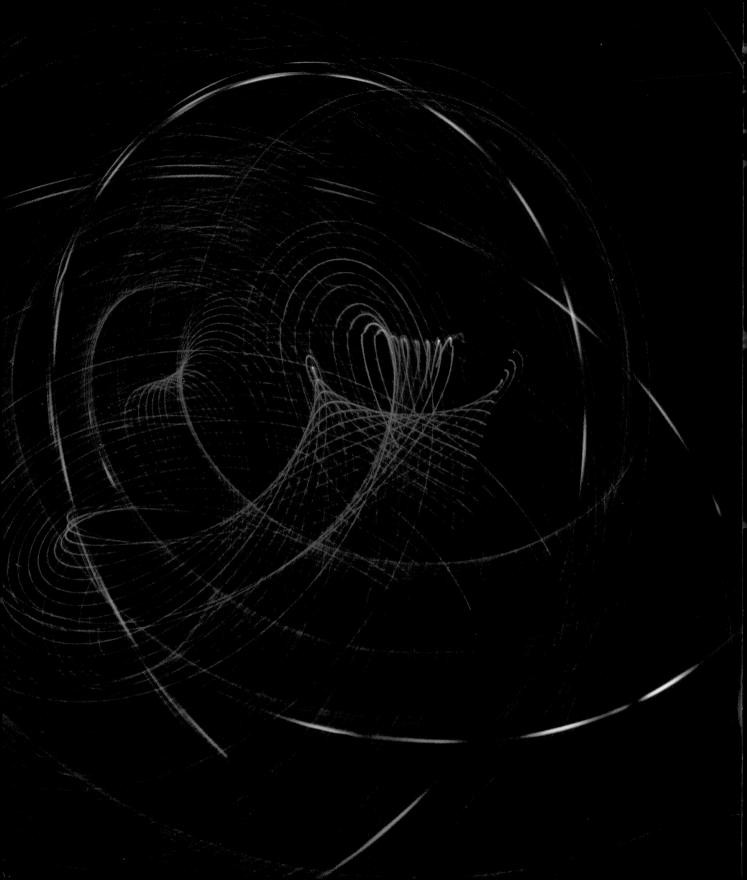

CHRIS GATCUM

Professional Photography Techniques for Innovative Images

Copyright © 2009 by The Ilex Press Limited All rights reserved.

Published in the United States by

Amphoto Books, an imprint of the

Crown Publishing Group, a division of

Random House, Inc., New York

www.crownpublishing.com

www.amphotobooks.com

AMPHOTO BOOKS and the Amphoto Books logo are trademarks of Random House, Inc.

Originally published in Great Britain as *Creative*Digital Photography: 52 Weekend Projects by Ilex,
an imprint of The Ilex Press Limited.

This book was conceived, designed, and produced by The Ilex Press Limited,
210 High Street, Lewes, BN7 2NS, UK

Library of Congress Control Number: 2009926713

ISBN: 978-0-8174-2450-3

Printed in China

First American Edition

10987654321

CONTENTS

6 Introduction

01	CREATIVE SHOOTING	89	Low-cost Filters
10	Creative White Balance	90	Reflectors
12	Cross Polarizing	, 0	Renectors
14	Diffraction Star Effects		
16	Soft Focus	03	LIGHTING GEAR
18	Creative Bokeh	94	Off-camera Flash
20	Zoom-burst	98	Portable Diffuser
22	Long Daylight Exposures	100	Snoot
24	Night Photography and Star Trails	102	Portable Grid Spot
28	Camera Tossing	104	Portable Ringlight
30	Panning	108	Portable Beauty Dish
32	Time-lapse	112	Studio Striplight
34	Shooting Smoke	116	Studio Ringlight
38	High-speed Water Drops	120	Studio Softbox
42	Painting with Light		
46	Toy Cameras		
50	Holga Hacks	04	DIGITAL PROCESSING AND PRINTING
54	TTV Photography	128	Digital Polaroid SX-70
60	Shooting Stereo	130	Converging Verticals and Sloping Horizons
62	Scanner Art	132	HDR Imaging
		136	Digital Cross Processing
		140	Digital Cyanotypes
	LENSES AND ACCESSORIES	144	Digital Lith
66	Legacy Lenses	148	Digital Infrared
68	Reverse Lens Macro	152	Model World
70	Improvised Lenses	156	Panoramas
72	Tilt Lens	160	Small World
76	Digital Pinhole Lens	164	Wall Art
80	Beanbag	166	Inkjet Transfers
81	Stringpod		
82	Light Cube		
86	Tripods as Lightstands and		Photographer Credits
	Lightstands as Tripods	174	Index
88	Cookies	176	Acknowledgments

INTRODUCTION

Photography is an incredibly demanding and challenging artform, and its complexity is growing all the time. Whether you're aware of it or not, when you take a picture all kinds of things come into play, from the chemistry of film photography and the physics of light, to the philosophical art of aesthetics and the formal design of composition. Most recently, digital capture has thrown electronics into the melting pot, adding yet another tricky subject and a whole new language that photographers need to get comfortable with.

With such a disparate mix of art and science it's easy to become overwhelmed by the unfamiliar technology and ideas, which is why there are lots of books dedicated to guiding you toward achieving "perfect" pictures. However, most concentrate on a prescribed formula

of apertures, shutter speeds, and ISO settings, and it's easy to get to a point where obsessing over getting the settings right on your camera and choosing the "correct" focal length for a picture can begin to take greater precedence than the shot itself.

Sure, the basics of photography are important—they always will be—but this book isn't going to dwell on the mechanics and technicalities. Instead, we're going to look at the other side of photography; the creative side, where critically sharp focus isn't a key criteria to success, using the "wrong" settings on your camera is actively encouraged, and making your own low-tech accessories can help take your photography in a radical new direction.

Covering all aspects of photography—from shooting to digital processing, as

well as looking at lenses, accessories, and lighting—the 52 projects that have been collected in this book will give you a different challenge for every weekend of the year, and they've each been given a difficulty rating so you've got an idea of how hard they are. Regardless of their complexity, each one will only take a couple of hours to explore, although some are only the tip of the proverbial iceberg, with plenty of tips to help you pursue them further if you want to.

So, take a break from reading the manual, give yourself a couple of hours off from learning the "rules" of photography, and start exploring a whole new world of creative image-making. This book's about having fun with your camera and, let's face it, that's probably why you started taking pictures in the first place.

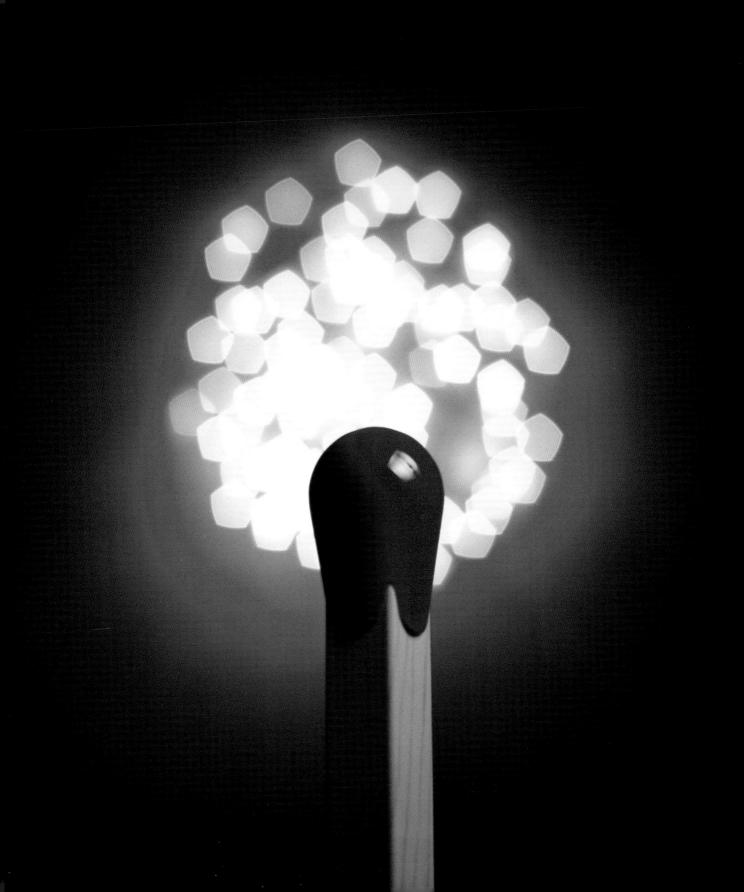

CREATIVE SHOOTING

Putting the "creative" into your creative photography starts the moment you decide to take a picture. It doesn't matter whether it's a spontaneous snap or a considered still life; the creative process has begun. After that a whole host of options sit in front of you, although most photographers only consider three things—framing, exposure, and focus.

This chapter goes way beyond this basic trio of choices, covering a range of exciting projects and techniques that you might not have considered before. So whether you want to photograph smoke or water droplets, shoot the stars, or get inspired by blur, this is the place to start developing your creative camera skills.

Have you ever taken a photograph in the beautiful golden light of the setting sun, only to be disappointed by the cold tones of the end result? If you have (and you wouldn't be alone), the chances are it's because your camera was set to its automatic white balance setting and it has been doing its job. After all, for 99 percent of the time the primary goal of a camera's white balance system is to make sure that your pictures are neutral, without any color casts. But there are times when you want a bit of color in your pictures, to capture—or even enhance—the atmosphere of the original scene; a hint of blue to convey sub-zero temperatures, or added warmth for that golden sunset, for example. At other times you might want to forget the rules about what's "right" and get creative with your pictures. This is where using the "wrong" white balance can help inject color and atmosphere into your pictures, and make them much more striking.

WHAT YOU NEED

- Point-and-shoot or digital SLR camera
- · Colored cardstock (optional)

DIFFICULTY *

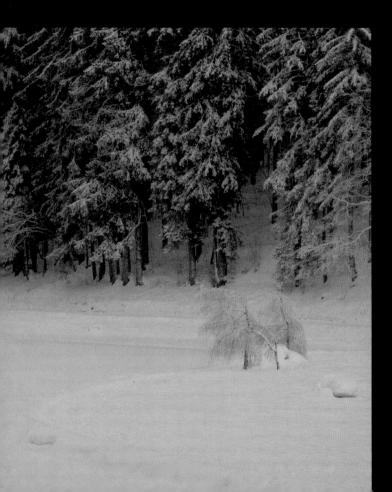

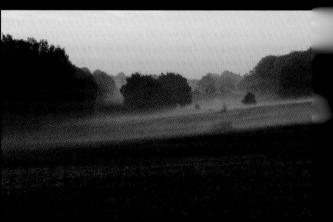

Above: Setting a cloudy white balance encourages the camera to produce warmer results, which adds to the atmosphere of this misty sunrise.

TIP

If your camera lets you shoot Raw files, you can very easily change the white balance of a shot after it has been taken. With the Raw file open in your conversion software it is just a question of choosing an alternative white balance setting from a dropdown menu—just like changing the white balance preset on your camera. If you don't like the change, you can switch it back, without affecting the image.

Left: Using the "wrong" white balance for this winter scene turns the snow an

Above: Switching from daylight white balance to a "wrong" tungsten white balance setting introduces a strong blue color cast to this watery image.

WHAT IS WHITE BALANCE?

Your brain does an incredible job of automatically adjusting for the different colors of light that your eyes see, so much so that you can walk out of a room lit by tungsten light into bright sunlight without noticing any major shifts in color. But tungsten and daylight are very different in terms of their color—tungsten is a warm orange, and daylight a cool blue—as you'd see if you went outside at night and looked at the windows of the warmly-lit houses around you.

Your camera is not quite so smart—it needs to be told what the lighting is. All digital cameras have an automatic white balance mode, which tries to do a similar job as your brain and automatically "correct" the colors it sees, so whites remain white. But the system isn't foolproof, and most books would tell you that you'll get better results when the camera is set to a preset white balance option, such as daylight, cloudy, shade, tungsten, flash, and so on. These settings tell the camera to compensate for the color emitted by a specific light source, so if the tungsten white balance setting is chosen, the camera compensates for the orange light by adding blue to the image.

This is where you can start getting creative—by "fooling" your camera. For example, if you use the tungsten white balance setting in normal daylight conditions, the camera will add blue to an image that is already lit by a cool blue lightsource. The result will be a picture with a strong, overall blue cast. Conversely, using the daylight setting when you take a picture under tungsten lighting produces a strong yellow-orange color cast.

CREATIVE WHITE BALANCE

In addition to setting the "wrong" preset white balance, most digital SLRs, and some point-and-shoot cameras, let you set the white balance manually, using a custom setting. This is usually done by photographing a white or gray card. The camera will calculate the adjustment required to get the card looking correct, or "neutral," and subsequent images taken in the same lighting will also be neutral. However, if you use a *colored* card to set the custom white balance, the camera will try to compensate by adding the opposite color—immediately introducing a color cast to your images. Using a pale green cardstock, for instance, instructs the camera to add red, so your images will be warmer. This could be ideal for photographing fall leaves, or enhancing a sunset.

SUBJECTS

The hardest part of this project is selecting a suitable subject. Not all subjects will be improved by adding a color cast, and fairly abstract or simple pictures tend to work best. A landscape shot at midday will look plain wrong with a strong blue cast, but in foggy conditions, when the detail is very soft and the colors muted, the results can be far stronger. Similarly, turning people blue doesn't always give a great result, but adding a touch of warmth to a portrait can make it look much more attractive.

atterns on car windshields. This is because car windows are made of tempered, heatoughened glass for safety, and the tempering process puts the glass under internal stress,
which in turn affects the way it reacts to light. The polarized glasses reveal areas of the
window that were put under stress when it was manufactured, thanks to a phenomenon
known as "birefringence." Other materials, such as transparent, injection-molded plastic,
are also birefringent, which is why the plastic covers over the displays of MP3 players and
wristwatches often show rainbow patterns when viewed through polarized glasses.

Photographers also use polarizing lenses (in the form of polarizing filters). to cut down the reflections from glass, and to reduce highlights on wet or moist objects. This is ust like shooting through polarized sunglasses and, if you combine a polarized filter with a polarized light source, things start getting really interesting. This technique—known as 'cross polarizing"—is important to science, where it is used in the study of crystals and nicroorganisms. But while scientists use it for its scientific potential, creative photographers an use it to produce stunning pictures where the normally invisible stress lines in plastic objects are transformed into beautiful, multicolored rainbows.

The traditional way of producing polarized light is to buy a sheet of polarizing plastic. or a polarizing gel, and tape it over a light source. This works well, but polarizing gels are expensive, and once they get scratched they become less efficient. However, the good news s you probably own a convenient source of polarized light already—the LCD screen used by a laptop or flat-panel TV or monitor—and there's no reason why you can't start exploiting—his in your photography.

WHAT YOU NEED

- Digital SLR camera
- · Polarizing filter
- Transparent plastic object, such as a ruler, protractor, or measuring cup
- LCD monitor or television
- Tripod

DIFFICULTY **

TIPS

Generally, it's not a good idea to rest the object you're photographing directly on the LCD screen. Not only do you risk damaging the screen, but the screen itself could be in focus, revealing the grid pattern of the red, green, and blue pixels that make up the display.

If you position your screen horizontally you can position a sheet of glass above it to rest your subject on—the glass won't be affected by the polarization.

Use a macro lens or closeup lens to crop in close and create abstract shots of the kaleidoscopic colors.

Left: Clear plastic measuring beakers from a photographer's darkroom are transformed using the cross polarizing technique

- To set your polarized light source, turn your screen's brightness to full, and fill the screen with a white image. This is most easily done with a computer as you can just open a blank window and extend it to fill the monitor.
- Put the polarizing filter on your camera lens, and mount the camera on a tripod in front of the screen.
- Rotate the polarizing filter on your lens until the image through the viewfinder is black, or as dark as possible.

 Rotating the filter gives you different degrees of polarization, so experiment with the angle. You'll likely find that you'll create the most striking photos when the effect is as dark as possible.
- Place your transparent plastic object between the LCD screen and the camera, and frame and focus your shot—you should see the colored effect through your camera's viewfinder or on the rear LCD screen.
- Turn off, or cover, any other light sources and take your shot. As LCD displays don't produce that much light and the polarizing filter consumes up to two-stops worth of light, your exposure will be fairly long (which is why you should use a tripod). Using a remote release is also a good idea, but if you don't have one you can use your camera's self-timer instead—either way, you want to try and avoid any camera shake during your long exposures.
- Once you've taken your shot, review the image on your camera's LCD screen. Adjust the exposure if you need to, using the EV (Exposure Value) setting to make your image lighter or darker. Then experiment like crazy! Different objects will produce different results.

Right: Convert your cross-polarized images into black and white and overlay them with a solid color for striking results, such as this picture of a recorder.

DIFFRACTION STAR EFFECTS

In the 1970s and '80s it was very popular for photographers shooting at night to use star or "cross" filters, which are simply clear glass filters with a fine, regular grid engraved into one surface. When these filters are used to photograph bright, point-sources of light—such as streetlamps at night—they create the effect of "starbursts." However, star filters are not subtle, and the engraved lines also cause another optical effect known as dispersion, which results in a rainbow effect in the streaks of light.

It's not too surprising that the overbearing look of star filters has led them to fall out of favor in recent years, and I won't claim for a minute that everyone should rush out and take all their pictures with one. At the same time, it's one of those effects that can actually work in some instances, and just because it's not currently fashionable doesn't mean you can't do it anymore! Best of all, your camera's probably already got a built-in star filter—I bet it doesn't tell you *that* in the manual!

This project takes advantage of a regularly occurring optical phenomenon known as "diffraction," which is something most, if not all, lenses suffer from. Diffraction is the slight bending of light around small openings (the aperture in your camera in this instance), and it's usually thought of as a problem since it's the primary cause of loss of sharpness when a lens is set to a small aperture. But what one person sees as a problem, we can see as a solution, because it is diffraction that will be creating our starbursts.

This project works best if you can find yourself a night or low-light scene with a few point-sources of light; streetlamps and Christmas lights work well, while light sources that have larger surface areas, such as shop signs or fluorescent tubes, do not. Take a walk around a town or city at dusk, or at night, and you're sure to find somewhere suitable.

Once you find a scene you want to shoot, set your camera up on a tripod and switch to Aperture Priority mode. Set a small aperture and start taking some shots. If you're using

an SLR, a lens set to f/4 will not have very pronounced starbursts, so set your aperture to f/16, or smaller. This should produce very clear starbursts, which you can check on your camera's LCD screen. And that's all there is to it—just by setting a small aperture you've discovered the "starburst filter" mode you didn't know your camera had.

WHAT YOU NEED

- Point-and-shoot or digital SLR camera with adjustable aperture
- Tripod

DIFFICULTY *

TIP

The number of rays from each starburst is related to the number of aperture blades in your lens, so as well as experimenting with the aperture to see what effect it has, it's worth experimenting with different lenses as well. Each lens you use will produce slightly different starbursts.

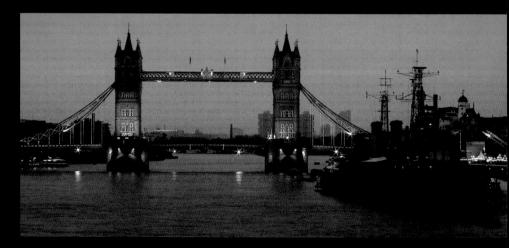

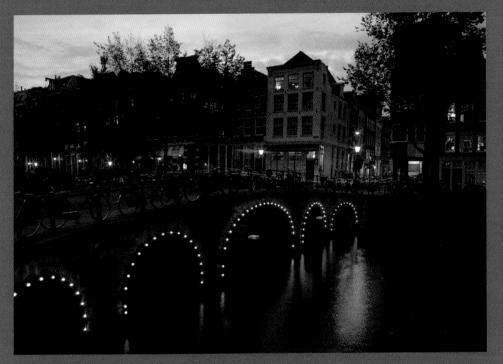

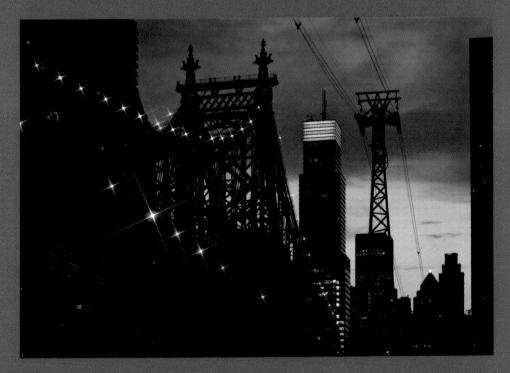

Above: Simply setting a small aperture Above: Simply setting a small aperture and photographing point-sources of light will produce fantastic starbursts. The number of aperture blades and the aperture setting you use will determine the number—and intensity—of the "bursts." The image above left (and detail, above right) was taken with the aperture set at f/16.

Left: A "proper" 4-point starburst filter was used for this image. The effect is more pronounced, but why buy a filter when you can change your aperture for free?

04 SOFT FOCUS

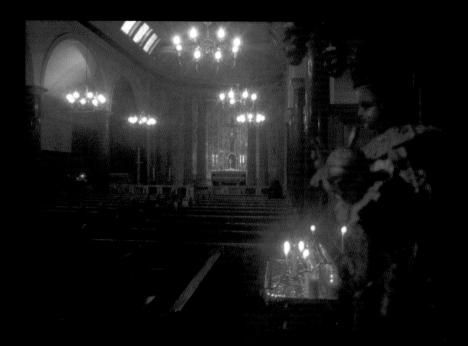

WHAT YOU NEED

- Point-and-shoot or digital SLR camera
- Nylon stockings and rubber band
- OR
- Petroleum jelly and UV/skylight filter

DIFFICULTY *

Like starburst filters, taking soft focus pictures was once so popular it seemed like it was impossible to find images that didn't have a diffuse look. However, while the soft-focus effect has definitely fallen from grace (for good reason, some might say), this doesn't mean it can't have a place in the creative photographer's armory. It might seem strange to spend good money buying the sharpest lens you can afford and then produce "soft" pictures, but not all photographs call for absolute clarity. Sometimes we don't want to show all the detail—in a portrait where winkles and skin blemishes need to be hidden, for example—while at other times a soft-focus effect can be used to emphasize the atmosphere in a landscape or a still life, letting us create mist where there is none, or simply blur the detail so we are left with suggestive outlines and shapes. At the extreme, soft focus can create surreal effects, smearing colors and tones across the frame.

Creating soft focus is extremely easy, and even with the most basic materials you can quickly produce a wide range of blur and color effects. The simplest method is to simply breathe on the front of your lens so it steams up. As the mist clears you can shoot through it, timing the shot to the amount of mist still left on the lens. You have to be quick as the mist can clear suddenly, and it doesn't always clear evenly—especially if you are outside in a breeze—which makes it really unpredictable, but, hey, it's completely free, what do you expect?

TIPS

When using nylons, the more you stretch the fabric the less intense the softening effect becomes.

You can also control the soft focus effect with the thickness of the material you put over the lens—use thicker nylons, or two pieces to increase the softness.

The aperture you use when you shoot through nylons will effect the focus. Smaller lens apertures increase the depth of field, so your disruptive material will be slightly more in focus. While you might not see much difference through the lens, the overall soft focus effect will be greater.

PETROLEUM JELLY

Slightly more predictable than breathing on your lens, but a little more messy, this classic soft-focus method is quick, easy, and extremely flexible. It involves smearing a thin film of petroleum jelly on the surface of a clear filter, such as a UV or skylight filter.

The effect is entirely dependent on how much jelly you apply and how you apply it. Use a tiny amount and smear it evenly to create a subtle softening of the image, or use a bit more and spread it in streaks across the glass to break your image into a dreamlike mass of color and tone. You can even apply the jelly selectively, leaving the center of the glass clear so only the edges are softened.

The great thing about this technique is the control you have over the final image. You can apply patterns or dabs for different effects, and if it doesn't work you can just wipe the filter clean and start again. The only thing you need to take care with is that you use a filter, and never apply jelly to the front element of your lens. While the jelly can be cleaned off a filter very easily with a lens tissue or soap and water, it can permanently damage your lens coatings if you apply it directly.

NYLONS

A favorite with fashion photographers (possibly because they have a lot of nylons lying around), stretching nylons across the lens opens up a whole world of opportunity as they not only reduce the sharpness, but, depending on the color you use, can

also change the color of the image. Using black material tends to smudge the shadows in a picture more than it affects the highlights, while white stockings have the opposite effect. Brown material adds warmth to an image as well as softening it, making it a great option for portraits.

Once you've got yourself an old stocking or pair of nylons, cut out a small section of material roughly 5 inches (12.5cm) square. Stretch the material over the front element of the lens making sure it is flat, even, and well-stretched. Secure it with a rubber band to hold it in place on the barrel of the lens, taking care to position the rubber band to hold the nylon in place around the autofocus ring so the lens can still focus.

05 CREATIVE BOKEH

Taken from the Japanese word for "blurry" or "fuzzy," the term *bokeh* is used to describe the out of focus areas that usually occur in the background of an image. It is most noticeable in images taken with wide apertures—f/2.8 or wider—as the shallow depth of field throws backgrounds out of focus. If you look carefully at an image with a very small depth of field you might notice small, blurry geometric shapes in the background. This is bokeh.

The bokeh will take on the shape of the aperture blades of the lens that is being used, so it might appear as pentagons, hexagons, or octagons depending on the lens; if you use a catadioptric, or "mirror" lens, you'll get donut-shaped bokeh due the circular design of the mirror in the lens. For some photographers, having the "best" bokeh is a key concern, so much so that some lenses—particularly those designed for portrait photography—have near-circular aperture blades. However, for this project, we're not interested in the finest bokeh—we want to create our own personal bokeh shapes, so we can add a unique touch to our images.

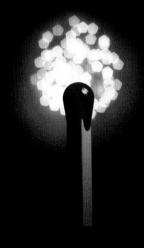

Left: Small, maneuverable light sources, such as Christmas tree lights, are perfect for arranging in the background to create bokeh. Attaching them to wires allows them to be positioned and securely held in place, helping to create images like this one.

WHAT YOU NEED

- Digital SLR camera
- Wide aperture lens (f/2.8 or wider)
- Black cardstock
- Scissors
- Craft knife
- Pencil
- Clear tape
- Compass

DIFFICULTY &

Left: While pentagon-shaped bokeh is an interesting phenomena, it is not very engaging when captured in isolation.

Try combining foreground interest with background bokeh to create images that are far more interesting.

TIPS

Set your lens to its widest setting to get the strongest effect from your bokeh filter.

Shooting close-up images will decrease your depth of field. Combine this with a wide aperture to maximize the bokeh effect in your pictures.

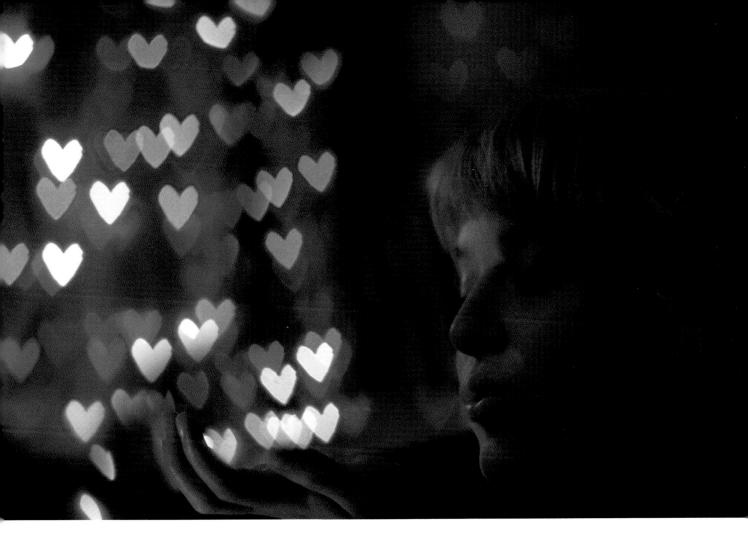

MAKING A BOKEH FILTER

A bokeh filter is easy to make—it's nothing more than a circle of cardstock with your chosen bokeh shape cut out of it.

For the best results, choose a lens with an aperture of f/1.8 and make a note of the filter diameter (this is normally written on the lens itself). Using a compass, draw a circle the same diameter as your lens's filter thread on a piece of black cardstock.

Cut out the circle and draw your bokeh shape in the center of the card—solid shapes such as hearts and stars work well.

Finally, cut the shape out of the card disc with a craft knife and you've made your own bokeh filter. Simply push the filter carefully on to the filter thread on the front of your lens and you're ready to start shooting! A fold of tape on the edge of the filter will help you remove it from the lens.

06 ZOOM-BURST

Once you've learned how to take a zoom-burst shot you will never be stuck for a way to bring dynamism and life into your creative photos. Better still, this is not a technique that requires any complicated set-ups or lengthy image-editing—and you can achieve it with the standard zoom lens that comes with virtually any SLR, so you don't need to spend a penny.

To create a zoom-burst image you simply need to turn the zoom barrel on your lens while the shutter is open, either zooming in or out. The striking effect is created by the movement of the image on the sensor in a similar manner to motion blur and, in essence, that's all there is to it. Zoom-bursts are a great way of highlighting a subject in a much more dramatic manner than simply using a shallow depth of field, or to exaggerate the impression of speed in your sports photography. It can also produce stunning abstract images that are perfect for creating giant wall-art prints (see Project 51). Here are some pointers for getting great-looking zoom-bursts, even if you've never tried it before.

WHAT YOU NEED

- Digital SLR camera with zoom lens
- Tripod

DIFFICULTY *

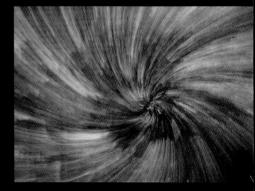

Zoom-bursts can be used to enhance an action shot (left) or to simply create abstract images (above and right).

TIPS

The length of your exposure and the speed you zoom at will both affect the result, so experiment with the shutter duration.

Fire your camera's flash during the exposure to record a moment of sharpness during the zoom-burst.

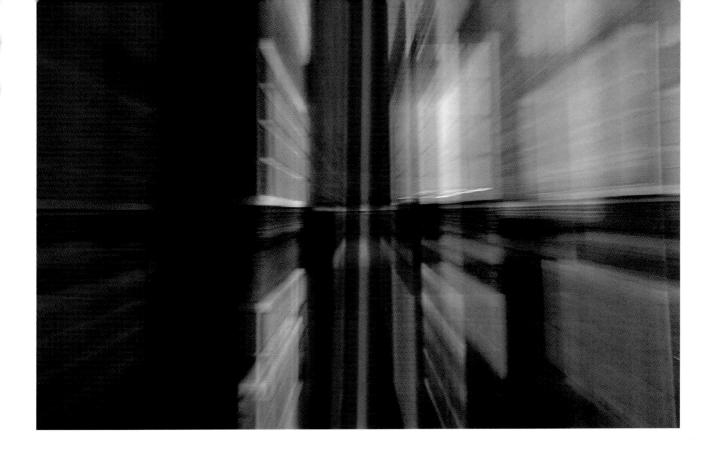

Set the slowest ISO setting your camera has (usually ISO 100) and use your camera in Shutter Priority mode to set a shutter speed long enough to give you time to zoom. This can be anything from 1/50 sec (which doesn't give you long) to a second or more. Line up your shot and begin turning the zoom smoothly as you trigger the shutter. Be sure that you have enough movement left in the zoom so the shutter closes before you reach the other end of the zoom range. This will keep the zoom effect even.

For most subjects, keep the camera as still as you can, preferably using a tripod. Any horizontal or vertical camera shake will be reflected in the zoom, which won't appear as a uniform pattern.

You'll find it easier to work in lower light situations, since these naturally require a longer shutter speed. In bright light you might need to use a neutral density filter to extend the exposure time. Great creative subjects include pin-points of light, like a night-time cityscape. In these high-contrast situations you can try hand-holding the camera to combine the zoomburst with deliberate camera shake for abstract results.

In general, you'll get the best results by turning the zoom barrel at a consistent speed. However, if you'd like to see the subject a little more sharply at one scale, stop turning the barrel before the end of the exposure, or begin the zoom half way into the exposure. This is great for creating the effect of light streaming through a stained-glass window, for example.

Zoom out as well as in, especially with a moving subject. If you zoom in on an approaching automobile, for example, it will seem to disappear, whereas zooming out so that it remains roughly the same size in the viewfinder will make it leap from a blurred background. Just make sure it's not coming right for you!

LONG DAYLIGHT EXPOSURES

As photographers, we spend a lot of time and money getting as much light into the camera as we can, and "fast" lenses with large maximum apertures are both coveted and expensive. There are times when using these lenses to keep the shutter speed to a minimum creates fantastic results, recording split-second moments of time in a sports event, or "freezing" a crashing wave. Indeed, some water shots look best when the liquid flow is halted through an extremely brief exposure time, revealing each gleaming droplet suspended in the air.

However, it's also possible to go to the opposite extreme, lengthening the exposure time to transform moving water into a soft, veil-like surface. This is easy to do at night, when light levels are low, but how about in the middle of the day, when the sun is high in the sky and your camera wants to make exposures of fractions of a second? The answer is to use a neutral density—or ND—filter on your lens.

Neutral density filters are simply dark pieces of glass or plastic that reduce the amount of light entering the camera, and as you know, the less light you have entering the camera, the longer the exposure time. Because they absorb all wavelengths of light equally, they effectively darken the image without affecting the color in any way—hence "neutral" density—and it's important not to confuse them with gray filters. Although they look similar, gray filters are not specifically designed to be neutral, so may introduce a color shift to your images, as well as lengthening the exposure.

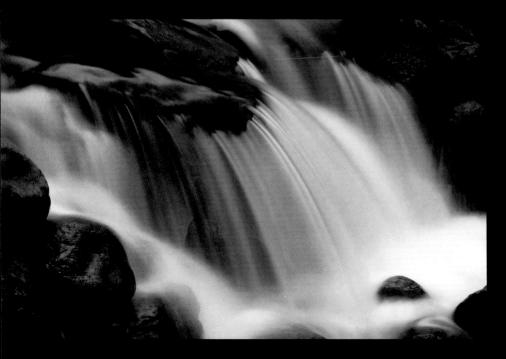

WHAT YOU NEED

- Digital SLR camera with filter thread or filter holder
- Neutral density filter (8x ND filters work well)
- Tripod
- Remote shutter release (optional)

DIFFICULTY *

TIPS

ND filters can be "stacked," so you can use more than one to increase the exposure time even further. However, as you add more filters the image quality will be reduced slightly, so using one high strength ND filter will give a better result than stacking three weaker ones.

Try combining your long daylight exposure with the "wrong" white balance setting to add an overall color-cast to your images (see Project 01).

Left: Using a tungsten white balance has added a cool blue cast to this long exposure of a small waterfall.

To make your long exposures you need to fit a neutral density (ND) filter to your lens. If all your lenses are the same diameter screw-fit filters are ideal, but if you want to use several lenses with different filter thread diameters it might work out cheaper to buy a square "system" filterholder and adaptor rings for each lens. That way a single ND filter can be used with more than one lens.

Set your camera on a tripod and frame the scene.

Remember that any moving objects in the view, such as clouds, leaves and branches, people, cars, and so on will all be blurred and, if the exposure is long enough, might even "disappear" entirely.

Set your camera to its lowest ISO setting and choose Aperture Priority mode. Select the smallest aperture setting (the biggest f/ number) as this will give you the slowest possible shutter speed. This will increase the depth of field (the areas in focus), but could also soften the image slightly as most lenses perform less well when stopped down too far.

You can let your camera work out the exposure for your long exposure shots because your camera's metering will automatically increase the exposure time to compensate for your ND filter(s). If you have one, use a remote release to avoid moving the camera when you trigger the shutter, or use your camera's self-timer to take the shot.

ND FILTER STRENGTH

Confusingly, the darkness of an ND filter is described by different manufacturers in different ways—this grid will help you cut through the jargon:

Darkening factor	Optical density	Darkening in stops	Percent transmission of light
2x	0.3		50%
4x	0.6	2	25%
8x	0.9	3	12.5%

Using this as a guide, you can see that a 2x or 0.3 ND filter will reduce your exposure by 1 stop and reduce the amount of light entering the lens by 50%. This means it doubles the exposure time, so a 1/60 sec exposure without the filter would be 1/30 sec with a 0.3 ND filter attached to the lens. A good starting point for this project is an 8x (0.9) ND filter, which reduces exposures by 3 stops, so your 1/60 sec exposure without the filter would become a subject-blurring 1/8 sec.

NIGHT PHOTOGRAPHY AND STAR TRAILS

A lot of photographers put their camera away when night falls, or else reach for their flash to throw a little light on their subjects. This is a real shame, because after the sun's gone down there's a whole new world to be discovered, and night photography can yield some pretty amazing results for very little effort—at it's most basic, all you need is a tripod!

During the day, a typical photographic exposure requires a fraction of a second, which means that you can usually use your camera hand-held, without much risk of blurring. But at night a single exposure can take seconds, minutes, or even hours, so you need to use some sort of support to prevent blurred pictures. Tripods are the most common type of photographic support, since they're collapsible and portable. They may not be entirely convenient, but they are a necessary evil for long exposures. Alternatives include resting cameras on solid surfaces, a beanbag (see Project 25), or using some other kind of fixed bracket or attachment.

Night photographs always looks different to the camera than to the naked eye; in fact, they can often look better photographed than viewed. This is because your camera doesn't suffer from the same limitations as your eyes, so while low light levels will leave you seeing a gray and colorless world, your camera can produce the same brightly saturated color photographs that it can create during daylight hours. The key to successful night photography is to record these colors in all their glory, and the best time to shoot is not in the dead of night, but in the hour or so that follows sunset. On a clear evening you will be rewarded with deep, rich blue skies, with a warm glow on the horizon and clouds as they reflect the last of the sun. The following are more things to consider.

WHAT YOU NEED

- Point-and-shoot or digital SLR camera (with Bulb mode for star trails)
- Tripod
- Hand-held light meter (optional)
- Remote release (optional)

DIFFICULTY **

TIPS

Consider shooting a sequence of images for an HDR image if the contrast is high.

Set a low ISO and long exposure noise reduction to minimize noise and enhance color saturation.

Use Aperture Priority to control the depth of field in your image, and let the camera determine the appropriate shutter speed.

Left: Shooting just after the sun has set, but before the night sky turns black, can reward you with rich blue skies that help keep color in your night shots

First, the contrast of a scene at night can be higher than during the day, especially if you're shooting in an urban environment where bright lights such as neon signs and illuminated buildings are set against dark skies. Sometimes you might not be able to record all of this in a single shot, with your exposure losing either the bright lights, the deep shadows, or both. If this happens, consider shooting an HDR sequence as described in Project 43.

Also, shooting at night requires long exposures, and a lot of photographers will instantly dial in a higher ISO setting to keep the shutter speed as fast as possible. Don't! Instead, set a low ISO to get better saturation and help prevent high ISO noise appearing in your images. There will be some noise caused by the long exposure, but you may find your camera has a "long exposure noise reduction" option. If it has, choose this setting. When you do, your camera will take two shots—one of the scene, and a "dark frame." This is a frame where the shutter doesn't open, so the camera makes a "black" exposure at the same shutter speed as the original shot. What it is doing with this dark frame is determining what the noise pattern is at that shutter speed, and once it has analyzed the noise it can remove it from the final picture.

Above: One of the main challenges of night photography in an urban area is balancing artificial lighting with the ambient light. If the contrast is too high for a single exposure, consider shooting a sequence for an HDR image.

08 > > >

STAR TRAILS

As the Earth rotates on its axis once a day, stars and other heavenly bodies appear to circle the night sky. This happens at an imperceptibly slow rate, so it isn't something that's easily visible to the eye—but it certainly records photographically! This project is essentially an extension of night photography, as all the requirements of ordinary night photography follow here, including the essential use of a sturdy tripod.

The only additional factor to take into account is the position of the stars. To the ground observer, all of the stars appear to rotate in the sky around a fixed invisible point. In the northern hemisphere this is located right next to Polaris, the aptly named North Star or Pole Star. The southern hemisphere doesn't have a useful pole star, but the constellation known as the Southern Cross points in its general direction. If you aim at the pole you will get perfectly round star trails.

To take your star trails photographs, you need to find a location as far as possible from city lights, as the light will pollute the sky. A remote wilderness area is perfect for this type of photography, although a citywide power failure would be a pretty cool time to try it as well! Choose a moonless night, free from clouds, and normally you would want to shoot when the sky is completely dark, so there isn't any light in the sky to reduce the intensity of the stars.

If you want to have perfectly circular star trails, you need to locate the pole position of the sky. If you live in the northern

hemisphere it's quite easy to find Polaris, as the two end stars of the easily-spotted Big Dipper (Ursa Major) constellation point straight to the pole star. An introductory astronomy book will point you in the right direction. You can also use a compass, since Polaris is always to the north and, in the southern hemisphere, the southern pole is to the south. Magnetic poles aren't quite the same as celestial poles, but you don't need navigational levels of accuracy here.

Once you've located the pole star, you know which direction to point your camera. It can be helpful to determine the composition of the image during daylight as an image with foreground interest such as mountains, trees, or houses can be far more interesting than just having arcs of stars in the night sky.

Now, attach your camera to a sturdy tripod and manually focus the lens on infinity. If you set an aperture of f/8, this should mean that both the stars and your foreground are in focus. Determine your exposure time (a hand-held light meter is useful for this), bearing in mind that the longer the exposure, the longer the star trails become. For the long exposure times you are likely to encounter (half an hour or more), your camera will need to have a "Bulb" mode, where the shutter opens when you trigger the shutter and stays open until you press it again.

As with "normal" night photography, set a low ISO setting and turn on your camera's long exposure noise reduction if it has it. Then simply open the shutter, sit back, and wait while your camera records the world spinning in space.

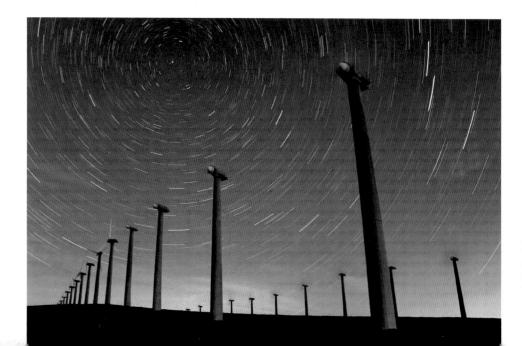

Left: If your star trail image contains Polaris (in the northern hemisphere), or you point your camera due south (in the southern hemisphere), your star trails will form concentric circles.

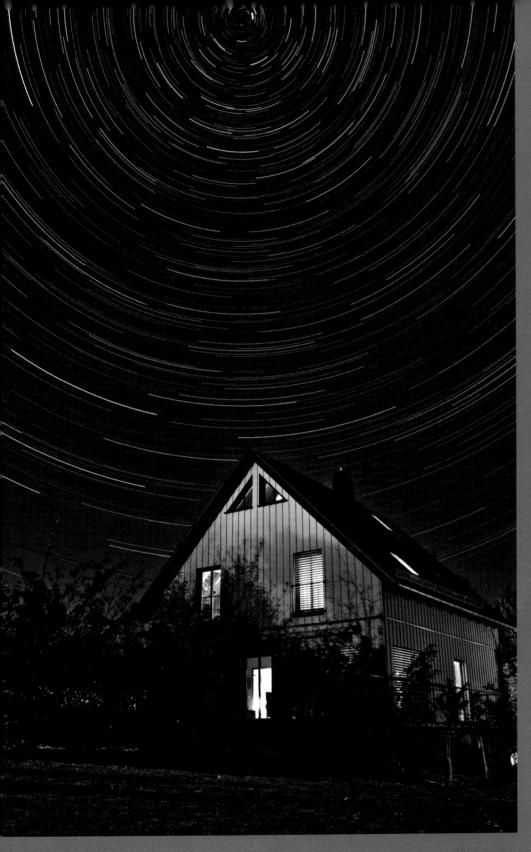

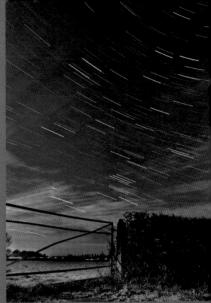

Left and Above: Including something in the foreground of your star trail shots prevents them from looking like white lines on a black background. It's a good idea to visit the location while it's still light to find something that will create a suitably interesting counterpoint to the star trails.

TIPS

Fully charge your battery before you shoot. If you have a source of AC power nearby, or a car adaptor for your camera, consider plugging it in to keep it powered.

If it's really cold or very humid, you might have a problem with dew or condensation forming on the lens during the exposure. If this happens, consider putting a hand warmer on the lens. You can also buy specialized "dew chasers" intended for telescopes.

You might notice objects other than stars in your star trail images. Orbiting satellites will appear as solid lines that don't follow the trail of stars, while aircraft will show up as a trail of dots in the photo due to their flashing wing- and taillights.

triggering the camera and tossing it into the air. That's really all there is to it, but the results can be fascinating, abstract forms of light art, where every image is unique, and nothing can be replicated. However, while serendipity plays a huge role in the outcome, there are ways that you can influence the picture.

One of the latest "extreme sports" in photography is camera tossing, and it's definitely

not something for the faint-hearted! At its most basic, camera tossing involves two steps;

• Point-and-shoot or digital

WHAT YOU NEED

SLR camera with self-timer and Shutter Priority mode (see WARNING first)

DIFFICULTY *

Camera tossing involves the

WARNING

possibility of permanent camera damage if you fail to catch the camera, or if it doesn't land on a very soft surface, so this might not be a technique to try out using a top-of-the-line digital SLR! Instead, look for a cheap point-and-shoot camera in a

TIPS

Camera tossing is often done in dark or dimly lit settings with bright light sources nearby. The contrast between the light and dark and pin-point lighting

creates the strongest images, like those shown here.

yard sale to practice with.

Try inverting the colors of your camera-toss pictures in your image-editing software for interesting results.

STARTING OUT

Two things have the greatest effect over your camera-tossing shots—the length of the exposure, and the speed of the "toss." Both of these will determine how much blur there will be, but there are no hard-and-fast rules. You want to set a reasonably slow shutter speed—start with shutter speeds of around 1/4 sec—but it's worth experimenting with longer (and shorter) shutter durations as well. The easiest way to do this is to set Shutter Priority mode, and dial in the shutter speed you want to use.

When it comes to tossing your camera, you want to *gently* throw it into the air, ideally so it tumbles end-over-end, spins, and rotates in the air—all kinds of techniques are possible, and ultimately it's all about seeing what works best for you. Before you toss the camera, start the self-timer. Generally, camera tosses work best when the shutter opens and closes while the camera is in the air. It may be possible to do this if your digital camera has an extremely long shutter lag, but using the self-timer is more reliable, ideally setting it to 2 seconds if you have this option. Try and time your toss so you throw the camera into the air just before the shutter opens. If you throw it too early the shutter might not open "in flight," while leaving it too late might mean the exposure is over before the camera has left your hand.

The final part of the process is to CATCH YOUR CAMERA! It's a natural first instinct to hold onto the camera strap, or attach a wrist strap or similar when you toss the camera, but this will affect the spin of the camera and limit the results you get. Besides, camera strap attachment points aren't always that strong and could actually break from a sharp tug. So toss the camera "untethered," put something soft on the ground as a safety precaution, and practice your catching!

Camera tossing works well when the camera is thrown in front of a small, bright light source, as in both of these images. The contrast and color can intensify the abstract results.

10 panning fixed subjects

Photography treads a line between art and science, and panning is one of those circumstances where a little of both is required. In motor racing, panning has become part of the visual language for photographers, where tracking a moving subject can produce a crystal-sharp centerpiece against a texture of soft streaks. The science is based on setting the most appropriate shutter speed, while the art centers on the panning, action with the aim of moving the camera in harmony with the subject. But what if we were to tip the balance in favor of the "art," panning the camera not only on moving subjects, but on a fixed subject? Suddenly a short pan across a visually rich subject, such as the mottled texture of a leafy forest, creates an altogether more stirring interpretation of the scene, adding an impressionistic touch to the shot the moment the shutter closes.

What we're doing in this project is introducing motion blur where there is no motion. Creating a motion blur of any kind—be it through moving the camera or because your subject is in motion—requires you to bring the shutter speed under your control. The best way of doing this is to use your camera's Shutter Priority mode, as this will let you set the shutter speed you want, while your camera chooses a suitable aperture. When you're following a moving subject, shooting at 1/60 sec for faster moving objects and 1/30 sec for slower ones is usually recommended, but when you are panning for more artistic reasons there's greater flexibility, as you do not need to worry about perfect sharpness anywhere in the frame.

To take your creative panning photographs, set your camera up on a tripod, switch to Shutter Priority mode, and select a slow shutter speed. Choose a shutter speed of 1/4 sec

or longer to start with, as this will give you enough time to move the camera during the exposure to create your motion blur. Now, loosen your tripod so you can move the camera fairly freely. You can either do this so the camera can only move horizontally across the frame, or vertically, or both, but consider the subject—with naturally vertical subjects, such as trees, a vertical pan will enhance their form, while a horizontal pan can blur it beyond recognition. Trigger the shutter and, while the exposure is being made, move the camera. The movement can be smooth and slow, or quick—it all depends on how much blur you want and the shutter speed you're using.

WHAT YOU NEED

- Point-and-shoot or digital SLR camera with Shutter Priority
- Tripod (optional)

DIFFICULTY *

TIP

For added depth, create multiple pans of the subject, moving the camera in different directions. Overlay the images in your image-editing program to create a painterly effect.

Below: A long, 1-second exposure was used here, and the camera was panned horizontally on a tripod.

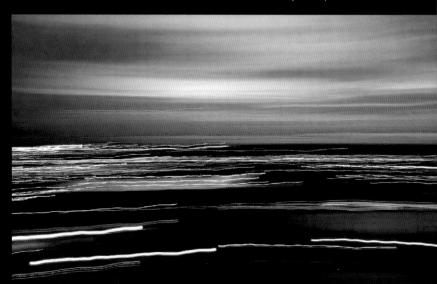

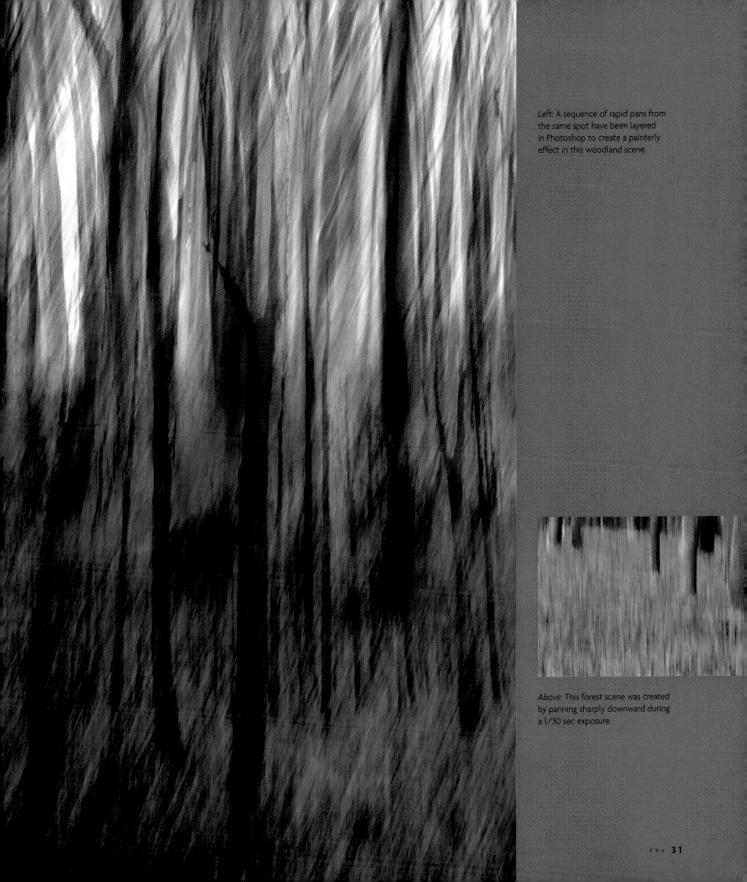

family photo album, and the passage of time is exactly what you see, with pictures of babies becoming adolescents, teenagers becoming adults, and the cycle starting again when a baby is born. Essentially, time-lapse photography is no different—it's just a series of photographs taken over a period of time to show growth or change, although these changes tend to cover hours or days, rather than lifetimes, and the subject tends to remain in the same place. When the pictures are put together as a sequence, the results can be pretty awesome. Time-lapse shots can be done either manually or automatically, and the method you choose will largely come down to your camera. If it has a built-in interval timer (or "intervalometer") then automatic is definitely the way to go. If it doesn't, you can still shoot time-lapse sequences, but you'll have to take your pictures manually, using a clock or

stopwatch and a lot of patience.

If theres one thing that still photographs are particularly good at portraying it's a frozen

moment in time, but they struggle to record the passage of time. Or do they? Look at a

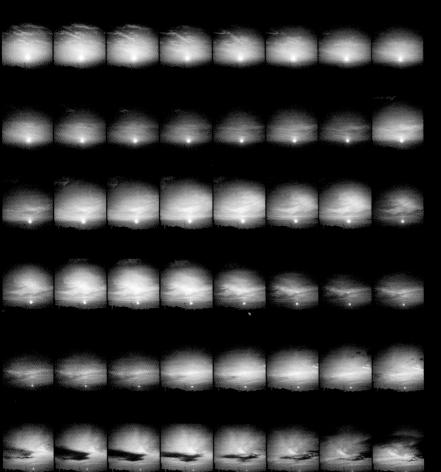

· Point-and-shoot or digital SLR camera · Tripod

DIFFICULTY *

WHAT YOU NEED

As well as being built into many cameras, quite a few digital SLRs come with software that allows

SOFTWARE-BASED **INTERVALOMETERS**

you to control your camera from your computer. If you look in the manual, you may find that the software has an interval timer feature. This means you can hook your camera up to your computer and have the computer "control" your time-lapse sequence. An added benefit is that the interval timer can download photos straight to your computer's hard drive. The drawback is that the camera has to be tethered to the computer, and probably an

For this sequence of the setting sun, the images were combined to create a single, large photograph.

external power supply, so it's not something you can do outdoors.

SHOOTING TIME-LAPSE SEQUENCES

For a time-lapse sequence to be effective, the framing between each shot needs to remain constant, so it's only the things that are changing over time that move. This means locking your camera onto a sturdy tripod.

To determine the exposure setting, you need to decide what time period the sequence will cover as the lighting may change. If you think the light levels will change across the exposure sequence—such as the sun setting, or a partial cloud that may or may not be covering the sun when an exposure is made—then one of your camera's automatic shooting modes is a good choice; Aperture Priority or Shutter Priority if you want to set a specific f-stop or exposure time, or Program if you are happy for the camera to determine both of these settings for you. On the other hand, if the lighting is constant—photographing the inside of a building over a period of time, for example—set your exposure using Manual mode so the settings remain constant.

You then need to set up your camera's interval timer (if you're using one), and how you do this will depend on your subject. A flower may open in the space of an hour in the morning, for example, so you might want to take a picture every five minutes. This means you would need to set the camera to shoot twelve frames over a 60-minute period. If you're not sure how many pictures to take, it's always better to shoot more frames and delete some at the post-processing stage than get to the end

of a sequence and discover you've missed a key moment. It's also very important to note that long time sequences will require your camera to be powered for the whole time. If a household power point is available then you should plug in your camera's AC adaptor. This is particularly valuable if you are using your camera tethered to the computer, as the connection may stop responding if the camera powers down, or goes into sleep mode after it has taken the first shot.

If you're shooting manually, you can ignore the last stage as you're going to have to trigger the camera yourself. This has the benefit of letting you switch the camera on to take a shot in the sequence, then power it down once the picture's on your memory card. The downside is you have to go through this routine at set times, until you've shot across the timescale you planned to record. In effect, you are a human intervalometer!

Once your sequence is shot, you can download the images and move on to post-processing. This could be as simple as placing all of the images in your sequence onto a single page, or printing them out separately to create some wall art (see Project 51). Alternatively, why not put them into a video editing program? By stitching them together as individual movie frames you can create a "stop frame animation" of your sequence. However, if you intend to make a short movie it's worth remembering that you will need to have twenty-four or twenty-five frames for each second of video, so you need a long sequence!

This classic time-lapse sequence shows a flower opening. By shooting the flower against a white background, the images could be assembled seamlessly.

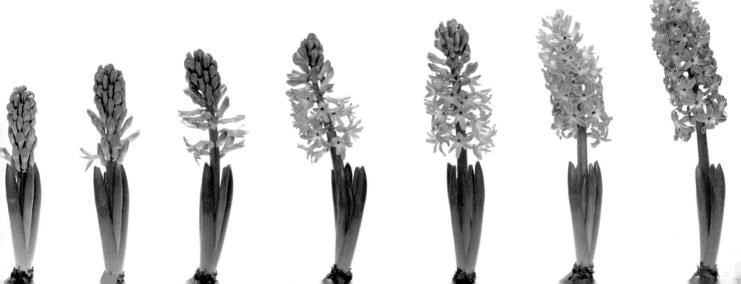

SHOOTING SMOKE

It may be elusive and unpredictable, but smoke can produce some of the most beautiful abstract pictures you're likely to see and, because smoke is so transient, the striking images you create are entirely unrepeatable, so no two shots will ever be the same. However, making these unique works of art does require a certain degree of patience, and you are going to see a lot of less-successful images along the way as you learn what works and what doesn't. But, while smoke isn't the easiest subject you'll ever photograph, the end results can be well worth the effort you put in.

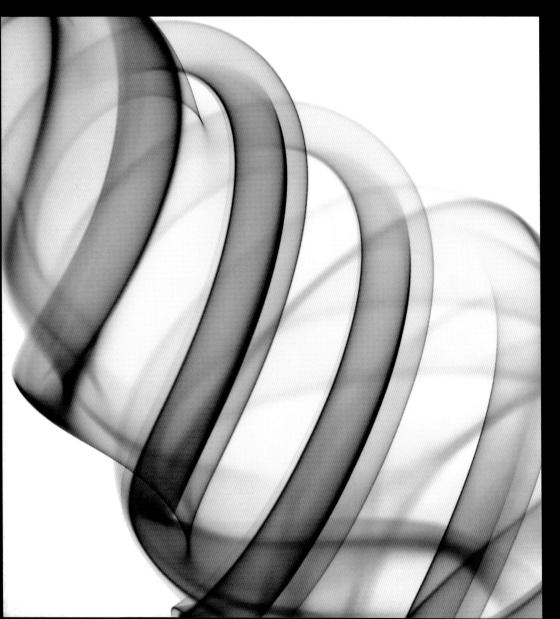

WHAT YOU NEED

- · Point-and-shoot or digital SLR camera with Manual exposure control
- Flash that can be used off-camera
- Tripod
- Incense sticks or cones
- · Black velvet, or similar material
- Image-editing software

DIFFICULTY * * *

Left: Inverting a smoke picture changes the background from black to white, while digital coloring enhances the abstract nature of the photograph.

TIPS

If you shoot Raw, you can finetune your exposures after you've shot your pictures. You also can adjust the crop, contrast, and color when you convert the files. Most Raw converters will allow you to apply the settings to a batch of images, making it much easier to edit and optimize shots taken at the same time.

Reversing the tones in an image after you've made the background black is a popular technique that will give your smoke shots a pure white background. Color should be applied after you've inverted the image.

THE LOCATION

Smoke photography needs to be done indoors so you get strong plumes of smoke, and you need to make sure there aren't any strong breezes or drafts in the room as these will dissipate the smoke before you get a chance to photograph it.

However, you also want the room to be well-ventilated to avoid the smoke becoming overpowering and making the room cloudy, which will reduce the contrast and sharpness of your pictures. This clearly contradicts the idea of working in a draft-free environment, so the best compromise is to take photographs for around fifteen minutes at most, air the room to clear the smoke, then start to shoot again.

THE SETUP

Taking pictures of smoke doesn't require a great deal of expensive equipment; all you need is a camera with manual exposure and focus controls, a flash that you can position and fire away from the camera, some black cloth (velvet is perfect) to use as a backdrop, and something to provide your smoke. Incense sticks or cones are good for this as they produce plenty of thick smoke and smell pleasant as well.

The basic setup of these four ingredients is simple. Start by pinning the backdrop to a wall and put your camera on a tripod around 3 feet (1m) in front of the black background. Place your incense stick or cone in between the camera and background, and position your flash to one side, or slightly behind, pointing toward the area where you think your smoke will be.

It's a good idea to try and focus the flash by fitting a simple snoot (see Project 34) around the front of it to prevent any stray light reflecting off the walls or ceiling of the room you're shooting in. Stray light will reduce the contrast in the image, but you want to have as much contrast in your pictures as possible, to bring out the subtle tones within the smoke.

Right: A "raw" smoke shot will have gray-blue smoke against a black background. This can work on its own, but many smoke photographers will color their pictures using image-editing software.

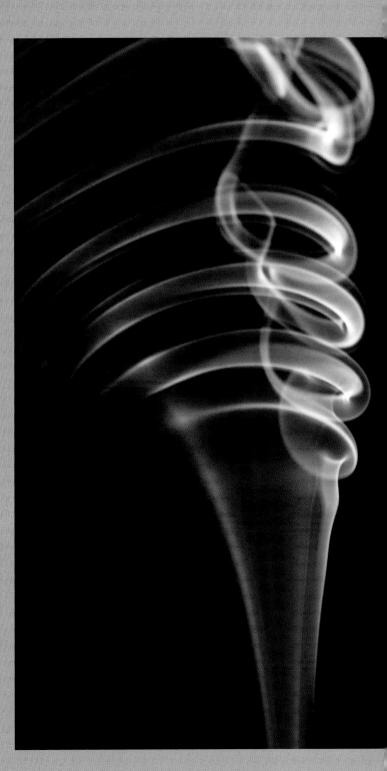

CAMERA SETTINGS

With your "smoke studio" organized, it's time to start shooting. Before you do, you need to set up your camera and flash.

Shutter speed: You need to use a fast shutter speed to freeze the constantly moving smoke and keep it as sharp as possible in the final image. Manually set your camera's shutter to the fastest shutter speed that will sync with your flash—usually this will be 1/125 sec or 1/250 sec.

Aperture: You want to set a small aperture so you get a good depth of field. Again, this is to keep the smoke sharp, because it won't stay in one place in front of the lens. An aperture setting of f/8 or smaller is a good starting point, and you'll need to be working in your camera's Manual mode to set this.

Sensitivity (ISO): Choose a low ISO setting of ISO 100-200 to make sure that the image you capture is as noise-free as possible. Smoke possesses a naturally grainy appearance and you don't want to exaggerate it.

Focus: Because you'll be working in darkness, your camera's autofocus will struggle to focus on the smoke, so manual focus is the answer. Set your camera to manual focus, place an object roughly where you think the smoke will appear (above the incense), and focus the lens.

Flash: The combination of a fast shutter speed, small aperture, and low ISO adds up to one thing—your flash needs to be putting out a lot of light. If your flash unit lets you, set it to full power to start with, and position it fairly close to the smoke.

SHOOTING

Now that your camera's set, you can light your incense and start shooting. Take a few shots at the basic settings to start with, and review them on your camera's LCD screen. You want the lightest parts of the smoke to be bright, without being overexposed, but at the same time you don't want to underexpose your images or the smoke will blend into the black background. Trial and error is the only real answer, as every setup will be slightly different.

Adjust the flash power (or distance) and aperture setting until you get your exposure settings right, and then start shooting for real. Don't look through the viewfinder as you shoot—your camera's set, so there's no need. Instead, watch as the smoke moves in front of you and try to take your pictures when the most interesting shapes are formed. To help create more abstract shapes, gently blow near the plume to get some movement in the air.

POST-PROCESSING

Post-processing is as important as shooting when it comes to smoke pictures, because it's at this stage that you'll select, edit, and possibly color your images. The first stage is to narrow down all of the shots you've taken to the ones that have the most interesting shapes. Use your image-editing program's cropping tool to emphasize and isolate the abstract patterns.

Next, adjust the background so it's a true black, and then bring out the contrast in the smoke. You can do this with Levels or Curves in Adobe Photoshop, or by using the Burn tool to darken the shadows, and the Dodge tool to lighten the highlights. Alternatively, you can simply paint the background black in your editing program.

At this stage your image will look good, but the smoke is probably gray and fairly uninspiring. Because of this, many smoke photographers choose to color the smoke, and some will invert the image first (see Tips), to set it against a clean white background. You can use any color adjustment tool to add color, and because your background is pure black (or white if you inverted the image) it will not change—only the color of the smoke plume itself will be affected.

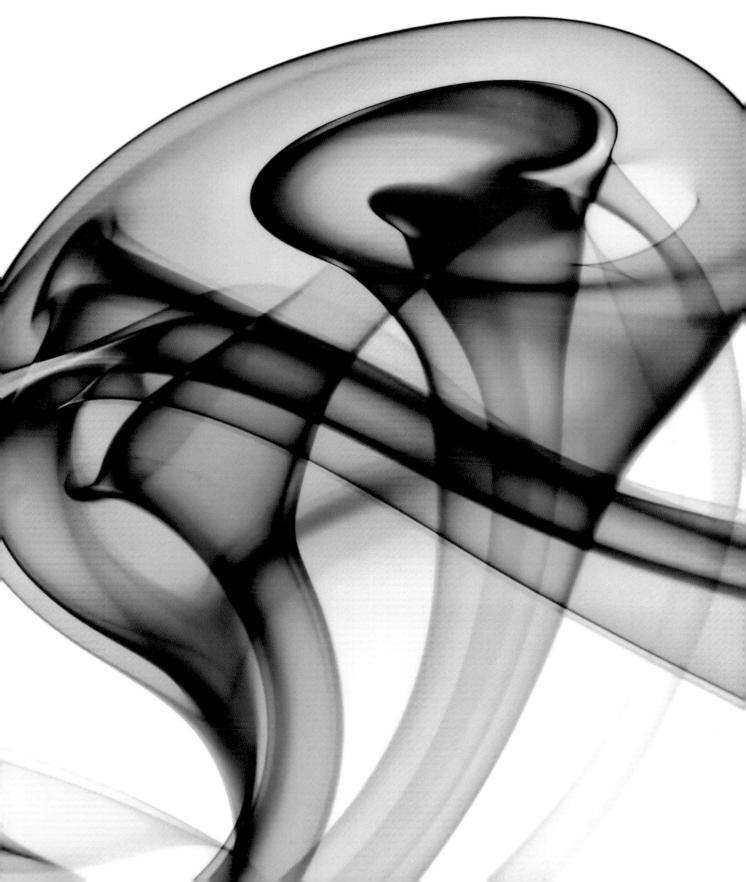

In Ingrespeed macro photographs of water droplets can look fantastic, especially when they're used to create stunning large-scale prints. However, it's something that looks—and ounds—like it's going to be incredibly difficult to do, and a lot of people think that to achieve a good result you need the most expensive camera, the most sophisticated flash system, and a bunch of specialist gear. But this simply isn't the case—the main ingredient for water droplet photography is good old-fashioned patience, which is the only reason this project has the maximum difficulty rating.

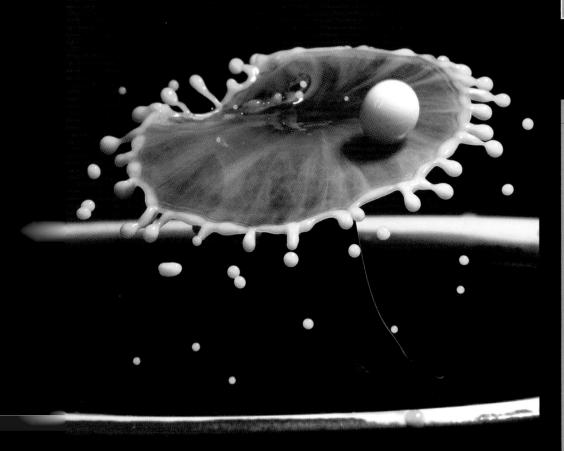

WHAT YOU NEED

- Point-and-shoot or digital SLR camera with Manual exposure control, manual focus, and macro lens/extension tubes/ close-up setting
- External flash (optional)
- Tripod (optional)
- Remote release (optional)
- Water dropper (or turkey baster)
- Container for water to fall into
- Colored background (optional)

DIFFICULTY **

BEAM SPLITTERS

If you start to take your waterdrop photography seriously, then you might want to consider getting (or making) a beam splitter. The sophistication of these devices varies, but the principal is basically the samean invisible beam is projected across the water-set and when a droplet breaks the beam, the camera is triggered automatically after a predetermined time that can be measured in fractions of a second. By carefully working on the position of the beam splitter and the delay before the camera fires, the whole process becomes much more controllable, to the point that you can consistently record the perfect crowns or droplets. However, while it makes the process more predictable, some would say it turns the art of serendipity into a science.

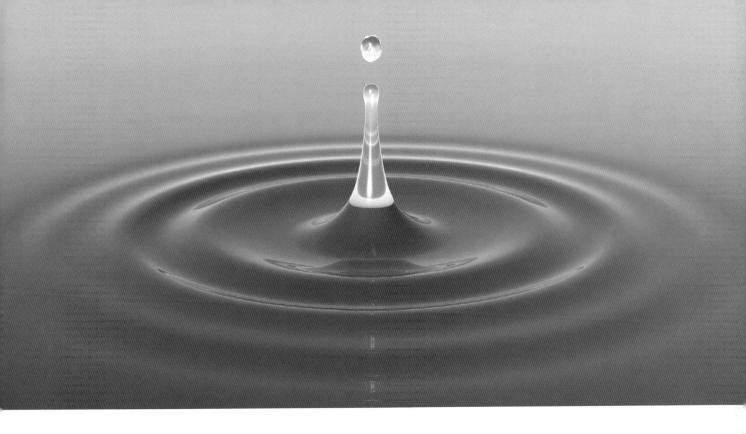

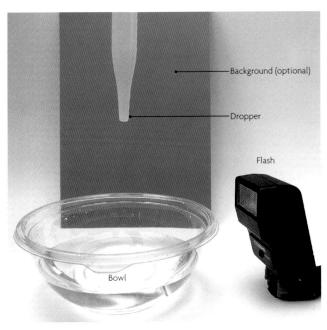

THE SETUP

Start by positioning a container of water on a table. This is where your water droplets are going to be formed, and you can use anything you like, from a fish tank to a glass, but consider if you're going to see any parts of the container in shot. If you are, then choose something that's going to be in keeping with the picture. Also think about the color of the container, as this can have a significant impact on your final image, especially if it appears in the shot, or as a background.

With your container in place, set up your camera. You can shoot water droplets hand-held, but attaching your camera to a tripod is strongly advised, simply because it means you can set a focus point and it won't change due to camera movement.

The key controls you need on your camera are manual exposure and manual focus. In addition, you need to be able to focus closely, and a dedicated macro lens on a digital SLR is the best solution, followed by extension tubes or close-up lenses. If you're using a point-and-shoot camera, then you'll need to use its macro or close-up mode.

Switch to manual focus, and pick a point in your container where you expect your drops to be—in the middle is usually a safe option. Hold a pencil, or something similar, just above the surface of the water in this position and focus your camera. It can help to have someone hold it for you while you focus.

EXPOSURE SETTINGS

The basic exposure criteria for water droplet photography is similar to smoke—you want a fast shutter speed, a small aperture, a low ISO, and plenty of light. And that means switching to your camera's Manual mode.

To keep your droplets sharp, set the camera's shutter speed to the maximum flash sync speed, which is usually 1/125–1/250 sec. Set a small aperture of f/11–f/22 so you get good depth of field (this is useful as the droplets won't all be in the same place, and close-up photography naturally gives a shallow depth of field), and finally set a low ISO for the smoothest results.

Flash is the best option to light the droplets as it produces a short, sharp burst of light that will help freeze the water. You can use your camera's built-in flash, but an external unit is better. Not only will it be more powerful, but you also can position it off-camera and close to the water so you get enough light for your fast shutter speed, small aperture, and low ISO combo. Fire off a few test frames to get the exposure right, increasing or decreasing the flash's power, or moving the flash closer to or further away from the water until it produces the right amount of light to match your camera settings.

SHOOTING

Now comes the hard part! Using a water-dropper (a turkey baster will also do just fine), drop water into your container, aiming as best you can at the area you focused on. As you do, shoot like crazy! A remote release will help here, because you can drop water and shoot without worrying about knocking the camera. Using your camera's continuous shooting mode may also help if your flash can recharge fast enough. Where the droplet is when the camera is triggered will determine whether you get a drop, a splash, or a perfect "crown"—the key is to just keep shooting and hope you capture the perfect moment.

With water droplet photography, timing is everything, and this is why you need a whole stack of patience—for every hundred shots you take you might only get one or two good ones. However, with practice your timing will improve, and your hit rate will increase.

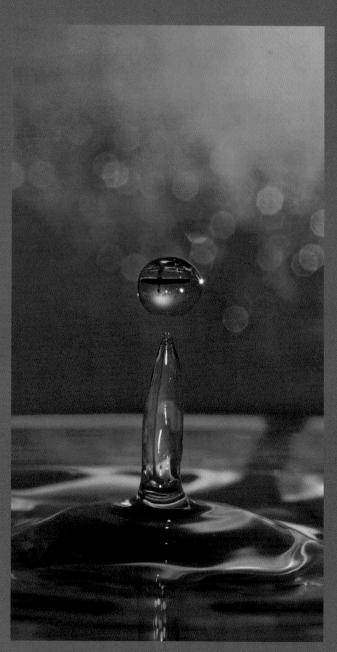

Above: Using a colored background is a great way of introducing color to your water shots

Right: As well as photographing the droplets splashing down, consider the start of their journey.

ADVANCED SHOOTING

Once you've mastered the basics of shooting water droplets, why not expand into slightly more creative areas?

Try adding food dye to the water you're dropping, to create a more striking contrast between the drop and the water it's hitting. Alternatively, try dropping colored water into pure white milk. The shot on page 38 shows milk being dropped into coffee.

Add a colored background behind your water set-up and its color will be reflected into the water drop. This can be used to add abstract patterns, or even an image to the droplet, but remember that the water will "flip" the image, so position your background upside down if you want it to appear the right way up in the droplet. Your background will be sharply focused in the droplet, but will be a blur in the rest of the picture.

Drop two or more drops in close succession, so as the first rises from the pool the second appears to "sit" on top of it, or create a "double splash"—as shown on page 38. The options and permutations are endless, and simply depend on how far apart you make your droplets, and precisely when your camera fires.

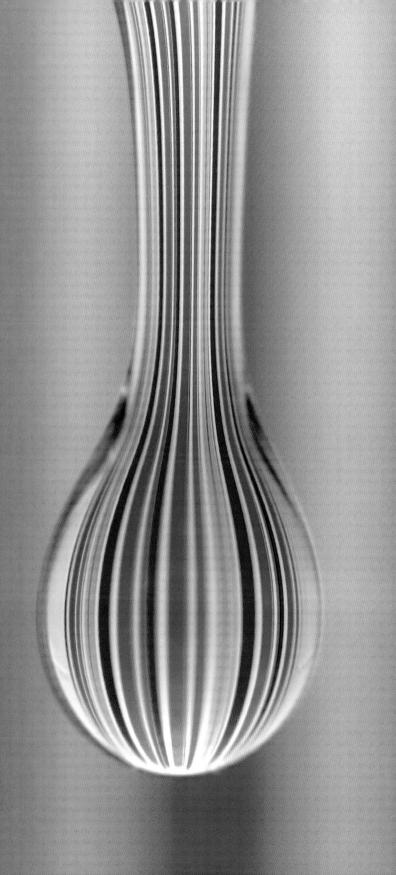

The word *photography* comes from two Greek words that translate roughly as "light paintbrush" or "light drawing," but it is more commonly translated as "painting with light." As photographers, we rely on the reflection of light in a scene to help us create images that capture a moment in time. More often than not we look for spectacular natural light, such as sunrises, sunsets, dramatic skies, or even the man-made light that illuminates a nighttime scene (see Project 8). However, we also have the ability to illuminate a scene as we see fit, in much the same way that painters can produce their own interpretations of a scene. This is most apparent when using studio lighting for a portrait or a product shot, but artificial illumination doesn't have to be restricted to the studio. With flashguns, torches, LEDs, and even lasers, you can illuminate an exterior scene in any way you choose, creating your own version of reality. This is the true, creative interpretation of "painting with light."

WHAT YOU NEED

- Digital SLR camera with B (Bulb) setting
- · Flashlight, flash, or similar

DIFFICULTY * * *

Using a colored flash can add extra dimension to your light paintings. For the shot below, a yellow-gelled flash painted the top and bottom, a bluegelled flash was fired at the bars, and a red-gelled flash was triggered inside each of the cells.

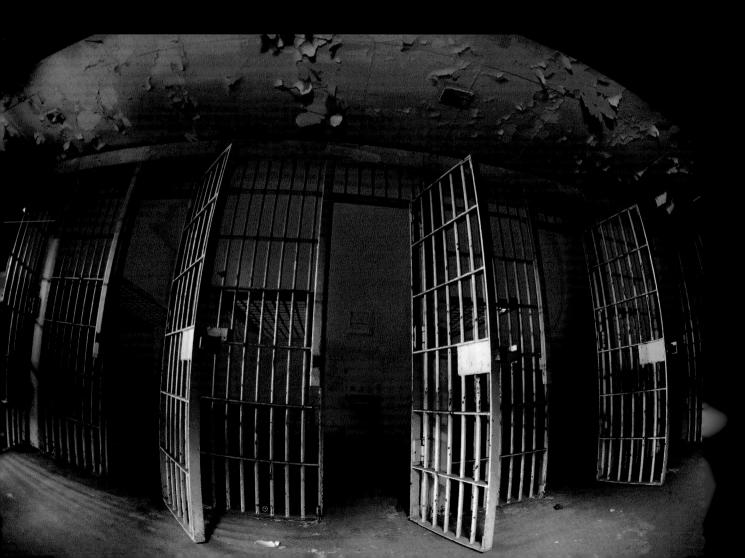

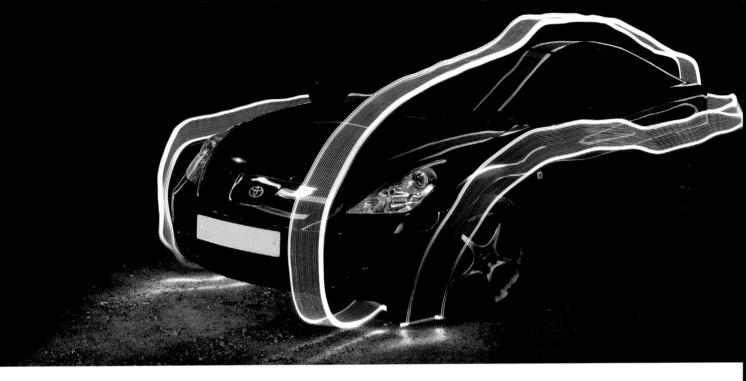

WORKING OUTSIDE

Just like a painter, to be a able to paint you need to start with a completely blank canvas. As photographers, this "canvas" needs to be black so that you can add, or "paint," the light onto the image as you expose your film or sensor. Working at night gives you the perfect opportunity to do this. A flash is the most obvious light source to use—particularly if there are people in your scene—as it will freeze any motion, but it is possible to use just about anything that creates light.

Try to find an appropriate scene to illuminate, and think about which areas you want to light, how you want to light them, and even the colors you want to light them with. Using cold blues and greens in a woodland scene can make it seem like a fantasy setting, while using an assortment of lighting and colors on a steel and glass building can make it look like something from a science fiction movie. Colored effects can be achieved by using a colored gel over your flash or light.

If you are lucky enough to own multiple wireless flashes then it is possible to hide them around a scene to light various parts of the subject. Simply set the aperture to f/8 to start with, and fire your camera's shutter in B (Bulb) mode. Adjust the flash brightness until you get the result you are after.

With a single flash it is possible to achieve the same results, but you need to be prepared to do a little bit of running around. Set your camera on a sturdy tripod and take an ambient light reading to see how long it will take to expose the scene. Decide how much ambient light you want the scene to have (usually you will want to expose so that the night sky is not completely black).

Above: You can use almost anything that produces light to illuminate your subject. In this spectacular car shot, a light "wand" was moved rapidly around the car to add the dynamic orange light trails.

Now, set your camera's exposure in Manual mode and, with the flash set to around 1/16 power, trigger the camera's shutter. Move around the scene, firing the flash to light up different areas while the shutter is open. It is best to wear black or dark clothing while you do this so that you don't become visible in the image, Make sure you don't fire the flash directly at the lens or it will show as a hotspot in the image.

After the image has been taken, see which areas have been properly exposed and which haven't. It may take a few attempts before you find exactly the right amount of light to use to expose each area, and you might find that you need to fire the flash a few times in and around one location, or that you need to increase the power of the flash. A fresh set of batteries, or even an external power supply for your flash unit may speed up the time it takes to recharge before you can fire the flash again.

The whole process can be quite hit and miss, and if you are covering a large area in only a short space of time it is a good idea to have a second person helping you fire another flash, or triggering the camera. Alternatively, set a small aperture and the lowest ISO setting so you get a longer exposure that gives you time to illuminate the whole scene.

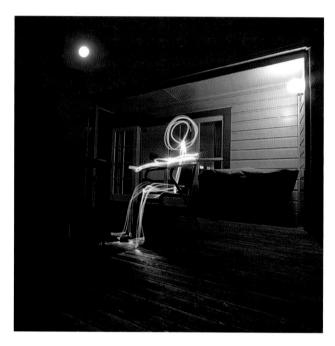

Above: The most interesting outdoor images often combine light painting with ambient light.

FLASHLIGHTS

A flash isn't the only way to light a scene, and a hand-held flashlight can be just as effective. Once again, start by taking an ambient light reading and set the camera's exposure to allow some of this light in to the image. Now, use a flashlight to light up parts of the scene. The flashlight will be a lot less powerful than a flash, so you will have to use a sturdy tripod and be prepared for long exposure times. Most digital SLR cameras will allow for up to thirty seconds before you have to use the B (Bulb) setting.

A flashlight is much more directional than a flash, and this lets you choose precisely what to light and what to leave in darkness. Use your flashlight as a paintbrush and paint the light onto the subject. Make sure you keep moving the flashlight so the lighting is smooth with no hotspots. Obviously, depending on the size of the area you are lighting you may need to vary the power output of any flashlight you are using, and maybe even use different flashlights, just as you might use different sized paintbrushes.

LIGHT STREAKS

As a child you might remember using a sparkler at night to make shapes and write your name in the air. Using a tripod and a long exposure, it is possible to capture these trails of light. You can use a sparkler, a flashlight, a lamp—any source of light will have some effect and help you paint a picture.

Once again, wear black or dark clothing so that you don't appear in the images, then turn so that you are shining the light in the direction of the camera, but not directly into the lens as this could introduce lens flare. Now paint your light trails. Try experimenting by using light to outline parts of a scene. Use a flashlight to draw around the outline of a car or tree, or draw outlines around everything in the scene using different colored lights. You could even use the light to draw cartoon-style characters, like the images shown here.

Right: Using a flashlight lets you paint light into parts of an image or, as shown here, point the light toward the camera and draw "freehand" images.

TIPS

Working outside, assistants can be useful. Not only can they help you fire the camera's shutter, they can help you run around lighting large areas. If you don't have anyone available to help you, use an infrared remote to fire the shutter. This lets you get into position to begin painting with light. If you are lighting a large area, every second counts!

Colored lighting gels come with some flashes, and can be placed over the light to produce different colored light. Lighting gels can also be purchased as plastic sheets and cut to size. If you are working on a tight budget, candy wrappers or plastic bags can even be used to change the color of the light.

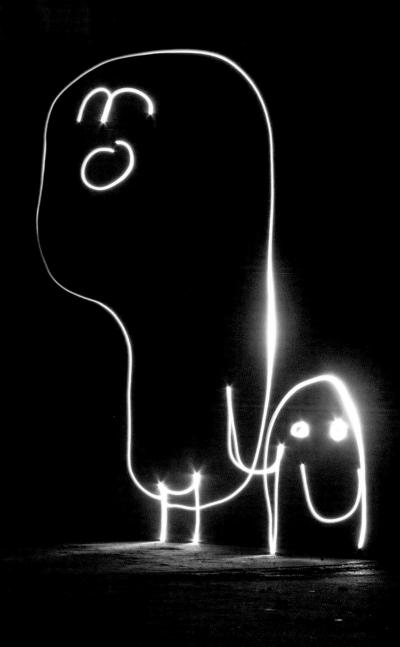

TOY CAMERAS

"Toy" cameras, such as the Diana and Holga, have been around for decades, but they have become hugely popular in recent years due to their low-tech approach to photography. Epitomizing everything "anti-digital," the combination of using film and a simple plastic camera takes the photographer back to the basics, providing a tangible "hands-on" approach to photography that is often overlooked, or simply not available in digital photography.

The Holga and Diana remain the most popular toy cameras today, using 120 (medium format) film that, despite a dramatic decline in production, is still widely available. Both cameras exhibit similar qualities, with vignetting, soft focus, and distinctly blurred edges typifying the pictures they make. Vignetting is the falling off of light that shows up near the corners of the frame, while the blurring and general soft focus is caused by the simplicity of the lens. These effects tend to be what most photographers aspire to achieve when using these cameras, and many photographs become instant works of art as a result.

The original version of the Diana was produced from the 1960s to '70s, and is no longer in production, but you can still find them, as well as their "clones" (cameras made exactly like the Diana, but with different names) on internet auction sites and at rummage sales. The Holga is a more modern camera, and still in production. The latest model—the Holga 120N—features a bulb mode for long exposures and a tripod mount, and as this camera is extremely easy to disassemble, it's the perfect camera if you want to make modifications to it for truly unique results (see Project 16). In addition to these two "essential" toy cameras, Lomography recently created a new, updated version of the Diana camera called the "Diana+." While remaining true to the original, the new model includes the ability to shoot either 4x4cm or 6x6cm images, has an additional pinhole aperture, and a tripod mount, making it the ultimate toy camera for the aspiring creative photographer.

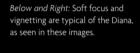

WHAT YOU NEED

(Holga, Diana, or Diana+)

• Toy camera

DIFFICULTY *

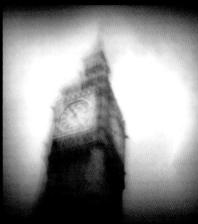

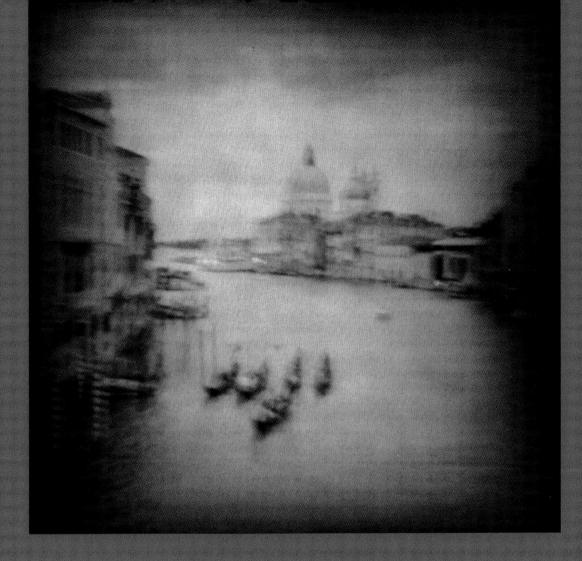

OTHER TOY CAMERAS

As well as the Holga and Dianas, there is a wide range of cameras that fall into the "toy" category, all of which produce exciting and unique results. Models to look out for include: Holga 135BC, Lomo Actionsampler, Lomo Supersampler, Lomo Fisheye (and Fisheye #2), Powershovel/Superheadz Blackbird, Powershovel/Superheadz Golden Half, and the Vivitar Ultra Wide & Slim.

HOLGA AND DIANA AT A GLANCE			
	HOLGA 120N	DIANA (ORIGINAL)	DIANA+
Film	120mm	120mm	120mm
Format	16 shots (6x4.5cm)	16 shots (4x4cm)	16 shots (4x4cm)
	12 shots (6x6cm)		12 shots (6x6cm)
Lens	Single element plastic	Single element plastic	Single element plastic
Aperture(s)	Sunny (f/11)	Sunny (f/22)	Sunny (f/22)
	Cloudy(f/11)	Partial sun (f/16)	Partial sun (f/16)
		Cloudy (f/11)	Cloudy (f/11)
			Pinhole (f/150)
Tripod mount	Yes	No	Yes
Bulb setting	Yes	Yes	Yes
Multiple exposure	Yes	Yes	Yes
Light leaks	Yes	Yes	Minimal to none
Vignetting	Yes	Yes	Yes

15 >>>

TOY CAMERA TECHNIQUES

Toy cameras open up a whole world of creative possibilities, regardless of whether you modify your camera or not. Here are just a few of the techniques you can exploit.

PANORAMAS

It's easy to create huge panoramic scenes using a Holga or Diana, simply by overlapping multiple frames. There are two main techniques for taking panoramic shots: pivoting and shuffling. Both techniques require you to start the panoramic sequence at the left of the scene you are photographing, and end up on the right—this is because the film advances from left to right.

Pivoting involves taking the first frame, advancing the film, then pivoting your body to the right for subsequent frames. The second method (shuffling) requires you to shoot the first frame, advance the film, then physically move to the right to take subsequent

frames, rather than turning your body. With both methods you should overlap the scene slightly, and keep the camera at the same height throughout the sequence frames. The pivot technique is best for landscapes, while shuffling is better for closer subjects.

It's important that you know how far to advance the film between frames when you create your panoramas, and looking at the numbers in your film counter won't be much use because this will just let you shoot sequential frames—with this technique you want to overlap them slightly to create a continuous panorama. Luckily, as well as the number on the film, we have another common reference point on the Holga, Diana, and Diana+, which is the arrow on the winding knob that points in the direction the film will wind. If you think of the tip of the arrow as the hour hand on a clock, all you need to know is how far to turn it between frames to create an overlap. Conveniently, the maximum winding you should do with a Holga to keep the exposures slightly overlapped

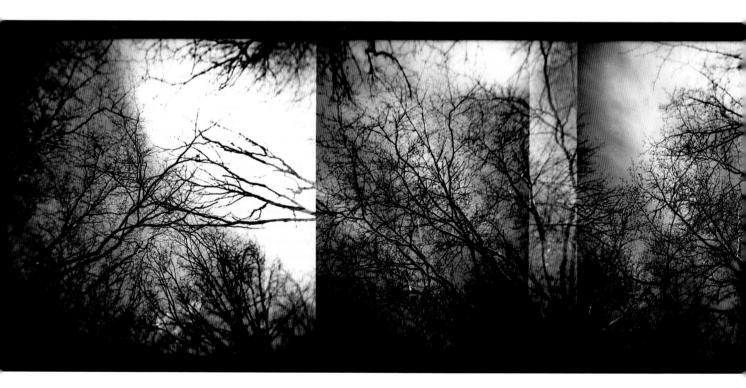

is one full turn, or a full "hour" on the dial. When shooting in 4x4cm mode (16 exposures) with a Diana or Diana+, turn the dial about forty-three minutes (just under ¾ of a turn) to keep the frames overlapped, while if you are shooting in 6x6cm mode using a Diana+, turn the dial just over ¾ of a turn (fifty minutes).

MULTIPLE EXPOSURES

As toy cameras don't have any mechanism to connect the shutter to the film advance, it is very easy to create multiple exposures on the same frame. Whether intentional or a "happy accident," multiple exposures can sometimes produce very interesting photographs. Combining different elements such as a sky and a person's head will give you what looks like a head floating in the clouds! When taking multiple exposures, bear in mind that the first exposure will have the heaviest imprint on the frame, and additional exposures will be added as semi-transparent layers.

BULB EXPOSURES

The Holga 120N and Diana+ both have a Bulb (B) exposure setting and a tripod mount, which means you can easily make long exposures with these cameras. Long exposures can be used in low-light situations, night photography, or just to create interesting effects on moving objects, such as water or stars.

The key to a successful long exposure is to know how long to keep the shutter open, which depends on how much light is available and the speed of your film. Shooting in daylight conditions requires a slow speed film such as 50 or 100 ISO, and the easiest way of getting the right exposure is to use a digital camera as a light meter. Set the aperture and film speed on your digital camera to match the aperture/film speed in your toy camera. The digital camera will then give you an exposure time that you can use to take the picture with your toy camera. To minimize camera shake, use a tripod and cable release.

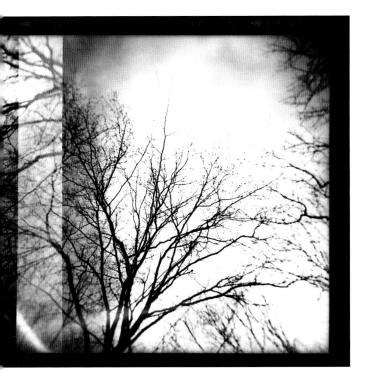

Above: Using your camera's Bulb mode, slow film, and possibly a neutral density filter can let you create dreamy, long-exposure images.

Left: Because the winding and shutter mechanisms aren't connected, toy cameras let you overlap your frames easily to create multi-shot panoramas.

TIP

Cross-processing your film is not a technique that is specific to toy cameras, but it is one that is commonly used to achieve interesting results. The technique involves shooting with slide (reversal, or E6) film and processing it in C41 chemicals, or shooting on C41 film, and processing it using E6 developer. Shoot your chosen film as normal, and ask your processing lab to cross-process it. The result will be strong contrast and shifted colors. Project 44 shows you how to re-create the look using your image-editing software.

16 HOLGA HACKS

The Holga 120 toy camera is easy to obtain, extremely inexpensive, and, best of all for the creative photographer, easy to modify, or "hack." While there are a number of models in the 120 series, the 120N is the simplest, least expensive, and most popular version, and it's the one that we're working on here. The 120N was introduced in 2004 as an upgrade to the 120S and, while it's a great camera, there are still simple modifications that can greatly improve the camera's picture-taking abilities. The following four modifications are covered here; extending the focus, modifying the aperture, preventing light leaks, and preventing camera shake in long exposures.

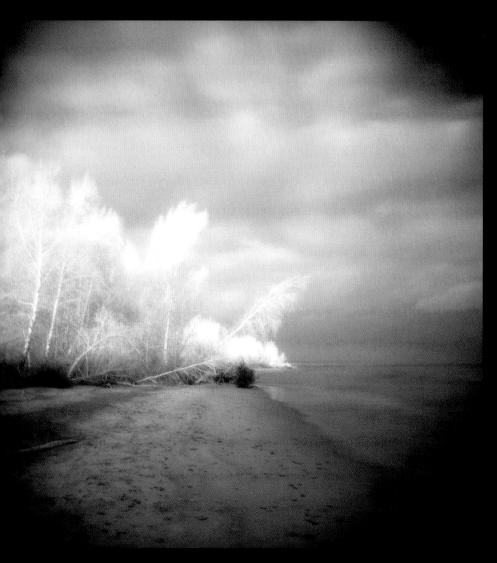

WHAT YOU NEED

- Holga camera (120N)
- · Jeweler's screwdriver set
- Phillips (cross-head) screwdriver
- Slotted screwdriver
- Black tape
- Scissors
- Flat, nonreflective spray paint
- Round or button-head screw
- Lens cap
- Tripod

DIFFICULTY * * *

Left: Light leaks can add an extra dimension to your Holga photographs, or ruin your shots, depending on your outlook. Consider "light-proofing" your camera if you want high-quality images.

Below: Inserting a screw between the shutter release and the camera body can hold the shutter open for shakefree long-exposure photography.

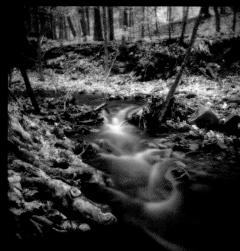

REMOVING THE FRONT ASSEMBLY

Removing the front of your Holga is the starting point for most modifications, and while it sounds daunting to disassemble the camera, it isn't that difficult.

Start by taking off the back of the camera and locating the two screws that hold the entire front assembly onto the camera (A). Remove the screws and pull off the front assembly.

You'll notice two yellow wires (B) that prevent the assembly from coming completely off—these two wires are for the hotshoe. I strongly suggest that if you have no intention of using an external flash, you simply cut these wires off. However, if you want to keep (and use) your hotshoe you can still make these modifications—working with the wires attached will just make things a little bit more difficult.

With the front assembly removed, you can now move on to modifying your Holga.

TIP

If you cut out the two yellow wires when you removed the front assembly, then you'll need to cover the holes that are left with a piece of black tape to prevent light leaks.

The Holga has a very simple twisting barrel focus mechanism that covers a specific focusing range from "one person" (close) to infinity (far). The mechanism that controls the distance that the barrel can turn (and therefore the range of focus) is simply a screw that physically stops the barrel from twisting past a certain point. Removing this screw provides an extended focusing range.

Looking at the back shutter assembly, identify the screw that is located in a hole (C). Remove the screw with a small Phillips screwdriver and you will now be able to twist the Holga's lens right off the camera. This will give you the ability to twist your lens out further than normal for closer focusing, and you can also move it tighter to the camera, extending the limit "beyond" infinity.

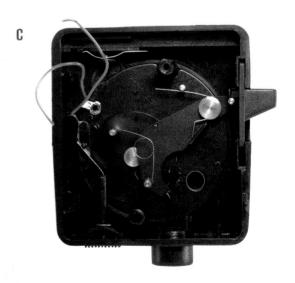

16 >>>

APERTURE MODIFICATION

The Holga 120N claims to have two aperture settings—"Sunny" (f/11) and "Cloudy" (f/8). While this was surely the intention, it is actually not true at all, and what appears to be a simple manufacturer's defect means that changing the setting makes no difference at all to the aperture you are using. We will correct this with a simple hack that will let us use the true aperture settings.

Start by removing the lens completely from the camera. The middle ring on the back side of the lens (A) will make the perfect aperture for our Sunny setting.

Using a slotted screwdriver, pry open the larger ring that holds our new aperture (B). Remove the ring and flip it onto its back side. It is important to note that the aperture you are removing is quite delicate so you should be patient with the next step.

Insert the tip of your slotted screwdriver between the two pieces of plastic (C) and gently pry away this delicate aperture. The aperture is held in place with glue, so be careful—if you apply too much pressure on one side it will break in half. Slowly work your way around in a circle to break away the glue and remove the small ring (D).

You now need to remove the shutter plate. Locate the two screws that hold the shutter assembly (E), but before you remove the screws, take a moment to look at the position of the shutter plate. When the screws are removed the shutter trigger on the right-hand side will fall out, so be aware that reassembling this is a bit of a jigsaw puzzle, but it's not too difficult. Remove the screws and carefully remove the shutter plate.

With the shutter plate removed, you'll see the rocker arm that controls the one aperture setting (F). Move the aperture switch back and forth and you will see how it works. When the aperture is moved to "Sunny," the rocker arm moves to the center. It is over this square hole that you want to add the new aperture ring that you just removed.

Simply tape the aperture over the square hole and you're in business. This is harder than it sounds, because you need to cut a hole in the tape just large enough for the aperture to sit on and then secure it onto the center of the square hole (G). If your hands aren't steady enough to cut a small hole with scissors, try using a paper hole-punch to make the hole. Apply the tape securely to the rocker arm, making sure that your new aperture isn't obstructed by the square hole underneath or any bits of tape (H).

The shutter assembly can now be re-fitted and reassembled by reversing the process and your Holga will have "proper" aperture settings.

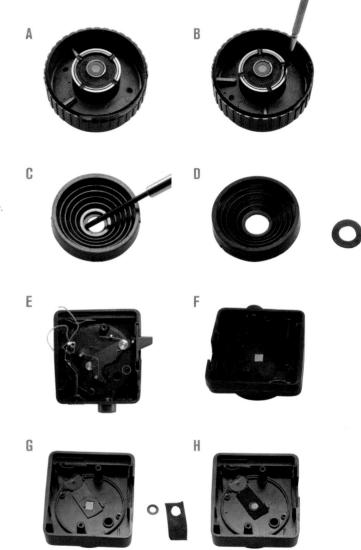

TIP

The shutter assembly is meant to fit snugly together, so with the extra bit of tape added to the rocker arm you may notice some stiffness to the aperture switch. To avoid this, loosen the screws that hold the shutter plate a quarter turn to allow a bit of give.

PREVENTING LIGHT LEAKS

Light leaks and Holgas go hand-in-hand, but while some Holga owners love them (and even encourage them), other Holga users hate them. This hack is for those who hate them, as you will seal every seam on the camera body and paint the interior to prevent any unwanted light from sneaking in.

The first task is to paint the interior of the Holga to dull down the reflective surface of the hard plastic. This is sometimes referred to as "flocking." In order to keep the spray paint inside the camera, place tape around the seams and add some masking tape for extra measure (A). It is also extremely important to cover up the center opening that leads to the shutter assembly—paint in here could lead to serious problems. You should also cover up the foam in the right-hand chamber. With the camera body masked, spray it with flat black, nonreflective spray paint in a well-ventilated area—outdoors is usually best (B). Allow sufficient time for the paint to dry, then remove all of the tape (C).

The next task is to cover up a couple of pesky holes that are notorious for leaking light. Look inside the rear of the camera, toward the top, and you will find two holes (D)—cover them both with a small piece of black tape.

Now it's time to load up some film and go out to take some pictures! But before you start shooting (and after you've loaded your film) tape up your camera. The aim here is to wrap it around all of the camera's seams so that light can't creep in through any tiny gaps and cracks (E). Don't forget that the film counter window is a prime suspect for leaking light, so you should always have the red film counter window taped up unless you are advancing the film.

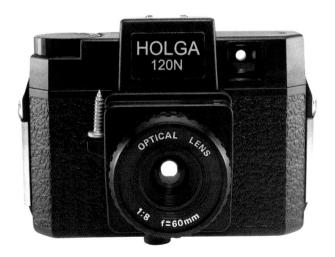

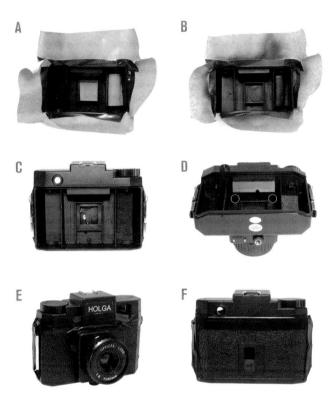

LONG EXPOSURES

With its bulb setting and tripod mount upgrade, the Holga 120N has the ability to take long exposures. However, pressing the shutter down, holding it open, and then releasing it will inevitably introduce camera shake, even if the camera's mounted on a tripod. This simple "trick" quickly solves the problem.

Assuming you have film loaded in your camera, it's set on a tripod, and pointing at the scene you want to photograph, put on your lens cap.

Set the exposure switch to "B" (Bulb) for your long exposure, and get a screw with a round head and flip it upside down. Press down the shutter release to open the shutter (with the lens cap still on) and push the head of the screw into the opening. Slowly release the shutter so it rests on the screw head. This is effectively "jamming" the shutter, which will stay open for as long as the screw is in place.

Now you can simply remove the lens cap to start your exposure, and put the cap back on to end it. Although this will create a small amount of shake, it will be a lot less than doing it the "normal" way. Remove the screw to close the shutter.

TTV PHOTOGRAPHY

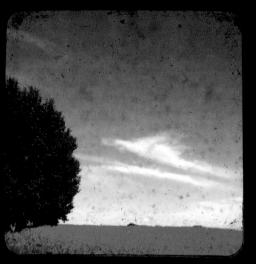

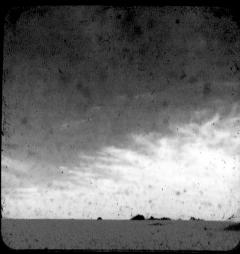

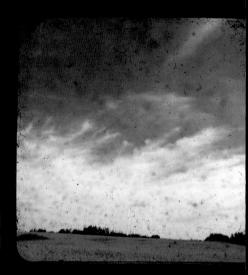

Through the Viewfinder—or TTV—photography is a relatively recent technique that combines a cheap, pseudo-TLR (Twin Lens Reflex) camera with a modern (usually digital) camera. The concept is quite simple; you compose the image using the TLR camera and record the image that appears on its viewfinder screen with a digital camera—complete with all the dust, scratches, and darkened edges.

A TLR camera has two lenses: the top lens (the viewing lens) reflects a reversed, mirror image to the "ground glass" or viewfinder, while the bottom lens (the taking lens) is the one that has a shutter and actually takes the picture. In this technique, no film is used in the TLR camera, so the bottom lens (and the TLR's shutter) is useless for our purposes. This is important because it means you don't need to get a fully functioning TLR if it's only going to be used for TTV photography, so keep an eye out at secondhand stores, rummage sales, and online auction sites for a broken (and cheap) TLR.

Kodak's Duaflex camera and the Argus 75 are the models most commonly used for TTV photography, but don't pay too much as these old cameras are plentiful. And don't bother with ones that are in spectacular condition—the key to taking interesting TTV shots is the viewfinder, so as long as your TLR has a viewfinder, that's all you need! Besides, a screen that has all sorts of flaws, such as ground glass with rounded corners or some good old-fashioned dust and scratches, will make your pictures more interesting.

Once you've got your TLR camera, the next step is to connect it to your digital camera, using what TTV aficionados refer to as "the contraption."

WHAT YOU NEED

- Point-and-shoot or digital SLR camera
- TLR (or pseudo-TLR) camera

Contraption:

- Corrugated cardboard or sturdy cardstock
- Electrical tape and/ or packing tape
- Scissors or a craft knife

DIFFICULTY *

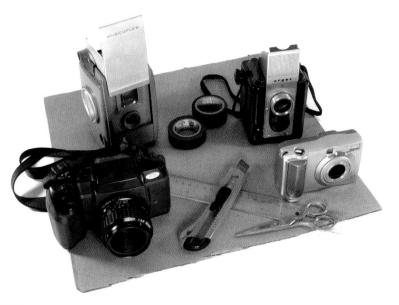

THE CONTRAPTION

The contraption is a sturdy, light-tight connection that performs two roles in TTV photography: it physically connects your cameras together, so they are aligned and the correct distance apart, and it shields the TLR's viewing screen from light so you get the brightest possible image on the screen. Due to its low cost and rigidity, corrugated cardboard is the most commonly used material in contraption building, but when it comes to the contraption's design, there are no rules. Here we'll look at a simple contraption to get you started. Note that I've fitted a 35mm SLR to the top of the contraption here, but that's only because I needed my digital SLR to take pictures of it!

Right: The TTV setup and the result—dust and scratches on the TLR camera's screen enhance the vintage feel.

ESSENTIAL POST-PROCESSING

As most TLR viewfinders are square, and your digital camera shoots rectangular images, your TTV photographs will include the entire frame of the TLR's viewfinder, with big, black edges. So, open up your image-editing program and crop your image square, leaving in some of the TLR's edges. You might need to rotate it as well, and flip it since the TLR's viewfinder shows a reversed image (so left is right and right is left!).

After that, it's up to you whether you want to adjust the brightness, contrast, and color—or even convert your image to black and white for an added "vintage" feel.

HOW BIG?

The first step is to determine the size of your contraption, and the main variable here is the type of lens you are using. A "standard" 50mm lens (or 50mm focal length setting on a zoom) will provide a minimum focusing distance of about 12 inches (30cm), but if you have a macro lens you could well be able to focus right down to about 2 inches (5cm). However, you need to make sure your chosen lens can capture the entire TLR viewfinder in the frame, so you need to do a simple test to find the length needed of your contraption.

Place your TLR camera on a flat surface, pointing at a well-lit subject so you can see the viewfinder image. Tape a ruler to the side of the camera, and get your digital camera out. Aim your digital camera at the TLR's viewing screen from directly above, and move it up and down until the TLR's screen almost fills the (digital) frame. Check that your digital camera will focus on the screen and then measure the distance between the two cameras.

Add to this measurement the amount of extra material you will need to fit around the TLR camera (the height of the camera is the easiest estimate), and add an extra bit so you have some room to fine-tune your focus.

Now that you know the height of the contraption, you can work out the measurements for the sides. Your contraption needs to fit around the TLR like a glove, which means measuring the outside perimeter of the TLR (sides, front, and back) and marking those distances down on your cardboard.

37905
75
3 9 10 11 12 Et 14 15
4 5 5 6

There are two things to note here: First, having your contraption fit a little loose is better than it being too tight (the looseness can be corrected with tape). Second, if you are using corrugated cardboard make sure the length (height) of the contraption follows the natural folds in the fluting of the corrugated cardboard—this will help the cardboard bend into a square to make the sides.

We're also going to add an extra flap to the top of the contraption to create a port for the digital camera. The length of the flap will be equal to the side of the TLR camera. The contraption template can now be drawn on our corrugated cardboard, with dotted lines showing where we will be folding instead of cutting.

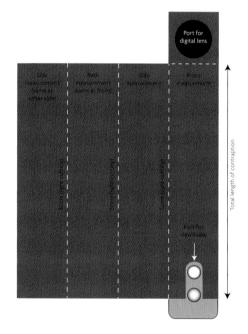

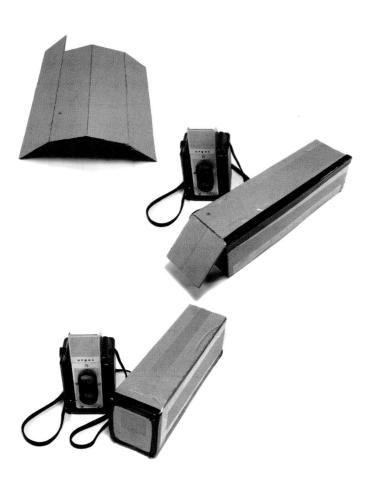

CONSTRUCTION

Cut out your contraption template and score the cardboard where you want it to fold. To make this easy, use a craft knife to cut through the top surface of the cardboard, but not all the way through. This will allow you to bend these areas as folds.

With the template cut out and scored for folding, tape the seams of the length together. Essentially, you are making a long rectangular box with an opening in one end to fit over the camera and a flap on the other end to insert the digital camera's lens into. Wide packing tape does the job well, but isn't light tight, so after putting on the clear packing tape, put a layer of opaque black tape on top to keep out the light.

Fold over the top flap and seal up these seams with opaque tape as well, using packing tape to offer some extra support.

17 >>>

ADDING PORTS

With your basic contraption made, you can now make the "port" for your digital camera's lens and the TLR lens. Start by taking your digital camera lens and tracing a circle around the circumference on the top flap of the contraption. Cut out the hole, using tape to seal the edges—this is where you will insert your digital camera.

Slide your TLR into the bottom of the contraption and mark the position of the sides of the viewing lens. Measure the distance from the top of the TLR camera to the top of the viewing lens and extend the side marks by this amount, so you can cut out a port for the TLR's lens.

Slide the contraption onto your TLR camera and tape the two together—it should be a snug fit. Use your tape liberally, and consider going under the camera, as well as around it to hold the TLR in place. You're now ready to put the digital camera into the top and start shooting!

TIPS

TTV shooting is awkward, and every photographer will develop his or her own preferred handling technique. Using a tripod to mount your TLR camera is the easiest option, as it gives you two hands to manipulate your digital camera. Another popular method requires you to hold the TLR in one hand and the digital camera in the other.

Set your "shooting" camera to autofocus, as it can be very difficult to focus manually and keep everything together, especially if your lens is in a port on top of the contraption.

Your digital camera's automatic exposure metering will read the black area around the TLR's viewfinder as part of the picture, so it's likely it will overexpose the image. If this happens, try using your camera's center-weighted metering mode, or decreasing the exposure using the exposure compensation feature.

Try attaching some close focus lenses (often called close-up filters), or holding the lens from a pair of spectacles in front of the TLR's viewing lens to get some really interesting close-up shots!

Right: TTV photographs have a distinctive, timeless quality. Many photographers using the technique add a cross-processed look to their images to enhance the "shot on film" appearance (see Project 44).

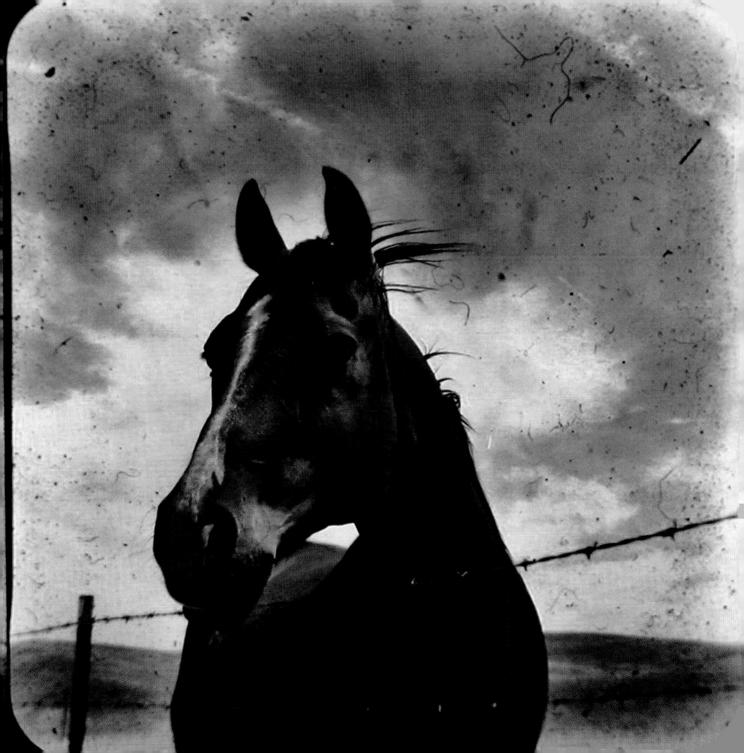

ree-dimensional quality that invites us to "walk right in" to the picture. It's something that as incredibly popular during the late 1800s, and once you start experimenting with stereo ctures it's easy to see where the appeal of this "parlor-trick" lies. The specific method that ur ancestors got so excited about was "stereo pairs," which is not only the basis for this oject, but the easiest and cheapest form of 3D photography.

WHAT YOU NEED

- 2 disposable 35mm cameras
- · Duct tape, or similar

DIFFICULTY *

TIPS

Take a shot of a piece of paper with "left" written on it for the first frame with the left camera, and one with "right" on it for the right-side camera. When you get your film processed it will make it much easier to see which image should be on which side.

If anything is moving in the scene, try to take your pictures at the exact same time, otherwise the movement will make your brain struggle to work out what's happening when you view the stereo pair.

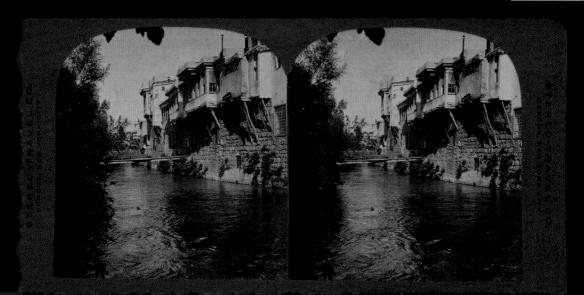

SHOOTING 3D

When we look at the world, our eyes see two images spaced roughly 2–3 inches (5–8cm) apart, one through each eye. Our brain brings these images together and uses the differences between them to create three-dimensional depth. Stereo pairs simply substitute the images seen through each eye with two separate photographs, but the result is the same—when we view the two images side-by-side, our brain is fooled into creating "depth."

So, the first step is to produce two images that look as if they've been seen through each of your eyes, which means you need two cameras spaced roughly 2–3 inches (5–8cm) apart. I'm using a pair of disposable 35mm film cameras for this, but you could use two identical digital point-and-shoot cameras if you wanted to.

Line the cameras up so the lenses are level, with a gap of roughly 2–3 inches (5–8cm) between the lenses—these are our "eyes." With the cameras held in position, take your duct tape and tape them together, being careful not to cover the shutter button or the winding lever on either camera as you'll need to access both of them to take your shots.

That's all there is to making your stereo camera, but there are a couple of things to think about while you're out and about shooting your stereo pairs. First off, you need to shoot each scene with both cameras (obviously), and you also want to try to shoot scenes that have good natural "depth" to them—like a person in the foreground, and a city in the background. The greater the depth in the scene, the more intense the 3D effect will be.

VIEWING 3D

While shooting your stereo pairs is easy, viewing them is a little harder. Basically, you need to identify the "paired" images and view them side-by-side, either on your computer screen, or printed. The easiest option is to have the film scanned when you get it processed, because you can crop the pictures in your image-editing program, paste them into a new document side-by-side (left-eye image on the left, and right-eye image on the right!), and then view them on-screen or print them on your desktop printer.

The key to viewing them successfully is the distance you need to be from the stereo pair and the size of the print—get these two things right and it makes the 3D experience a whole lot easier.

As a guide, start by making your images 3 inches (7.5cm) on their longest edge and printing them on standard 6x4 inch (15x10cm) paper. Take the printed pair and hold it roughly 18 inches (45cm) away from you, under even lighting.

Now comes the really hard part. "Cross" your eyes, staring "through" the picture, so the two images you're looking at become three. The image in the center will magically become a 3D version. You might need to adjust your viewing distance (and the "crosseyed" viewing can take a while to get used to), but once you get the hang of it you'll experience your pictures like never before!

SCANNER ART

Scanners are traditionally used for digitizing flat documents or pictures, but there are far more exciting things that can be done with them. Scanning everyday three-dimensional objects can produce stunning results, with professional looking lighting, and hardly any effort on your part. As the actual process of scanning anything is so simple, all you have to do is engage your imagination to dream up what you are going to place on the scanner's glass platen to make your artful images.

Flatbed scanners use a light source attached to the sensors that record the image as the scanning head travels the length of the glass platen. As the lamp and sensors are so close together, light appears to come from all angles, revealing masses of detail in your subject and producing shadow—free pictures.

WHAT YOU NEED

- Flatbed scanner
- Object to scan
- Cloth/colored paper for backgrounds (optional)

DIFFICULTY *

BLACK BACKGROUNDS

To get a stunning jet-black background, which will set off flowers and bright colors really well, just leave the scanner lid open when you scan. The light from the scan head is so bright that the room you are in will seem very dark, and the scanner will just record a black nothing. However, you can take control of the background if you want to, using paper or fabric to create colored or textured backdrops.

COLOR BACKGROUNDS

The easiest option is to lay a piece of colored paper over the object, but it needs to be quite close to the platen for the scanner to register it, so this only works with objects that do not stand too far off the platen. Alternatively, use a piece of fabric that can drape over the object. How far you should place your background from the platen depends on how powerful your scanner is, but generally the maximum distance will be about 6 inches (15cm).

BEFORE YOU BEGIN

Clean the platen

It is important to make sure your glass scanning bed (the "platen") is free of dust and fingerprints, as these will show up in your pictures. A lens cloth or lint-free cloth will do the job very well.

Hard or messy subjects

Your scanner's glass platen is delicate, and will damage easily if you scan hard or sharp objects. Wet subjects—like food—will need to be cleaned off carefully too, and may leave greasy marks. You can place potentially dangerous objects on a thin sheet of absolutely clear film, such as Mylar, but this can cause flare, strange colored artifacts, and a general softening of the image.

Bold colors

The scanning process can produce powerful colors that really jump out against a black background, so make the most of it. Choose objects that have bold colors, or colors that can be brought out to good effect. Remember, there will be no shadows in these pictures, so color is an extremely important part of the final result.

Keep it simple

Often, the best results from this process come from simple compositions, so try not to over-complicate things.

SCANNING

Having cleaned the platen, position your object on the scanner bed, keeping as much space around it as the composition will allow—this will give you maximum options for cropping later.

Either place your background over the object or leave the scanner lid open for a black background.

Open the scanner software on your computer, and set the scanner to "reflective" mode. This is the same setting you would use for scanning color prints.

LED scanners

Some scanners use LEDs as their light source, which are much less powerful than other desktop scanners. Although they can be used for this project, you need to remember that as the light source is not as bright, you will need to switch room lights off to create a black background. You'll also find that this type of scanner produces a much shallower depth of field, and parts of the subject that are further away from the platen will not be well illuminated. This means that if you want to use a colored background, it will need to be close to the platen.

Set the resolution to 300ppi (pixels per inch), which is the optimum resolution for high-quality images. Then set the scaling of the image. If you set the scaling at 100 percent, your object will be "actual size."

Perform a preview scan to get an idea of the composition and how the object will be lit. You can also adjust the contrast and color settings to get the effects you want.

Once you are happy with the Preview image, scan the object. Import the image into an image-editing program to fine-tune the contrast and remove any dust.

LENSES AND ACCESSORIES

As you saw in the previous chapter, there are lots of ways that you can get creative with your photography, simply by experimenting with your camera settings or photographing subjects that you hadn't previously considered.

Exploring different shooting techniques is definitely a step forward, but there's a time when we all feel that our camera is holding us back. The photographs we aspire to take often seem to have been captured by photographers with bulging kit bags that contain the latest camera and every possible lens and accessory that fits it. It's easy to conclude

that to take the best pictures you need to buy a whole load of expensive gear and, if you can't afford it, it's even easier to start thinking that great, creative shots will always be beyond your means.

But you can stop thinking like that right now—you don't need a stack of money; imagination is the currency we're most interested in. In this chapter we're going to take a look at lenses and accessories. Some of them you can buy, but most of them you can make just as easily, and while some will solve more practical problems, they will all open up a world of creative opportunities.

LEGACY LENSES

Perhaps the most important component of your digital SLR system is the lens; the crucial part of the camera that funnels light toward your sensor, focuses the image, and controls the depth of field. Unfortunately, it can also be the most expensive part of a digital SLR, and the cost can mean you have to make do with what you've got, rather than having the choice of focal lengths and apertures that you want. However, there is an answer, or at least a possible solution if you want to expand your lens collection, maintain image quality, and stick to a budget—manual, "legacy" lenses.

Travel back thirty years or so and 35mm SLRs relied almost exclusively on manual focus lenses. The zoom lenses of the time were pretty awful by today's standards, but some of the prime, fixed focal length lenses were truly astounding. As film gave way to digital,

these lenses increasingly found themselves in yard sales, flea markets, and online auction sites, where the asking price can often be close to nothing. But although the price is low, the lenses haven't gone "bad" over time—they're still the same metal and glass objects that control and focus light as they always have. And, best of all, many of these excellent optics will fit straight onto your digital SLR.

WHAT YOU NEED

- · Digital SLR camera
- Compatible legacy lens

DIFFICULTY **

Below: Wide aperture lenses and macro accessories are two great reasons why you should give legacy lenses a try. For this image, and the one on the previous page, a standard 50mm, f/1.8 lens and a macro teleconverter were used on a FourThirds digital SLR.

TIPS

A fast aperture 50mm lens makes a great portrait lens on a non-fullframe digital SLR, and is the ideal starting point for your legacy lens collection.

Old macro lenses and accessories are far cheaper than their modern counterparts, yet often perform just as well.

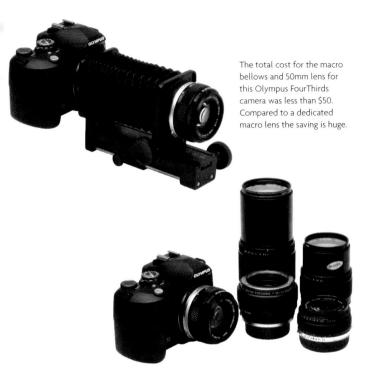

WHAT FITS?

Your choice of older lenses largely comes down to one thing—the lens mount on your digital SLR. Even today, a number of camera manufacturers continue to use the same lens mount they used for their 35mm SLRs (or a variant with the same dimensions), so "legacy" lenses will fit straight on. Nikon and Pentax (and Samsung, which shares the Pentax lens mount) are the most notable names in this regard.

Other manufacturers have changed their lens mount in the digital age, such as Olympus, which abandoned its 35mm OM system to pursue the digital FourThirds system. However, this doesn't mean you can't use the older OM lenses—there's a widely available adaptor that lets you fit them to any FourThirds camera. It means buying the adaptor, but once you have made the investment, a whole world of high-quality, low-cost Zuiko lenses and lens accessories opens up to you.

Unfortunately, things aren't quite so positive when it comes to Canon and Sony. Canon's older FD mount was usurped by the EOS system's EF lens mount before digital cameras arrived, and Sony's lens mount (based on Minolta's AF lens mount) isn't compatible with Minolta's older, manual lenses. There are adaptors available that will let you fit FD lenses to Canon's EOS mount, or manual Minolta lenses to a Sony digital SLR, but in both cases the investment far exceeds the benefits.

WHY YOU SHOULD USE THEM

While you might think that attaching a thirty-year-old, \$10 lens to your digital SLR is a pointless exercise, there are benefits to using older lenses. For a start, many legacy lenses have wider apertures than their modern zoom counterparts, which not only means you can shoot hand-held in low light, but you can also start to take pictures with a very shallow depth of field. The best example of this is a "standard" 50mm lens, which typically has a maximum aperture of f/1.8 (a far cry from the f/4 maximum aperture of most modern zooms) and can be bought for only a few dollars. On a non full-frame digital SLR, the 50mm focal length effectively becomes 75-100mm (depending on your digital SLR), making it the perfect lens for portraits. Similarly, modern macro lenses are incredibly expensive, but legacy macro lenses—and accessories such as extension tubes and macro bellows—can be much more affordable, allowing you to start exploring the world of close-up photography for only a small investment. However, perhaps the biggest argument for using an older, prime lens is sharpness—it might sound crazy, but some vintage lenses produce far sharper results than modern zooms, especially compared to the budget lenses bundled with digital SLR kits.

WHY YOU SHOULDN'T USE THEM

Of course, if older lenses are so good, everyone would be using them, but they're not. The main problem is that while some older lenses work fantastically with digital SLRs, some aren't quite so hot. More importantly, it's impossible to tell which ones work well and which don't without actually trying them, and that's not too helpful if you don't already have the lens.

Also, as they were designed for film, not digital sensors, chromatic aberration (the "fringing" you sometimes see around backlit objects) is generally more pronounced and some suffer from internal flare caused by light reflecting off the sensor onto the back of the lens. This doesn't apply with all legacy lenses, but again, it's impossible to know what the results will be without trying a particular lens on your camera.

Finally, legacy lenses are harder to use. Focusing has to be done manually, the exposure often has to be set manually, and, depending on your camera, you might experience inconsistent exposures for no apparent reason. However, if you can live with their handling and occasional image-quality quirks, some legacy lenses have a lot to offer the creative photographer, be it their wide apertures or the low cost of specialist lenses. So, if you've got a compatible camera, get yourself a 50mm f/1.8 standard lens and give it a go—you'll probably be pleasantly surprised!

WHAT YOU NEED

- Lens with a focal length of 50–135mm (can be a zoom)
- · Manual 50mm lens
- Filter system adaptor ring for each lens
- Metal cement
- Clamps or clothespins

DIFFICULTY *

WARNING

Make sure you switch off your camera's autofocus system before using your macro combination. The added weight of the 50mm lens could damage the focusing motor in the camera or lens if you try to focus automatically.

If you have never tried macro photography before, prepare to become hooked! Shooting the world in close-up opens a completely new chapter of tiny details and shapes in everyday objects that you never took the time to notice before. You can't really beat a good macro lens if you want to take macro photography seriously, but there are ways of making your current camera focus much closer without having to buy specialist and expensive equipment. In this project I'll show you how to use a low-cost, manual lens to magnify tiny objects. While it's not quite as flexible as using a proper macro lens, it's still capable of producing very high-quality results.

For this project you need a standard lens with a wide maximum aperture and a manual aperture ring so you can open the aperture as wide as it will go. An old, 50mm legacy lens (see Project 20) is perfect. Once you've got your standard lens, it's simply a case of reversing it (so the front of the lens points toward your camera) and mounting it to your digital SLR's zoom lens or in this case, a second 50mm legacy lens.

TIPS

If you use your camera's zoom lens, you can use your camera's exposure metering system as usual with your macro combination—set your manual lens to its widest aperture first.

Don't focus using the telephoto/zoom lens attached to your camera. Instead, manually set the telephoto lens to its infinity focus setting and move the whole macro unit backward and forward to focus.

You're going to attach your lenses to each other using their filter threads, and to do this you need a filter system adaptor ring for each lens. The size you need will be written inside the front of the lens cap or around the front of the lens itself—most 50mm, f/1.8 lenses use a 49mm or 52mm screw thread

Lightly sand the front, flat faces of the rings to roughen them, or score them with a sharp craft knife to create a "key" for the metal cement that you'll use to stick them together. Apply the cement to the flat side of one of the filter rings (the thinnest one if their sizes are different) and stick it to the flat side of the other ring so they are face-to-face.

Clamp the rings together to make sure they stick evenly, and let the cement set thoroughly, ideally by leaving the rings clamped together overnight.

> Once your cement has "set," fit your telephoto lens (or zoom) to your camera and screw the coupled adaptor rings to the front of it. I've used a 50mm legacy lens here.

Reverse the second lens, and attach this to the exposed filter thread on your camera-mounted lens. The assembly will be quite front heavy, but you now have a very useful macro lens. This combination focuses down to less than 1 inch (2cm).

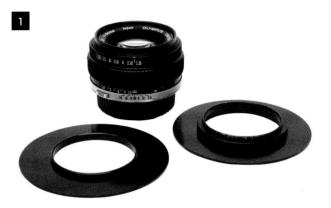

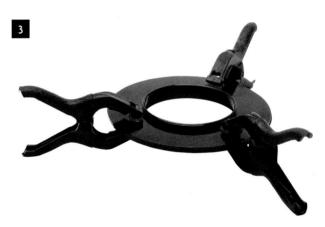

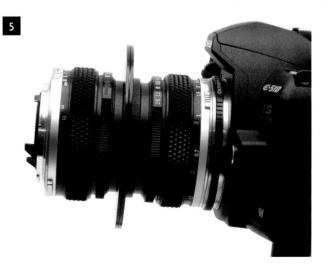

keeping distortions and aberrations to a minimum, but who said every picture you take has to be technically perfect? Sometimes, "imperfect" pictures, whether they're softly focused, heavily distorted, or plagued by heavy fringing can have far more vitality, transforming a relatively mundane scene into something much more interesting. This project looks at a number of ways that you can deliberately degrade an image using improvised, low-tech

The lens on your point-and-shoot or digital SLR camera is great for taking sharp pictures and

magnifying glass, peephole, or similar) • Tape · Lens cap (optional) lenses in front of your camera's usually high-quality optic. There are no fixed rules here, and some of the effects you might not like at all, but that's fine—it's all about thinking beyond your camera's "normal" potential and getting a little more creative. DIFFICULTY *

EYEGLASS LENSES

The lenses in your eyeglasses might help you see better, but on your camera they can help you take creative pictures. Simply pop a lens out of your glasses and use

tape to hold it over your regular lens. The effect your eyeglass lens gives will depend entirely on whether it's designed to correct long- or short-sightedness, and the strength of the lens. For the picture here, a monocle lens was used instead of an eyeglass lens for a soft,

dreamy look, with slight vignetting. The images were

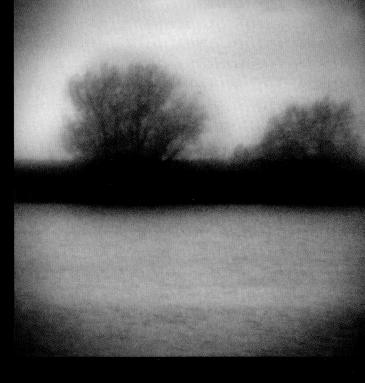

WHAT YOU NEED

SLR camera

· Point-and-shoot or digital

• Improvised lens (eyeglass lens,

PEEPHOLE FISH-EVE

You don't have to spend a whole load of cash to get that crazy, round, fish-eye look—just head to your local hardware store and buy the widest peephole they sell!

If you're using a point-and-shoot camera, unscrew the two parts of the viewer and hold one end up to your lens for an instant fish-eye effect. It will help if you set the camera to its macro mode and zoom the lens in as far as it will go, but other than that, all you need to do is point and shoot.

Alternatively, if you're a digital SLR user, drill a hole in a spare lens cap and glue the viewer to it. Tape the edges to stop any light from creeping in at the join, and stick the lens cap over your lens for the same wide-angle, fish-eye look. You'll likely end up with lots of black space around the circular image, but just crop this out with your editing software's cropping tool.

NOVELTY LENSES

Potential improvised lenses can be found in all sorts of places. The novelty "Leica" shown here cost around \$10 from a museum gift store. The prism lens in it has great potential as an improvised lens, as shown by the image below. Simply hold your camera against the Leica's prism lens and push the shutter button for an instant kaleidoscope of color fringing and mini-images!

ANSOUVE A

TIP

An alternative to using an eyeglass lens over your regular lens is to use a magnifying glass for "quick and dirty" close-ups—just hold the lens in front of your camera and shoot what you see. The results are likely to suffer from fringing and severe focus fall-off, but that just adds to their unique charm.

23 TILT LENS

Tilt and shift lenses were originally designed to correct perspective distortion, particularly in architectural photography. Instead of being "fixed", the lens can be tilted, so the front isn't parallel to the plane of focus (the film or sensor). By adjusting the angle of the front lens, the path of the light changes, which corrects the perspective. However, their ability to also change the focal plane in an image has long been used for more creative purposes. When the plane of focus is adjusted and used in combination with a large aperture, a very shallow depth of field is created, similar to that of a macro lens. But, with a tilt lens, the line of sharpness in an image can be manipulated, so instead of running horizontally across the frame it can run diagonally, or even vertically.

There is a downside, though—tilt and shift lenses are very expensive. Recently, the LensBaby appeared as a lower-cost alternative, offering photographers the chance to attempt selective focus photography for a more modest cost, but even the price of these has started to creep upward. However, with a little ingenuity and a few inexpensive items, it's entirely possible to make a great little tilt lens of your own.

WHAT YOU NEED

- · Old medium format lens
- Body cap for your digital SLR
- Concertina-style sink plunger
- Thick black cardstock
- Black tape
- Ruler
- Scissors
- Craft knife
- Ruler
- · Marker pen or Sharpie
- Drill or rotary tool
- Epoxy resin (or strong glue)

DIFFICULTY * *

CHOOSING A LENS

Because you will be changing the direction the lens points in, you need to make sure your tilt lens produces a larger image circle than your regular digital SLR lens, and this means getting a lens that's designed for medium format photography. The low-cost option is to scour flea markets, yard sales, and internet auctions for an old medium format enlarger lens or bellows camera. As you only need the lens you don't need to worry about the condition of the camera, so save some money and buy a used example. Then remove the lens—it's usually only a couple of screws holding it in place.

There are three key ingredients for making your own tilt lens. In addition to a medium format lens, you will also need a rubber or plastic concertina-style plunger (this will provide the tilt mechanism), and a body cap for your SLR (which will be the lens mount).

Before you start to assemble your lens, the first step is to work out how far the lens needs to be from the camera's sensor. To do this, hold the lens close to a light-colored wall, facing an opposite window.

Open the lens aperture fully. Move the lens closer to the wall and then further away until the projected circle of light that's coming through it is sharp. Use a ruler to measure the distance from the rear of the lens to the wall.

In addition to this distance, you also need to know the "flange depth" of your particular camera, which is the distance from the lens mount to the sensor. This should be in your camera's manual, or on the manufacturer's website under "specifications." Subtract the flange depth from the focus distance you measured—this is the length that your tilt lens needs to be.

Remove the handle from the plunger and, measuring from the narrow end, mark the tilt lens's length on its side. Cut around the circumference of the plunger at this point so you are left with a shorter "skirt."

Cut a small, circular hole in the top of the plunger that is slightly smaller than the diameter of your SLR's body cap.

- Using a drill or rotary tool, cut out the center of the body cap so you are left with a plastic ring. It's best to do this from the back of the body cap so you don't accidentally cut off the mount itself.
- Now it's time to glue the plunger to your body cap lens mount. A strong bond is needed, so score the parts with a knife or use abrasive sandpaper to roughen the surfaces. Glue the pieces together using epoxy resin and leave them overnight for a solid bond to form.
- Once the glue has dried, trace around the wide end of the plunger onto a sheet of thick black cardstock. Cut the disc out, then make a hole in the center of the cardstock that is large enough to hold your lens. Glue the cardstock to the bottom of the plunger using epoxy resin and leave it to dry—this is going to be your lens panel.
- When the card mount is firmly stuck, wrap black tape around the edges of the lens panel and the lens mount (body cap) to prevent any light leaks.
- Finally, attach the lens. Although it might stay in place using friction, it's better to glue or tape it in place. Once it's stuck, hold the end that will be mounted to the camera up to your eye. If you can see any light leaking in, now's the time to seal the holes with tape. Then simply mount your tilt lens onto your SLR as you would any other lens.

USING YOUR TILT LENS

With your tilt lens on your SLR, push and pull different areas of the plunger to adjust the focus in the image, keeping some areas sharp and letting other parts of the picture blur. It takes practice to master, but by twisting, pushing, bending, and pulling the plunger you will create some great-looking images. Because of the constant pressure you are applying to keep the image in focus, camera shake can be a problem, so use a fast shutter speed and try setting your camera to its continuous shooting mode so you take a "burst" of exposures that you can choose the best from.

When it comes to measuring the exposure, the first thing you need to do is make sure your camera will fire with the tilt lens attached. Because it won't recognize the body cap as a "lens," look in the menu (or camera manual) for a "shoot without lens" option, or similar. Then, switch your camera to Manual, set the aperture on your tilt lens, and use the scale in the camera's viewfinder to set the corresponding shutter speed.

Pinhole photography is the ultimate in low-tech, taking us right back to when man first noticed the properties of light. But, more than that, pinhole photography can produce fantastically creative images. In basic terms, when light travels through a very small hole it becomes focused a short distance behind the hole, so holes the size of pin pricks can be used in place of a lens. Of course, a pinhole lens doesn't rival the quality of a glass lens—it's not even close—but it can still produce very interesting effects.

The best way of making a pinhole lens for your SLR is to use a body cap (the cap that

you would put on the camera if you didn't have a lens attached). This is because the body cap will fit your camera like a regular lens, is light tight, and is durable enough to be dropped in your camera bag alongside your normal lenses.

WHAT YOU NEED

- Empty aluminum drink can
- Heavy duty scissors (or similar) to cut the can
 Fine-grade sandpaper
- Fine-gEraser

• Glue

Narrow, sharp needle or pin
Body cap for your SLR
Drill with a 4/10 – 1/2 inch

DIFFICULTY **

(10-12mm) bit

WARNING

You need to be very careful making your pinhole lens as you're going to cut open a metal can. The edges you will be left with are VERY sharp, so take care!

EXPOSURE GUIDE

If your camera cannot work

out the exposure with your pinhole lens attached, set the

ISO sensitivity to 200, the camera to Manual, and use the following exposure times as a starting point:

- Bright Sunlight: 2 seconds
 Hazy Sunlight: 4 seconds
- Hazy Sunlight: 4 seconds
 This Clouds 10 seconds
- Thin Cloudy: 10 secondsThick Cloud: 25 seconds
- Indoors (brightly lit room):
 5 minutes
- Indoors (dark room): 1 hour
 Night: Anything from 1 hour

to all night!

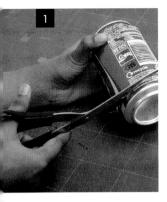

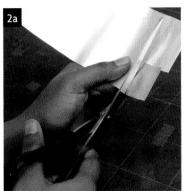

The start of your pinhole lens is nothing more exotic than an empty aluminum drink can. Empty the can and wash it out, then cut off one of the ends. Cut down the length of the can and remove the opposite end so you've got a sheet of aluminum. Leave it overnight under a few heavy books to flatten it out—this will make it easier to work with, and less dangerous.

Once it's flat, cut out a square from your aluminum sheet, roughly 1½-inch (4cm) square. Using your sandpaper, remove the paint from the painted side of the can. You don't need to do it all, just a small patch in the center where your hole will be made. Turn the can over and repeat the process on the other side to reduce the thickness of the aluminum.

Place your thinned aluminum lens panel painted-side down on an eraser. Using a "drilling" action, gently press the needle into the can until the tip of the pin goes through the metal. Only the very point of the pin should puncture the metal.

Hold your lens up to a light to see the hole you've made. If this is your first attempt, and the pin went all the way through (not just the tip), then it is probably too big. But don't worry—there's plenty of aluminum left on your sheet, so try it again!

Once you have your "perfect" round hole, place the lens panel painted-side up, and use your sandpaper in a circular motion to flatten off the slightly rough bump left by the pin coming through the metal. The hole will probably get filled with dust, so blow it and hold it up to the light again. You should now have a perfect pinhole lens, ready to attach to your body cap.

- The first step in converting a body cap into a pinhole lens is to find its center. The easy way to do this is to draw around the cap on a piece of paper. Cut out the circle you've drawn and fold the paper into quarters. Line the curved edge against the edge of the body cap and the "point" of the paper will show you the center of the cap. Mark the center point.
- Now, get your drill and make a hole in the center of the body cap to mount your lens. Use a large drill bit, and carefully drill through the center of the cap. The plastic is quite thick, so take your time.
- Once you've made your hole, use your sandpaper to tidy the edges and remove any plastic burrs.
- All you need to do now is simply glue your pinhole lens to the back of the body cap, keeping the hole as central as you can.
- Once the glue's dry you're ready to fit the body-cap pinhole lens to your camera and start shooting!

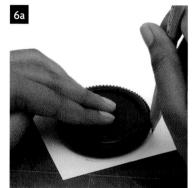

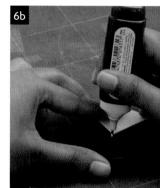

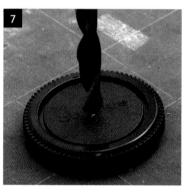

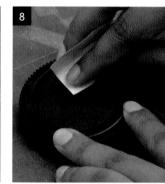

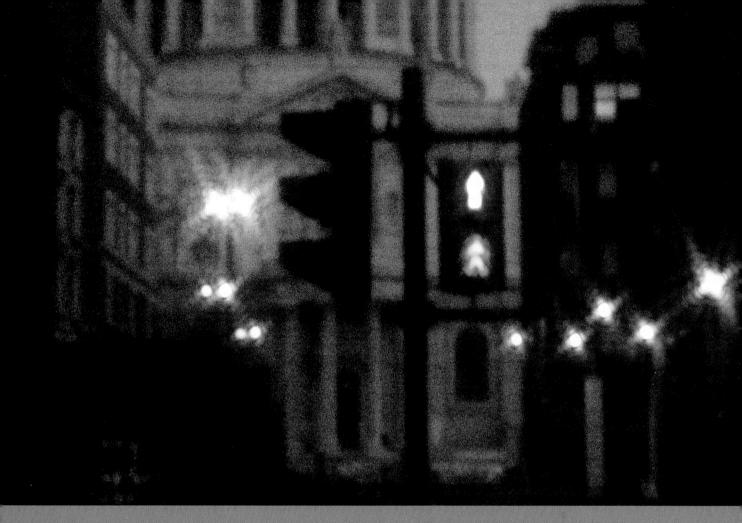

USING YOUR SLR PINHOLE LENS

Most of today's digital SLRs have electronic connections in the camera body and the lens so the two can communicate with each other, but as your pinhole lens is nowhere near as sophisticated, there are a few things you have to do before you start shooting.

The most common problem is finding your camera won't fire with the pinhole lens attached. This is because without the electronic connections the camera might think there isn't a lens fitted. This is the same problem you might encounter using a homemade tilt lens (Project 23) and the solution is the same—look for a "shoot without lens" option, or similar.

You'll also find that the viewfinder image will be very dark; perhaps so dark that you can't see through it. This is because you're looking through a tiny lens that lets in very little light, but it's not something to worry about. One of the joys of digital photography is the ability to review the results on your camera's screen, so if anything's not quite right just take another shot!

The same rule applies to your exposures. Because your camera doesn't know what lens you're using it won't know what aperture to base the exposure on (with your pinhole lens it might be around f/150!) so it might not be able to work out the exposure for itself. The easiest way to get round this is to set ISO 200 and use the Exposure Guide on page 76. Set your camera to its Manual exposure mode (normally marked with an M on the mode dial), and set the shutter speed to "B" or "Bulb." This setting will open the shutter when you press the shutter release and—depending on your camera—it will keep it open for as long as you hold the shutter button down, or keep it open until you press the shutter release again. After you've made your exposure review the image on your camera's screen; if it's too dark, increase the exposure time or, if your first picture is too light, decrease the time.

However, supporting your camera is important, so if you don't feel like carrying a tripod, why not take a beanbag instead? A beanbag can help hold your camera steady on the ground, on cop of a wall, or pretty much anywhere else you can put it. There are lots of ways to make a beanbag, but the version here is one of the easiest because there's no sewing involved—I'll be using fabric fuse tape that you simply put between two pieces of fabric, heat with an ron, and it bonds the pieces together without sewing.

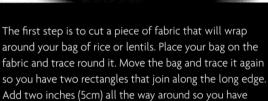

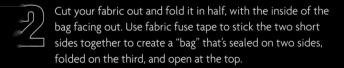

extra material to stick.

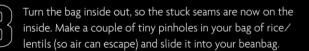

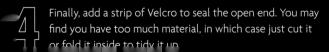

WHAT YOU NEED

- Thick cotton fabric
- Iron-on fabric fuse tape (hemming tape)
- · Velcro
- Medium-sized bag of rice or lentils

DIFFICULTY *

TIP

If you're handy with a needle and thread, it's a good idea to sew the seams of your beanbag instead of using fuse tape, as this will make the beanbag more durable. You could also use a heavy-duty, waterproof fabric, but because this type of material tends to be plastic-based you will definitely need to sew it—using fabric fuse tape and a hot iron on plastic will just leave you with a sticky, melted mess.

WHAT YOU NEED

- · Length of cord (12 inches/30cm longer than the distance from
- your foot to your eye) · Tripod thread or thumbscrew (3/8-inch)
- Plastic zip ties/cable ties

DIFFICULTY *

you sharp pictures using shutter speeds around two stops slower than would usually be safe.

Like a beanbag, a stringpod is a great alternative to carrying a heavy tripod around with you and it works just as well with digital point-and-shoot cameras as it does with SLRs. The principal behind the stringpod is simple—you attach your camera to one end of a cord and hold the other end with your foot. By pulling the cord tight you add tension, and this decreases the chance of camera shake. It isn't a substitute for a tripod, but as a stabilizing device it can give

I'm using steel-core washing line for my stringpod.

Make your loop, with the mark in the center. I'm again using zip ties to tie it off. Trim off any loose or untidy ends and that's it—one stringpod that can be stuffed in a pocket or camera bag. When you want to use it, simply attach your camera to one end, stick your foot through the loop at the bottom, and pull the cord tight for instant camera stabilization!

center of the loop where your foot needs to be.

To make your stringpod you need a length of cord that's roughly the distance from your foot to your eye, plus 12 inches (30cm)—so if you're 6-feet tall you'll need a 7 foot cord.

> The first step is to attach the cord to a screw that will fit into the 3/8-inch tripod socket in your camera. I'm using the screw from an old tripod, which is ideal as it's the right size and has a loop on the bottom to attach the cord to. To "tie" the screw in place I'm using plastic zip ties (or cable ties), simply because the steel-core cord is hard to tie a knot in.

> You need to make a loop at the opposite end of the cord that you can put your foot through to hold the stringpod tight. The easiest way to find the right position for the loop is to attach the cord to your camera and put your foot on the other end of the cord. Keeping the cord tense, raise the camera to your preferred shooting level, and mark the point on the cord where it touches the ground—this is the

TIPS

Instead of washing line cord. you can also use thick string or a thin chain to make an equally

effective stringpod.

go through.

Scour flea markets and yard sales for old tripods that you can salvage a screw-thread from, or use a 3/8in thumbscrew with a hold drilled in it for the cord to

site such as eBay you need to have your item listed with a picture. And the better the picture, the more attractive the item will appear to potential bidders. It's not just internet auctions, though—any product photograph should look its best, and if you've ever struggled to control lighting, shadows, and backgrounds, you'll know the importance of even lighting and the frustrations involved in creating it. You can buy light tables, light tents, and light cubes that will all help you acheive the "perfect" product shot against a white background,

but before spending a lot of money, why not try making a light cube yourself? This project

will get you set for taking great product shots using materials that are extremely simple (and

cheap) to obtain, and you might have most of them lying around already!

It's widely accepted that if you want to get the best price for an item on an internet auction

HOW IT WORKS The light cube is little more than a cardboard box lying on its side so the flaps open toward

to make a seamless background. By removing the sides and top of the box and covering them with diffusion material you can light the inside of the box with three lights for great, shadowless lighting. An optional "floating platform" can be used to remove all bottom shadows, and you can make the box any size you choose, so it will work regardless of whether the objects you're photographing are large or small.

the camera. Your objects will sit inside the box on a piece of white card that is curved

WHAT YOU NEED

- · Cardboard box (size determines size of light cube)
- with daylight-balanced bulbs). or flash units · Masking tape

• Three portable lamps (ideally

- Tissue paper/tracing paper/

 - parchment paper (or similar)
- · Large sheet of white paper • Box cutter/craft knife/scissors
- Sheet of acrylic/Plexiglas (optional)
- Clear plastic cups or glasses (optional)

DIFFICULTY *

WARNING

To avoid the risk of fire, never

leave your light cube unattended with the lights on if you use continuous lighting.

TIPS You don't have to shoot

everything against a white background—just replace the white paper in your cube with colored paper.

Try adding a colored gel over one of your side lights to add a splash of color. A light blue gel will work well with chrome or metal objects, enhancing the cold, metalic feel.

Position your box on a table so the opening of the box faces up, as shown. With a pencil or marker, draw guidelines on the two short sides to identify where you will be cutting. You don't want to cut too close to the edges as the box will become unstable, so leave at least ½ inches (4cm) of cardboard all the way around your marked holes. Do the same for one of the larger sides, but extend the hole through the flap, as shown.

The next step is to cover the sides with diffusion material, to help even out and soften the lighting you use. Tissue paper, tracing paper, and parchment/wax paper are all good for this, and using two sheets of material over each hole will increase the diffusion effect. Cut sheets of diffuser to size, allowing them to overlap the sides of the holes, and stick them down with masking tape.

To add the background, cut a sheet of white paper to match the width of the box. Tape the paper to the top edge, inside the box. Let it curve gently onto the bottom of the box—do not press or fold it into the back corner—and tape the front down to hold the shape of the curve. This will create a "seamless" look to your pictures.

To light your products, position a lamp or flash unit on each side of the box, with a third light above. Allow the top flap to hang down slightly, as this will add slight frontal lighting. Assuming your lights are all the same power, or your flash units are set to deliver the same output, the result will be near-perfect, even lighting.

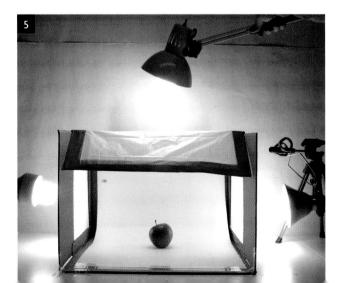

ADDING A FLOATING PLATFORM

The lightcube will successfully eliminate most shadows, or at least minimize them so they are easy to touch up in an image-editing program. However, it is practically impossible to remove all of the shadows, particularly from objects that do not have a flat bottom. If it is essential that you remove these bottom shadows, try creating a floating platform that will allow light to reach the underside of the subject.

A simple floating platform can be created by taking a clear piece of acrylic/Plexiglas and covering it with a sheet of tissue on top. Put the platform in the light cube, elevating it with clear plastic cups or glasses, and place your object on top. Now, the lights from the side of the cube will also pass under the object, and the white background will reflect light up, reducing the shadows underneath your subject.

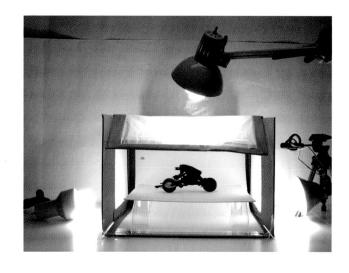

Use wire to support objects at different angles, then erase it using your image-editing software.

USING YOUR LIGHT CUBE

There's a certain amount of trial and error in using a light cube, mainly with the lighting, white balance, and exposure.

To produce a "true" white background, it's easiest to use a daylight-balanced light source, and set your camera to its daylight, or "sunny," setting. Flash is ideal for this, but buying three flash units can be expensive. Instead, try using desk lamps with screwin "Daylight" fluorescent lightbulbs and set your camera's white balance to "Fluorescent Daylight." There is usually more than one fluorescent white balance setting available, so consult your camera's manual to see which one you should use.

For the exposure, set your camera to a low ISO setting (ISO 100 or 200) to minimize noise, and mount the camera on a tripod. This will free up your hands to manipulate the lighting when necessary and, in addition, use your camera's self-timer so you won't be touching the camera when it fires. This will reduce the risk of camera shake.

With your object, make a test exposure, and review the result. It is quite likely that it will look a little dark, because the brightness of the light cube will fool your camera into underexposing. Use your camera's exposure compensation (EV) control and dial in +1-2EV to lighten the exposure. Adjust the EV control until you get a pure white background.

Finally, don't be afraid to adjust the brightness and contrast in your editing program to fine-tune the result—once you've mastered using a light cube, your product photography will be flawless every time!

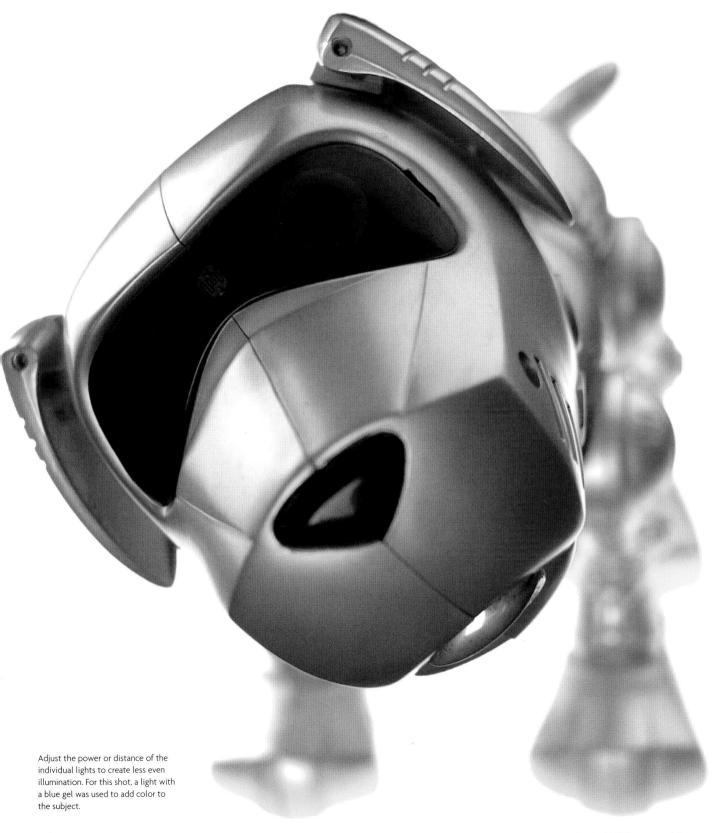

TRIPODS AS LIGHTSTANDS AND LIGHTSTANDS AS TRIPODS

We all know that tripods are for cameras and lightstands are for flash, right? Wrong! Thanks to their common 3/8-inch or 1/4-inch mounting threads, these two supports are fully interchangeable, and once you start mounting your flash units on a tripod, or your camera on a lightstand, a whole world of possibilities opens up for you.

TRIPODS AS LIGHTSTANDS

Starting with tripods, the most commonly used mounting thread has a diameter of 1/4 inch, which is the size of the thread in the bottom of your point-and-shoot camera or digital SLR. Now, some hotshoe flash units come with small plastic stands so they can sit upright, and these stands often have a 1/4-inch socket in them, which means they can be mounted on a tripod straight off. Similarly, most hotshoe adaptors that are designed to let you use your flash off-camera also have a 1/4-inch socket in them, so they'll also fit straight onto a tripod.

There are several reasons why you might want to attach your flash to a tripod, the first (and most obvious) being to hold it off-camera so you can get a little more creative with your lighting (see Project 32). But as well as allowing you to get your flash away from the camera, tripods have several other advantages, such as their ability to go lower to the ground than a "normal" lightstand. Immediately this gives you greater variety in where you position your flash—especially if you use a small tabletop tripod such as the one shown here—which in turn means greater creativity in your lighting.

At the same time, tripods are much cheaper than lightstands, and lightweight tripods regularly appear in yard sales or thrift stores as owners upgrade to "better" models that will hold their expensive digital SLRs more securely. This is great for us, because a lightweight tripod that couldn't hold a point-and-shoot camera steady on a still day will make the perfect stand for a flash—and if it's going real cheap then even better! So next time you're rummaging in a yard sale, keep an eye out for a tripod—not for your camera, but for your flash.

WHAT YOU NEED

- Tripod with 1/4-inch thread
- · Lightstand with ¼-inch thread

DIFFICULTY *

A flash, a hotshoe adaptor, and a tabletop tripod—the perfect low-angle, off-camera lighting solution!

LIGHTSTANDS AS TRIPODS

Just like tripods, many lightstands use a 1/4-inch thread, either to mount a flash or a bracket for a studio strobe, and because this thread is the same size as the one in your camera, there's no reason why you can't use a lightstand to mount your camera. The main benefit of using a lightstand instead of a tripod is the height it can give you. Even the least expensive stands rise to 10 feet (3m) or more, and this is going to be a lot higher than most tripods.

With this increased height comes a whole new perspective (quite literally) for your photographs, and shooting groups of people from a high vantage point will definitely make your shots stand out. However, lightstands are not without their drawbacks. For a start, the legs spread at the bottom, sending a single center pole skyward, and this single pole can move around more than a tripod, meaning you need to use fast shutter speeds to avoid camera shake.

Also, lightstands have a fixed mount, so you need to use either a tripod head or a flash bracket to prevent your camera from pointing at anything except the horizon. Then comes the challenge of composing your shots—impossible if your camera's 10 feet up in the air and you don't have a set of steps handy—so you'll have to "guess" the angle of your camera, fire off a test shot or two, then adjust the angle depending on the preview image.

But how are you going to take the picture to start with? Unless you're endowed with incredibly long arms, it's unlikely you'll be able to reach your camera's shutter release while it's up in the air. Consider investing in a remote release so you can trip the shutter from ground level. Failing that, you could always consider the "self-timer challenge"—set your camera's self-timer to its maximum delay (usually 12 seconds), trigger the shutter, and while the self-timer counts down, hoist the camera skyward, stabilize the stand to try and prevent it from waving around too much, and hope you get this all done before the timer runs out.

However, despite these many shortfalls, lightstands do still have a height advantage over most tripods, so don't discount them entirely when it comes to adding a fresh perspective to your photographs.

Left: A flash bracket that's designed for angling a studio strobe is also ideal for changing the direction of your camera when it's on top of a lightstand.

TIP

Some lightstands use 3/8-inch mounting studs, not 1/4-inch, so check to make sure your tripod head is compatible—some will fit both sizes, others will only fit the smaller thread.

TIP

Really cheap tabletop tripods might not be any use for putting a camera on, but they're perfect for mounting a flash for projects such as Shooting Smoke (Project 12) and Water Droplets (Project 13). mr a studio, cookies are used in from or a light to project shapes onto the image. At its most basic, a cookie is nothing more than a piece of cardboard with holes cut into it, which can create a simple mottled background, or be designed to look like windows, or blinds that create the impression that a photograph was taken using natural light flooding through an ornate window, even though it might have been shot in a windowless studio.

Making a cookie is really easy—all you need is a large sheet of cardboard or foamcore. Draw your chosen shape onto the cardboard and cut it out, then position the cookie between the light and the subject. Unless you have a spotlight that you can focus on the cookie, the shadows cast by the cookie will be soft edged, which is useful when it comes to smoothing out any slight imperfections in the cut-out shape, but it can make the shadows indistinct. To create harder-edged shadows, move the cookie as close to the subject as you can, and use the "hardest" light you have (direct, undiffused flash is ideal). Also, the further the light is from the cookie, the harder the shadows will become.

Shining a light through a series of slits cut into a sheet of foamcore creates the appearance of window blinds.

WHAT YOU NEED

- Sheet of cardboard or foamcore
- Scissors or craft knife

DIFFICULTY *

The distance between the cookie and the subject controls its intensity. Here, the "window blind" effect is subtle, but makes the lighting more interesting.

TIPS

Cookies don't have to be cut from cardboard—putting a plant in front of your light is a simple way of creating an abstract, leafy background—like light passing through a leafy canopy outdoors.

If you own a slide projector, try cutting small cookies out of foil that will fit in a slide mount. Put these in the projector and you'll be able to get hard-edged shapes in your images. The downsides are the projector's low light output, and any slight mistake will be enlarged when it's projected, so you need to be careful when you cut it out.

LOW-COST FILTERS

WHAT YOU NEED

- · Skylight or UV filter
- Filter gels
- Compass
- · Scissors or craft knife

DIFFICULTY *

Filters, particularly those for lenses with large diameter filter mounts, can be expensive, and if you just want to experiment with a technique then the cost can be prohibitive. One way around this problem is to buy sheets of transparent filter material, known as gels. Large gels are readily available from photographic and theatrical supply stores, often for use with lighting equipment, and come in a wide range of colors. Although they aren't "optical" quality like proper filters, they are relatively inexpensive, can easily be adapted for use as photographic filters, and are definitely worth using for tests and experiments before investing in a more expensive, high-quality filter.

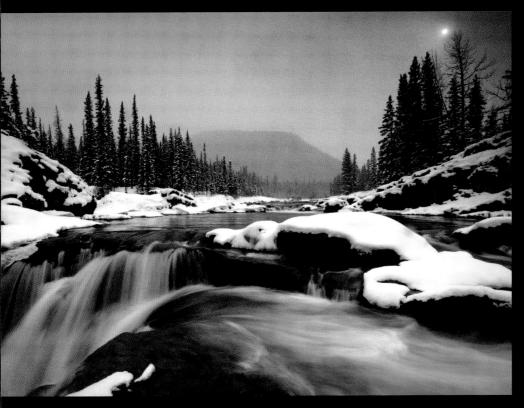

TIPS

Some lenses require gel filters by design. For example, fisheye lenses have such a large, curved front lens elements that normal filters can't really be used. For that reason fisheye lenses often have small slots in the back that can accommodate small square gel filters.

If you want to experiment with long exposures (Project 07), neutral density lighting gels will let you experiment with different filter strengths without spending a lot of money.

To make your filter, take a skylight or UV (ultraviolet) filter that fits your lens. Use a compass and set a radius that is a fraction less than the internal radius of the filter. Tape a thick piece of cardstock to the center of the gel to prevent the tip of the compass from piercing the material, and draw a circle the diameter of your filter. Cut the filter out of the gel using sharp scissors or a craft knife and just fit it inside the back of your filter, so it is sandwiched between the filter glass and your lens. Then attach the filter to your camera's lens and you're set to shoot.

RE

REFLECTORS

In the studio, professional photographers have access to multiple strobes that let them direct light onto their subjects from all angles—be it a model in a fashion shoot, a portrait, or a still life. Our eyes understand shapes, depth, and three dimensions because we judge shadows and highlights to build a mental picture of what an object is like in real life. Lights of different powers are used to ensure we can see all the detail that is important, while still seeing that an object has shape.

Fortunately, you don't need lots of expensive studio strobes to use the same techniques in your own photography—you can use one light (be it the sun or something as simple as a table lamp) and a collection of reflectors to do the same job. Reflectors can act as additional lights when they bounce light, and using more than one lets you bend the light from a single source around your subject. They are also cheap and quick to make, and with a bit of imagination you can create all sorts of effects.

WHAT YOU NEED

- Aluminum foil
- Gold paper
- Stiff cardboard or cardstock
- Glue or tape

DIFFICULTY *

A small, handheld mirror has been used like a spotlight to make this flower stand out from the background.

BLACK REFLECTORS

It might not be obvious, but you can use black reflectors in your photography. Rather than reflect light they will absorb it, so they can be used to darken shadows on one side of a subject, rather than lighten them. This is useful for adding definition to a portrait when the lighting is generally flat.

Outdoors, a white reflector can help balance out the lighting on the subject, lightening shadows for a softer, more natural look.

WHAT DO THEY DO?

Reflectors are used to balance light and shade in an image. Your camera's sensor can only cope with a certain range of brightness, so you have to do something to stop shadow areas from being too dark for the camera to record, because all detail in that area will be lost. Imagine, for example, someone is sitting sideways by a window. The side of their face closest to the glass will be bright, and the side facing away from the glass will be dark—possibly too dark. The idea of using a reflector is to bounce some of that window light back at the person to add light to the dark side of the face and even up the brightness range. If you are taking portraits, deep shadows will also emphasize wrinkles and skin defects and are not very flattering.

There are many different types of reflectors that you can make, and each has it own characteristics. The "power" of your reflector depends on three things: how close it is to your subject, its color, and whether it is shiny or matte.

WHITE REFLECTORS

White reflectors are easiest to make, as all you need is something white and flat—a piece of white cardstock, a sheet of polystyrene, or even a newspaper. To make the reflector easy to use it should be solid enough to lean against something or hold without collapsing, so if you're using white paper, stick it to a piece of cardstock (or just use white cardstock). White reflects light well, so it produces a soft, neutral-colored reflection that is especially good for portrait photography.

Gold reflectors can enhance portraits by giving your model's skin a warm glow. You can vary the intensity by moving the reflector closer or further from the subject.

ALUMINUM FOIL REFLECTORS

Instead of white paper, stick aluminum foil to a sheet of cardboard instead. It will reflect much more light than white paper, but its effect is much cooler. The light can be harsh, so experiment with the foil laid out flat and also crumpled up, then flattened and stuck to the board. Silver reflectors are more commonly used for still-life photography than portraits.

GOLD PAPER

Reflective gold paper is great for portraits, either inside or out. You can choose between really shiny paper for a hard effect, or matte paper for a softer effect. The gold surface will create a warm light that emulates a sunset situation, adding a healthy glow to skin tones.

MIRRORS

Although you can't actually make them, mirrors reflect a lot of light and almost act as an extra light, rather than a reflector. Depending on the type you use they can appear as spotlights on your subject—make-up mirrors on hinges are great as they are easy to direct, or try using mirrored tiles for larger subjects.

LIGHTING GEAR

Today we have the luxury of digital SLRs that can "talk" to the flash, and without any intervention it can determine the exposure for us, even when multiple flashes are used or we want to balance the flash with ambient light. So why, when it's been made so easy for us, is flash still so underused?

Perhaps it's because you cannot previsualize flash as it only exists for a split-second, and if you're not sure what it's going to do, why bother wasting a shot?

Or maybe it's because when you slide a bigger flash unit into your hotshoe the result you get just isn't going to do the subject justice? But then again, harsh, direct, on-camera flash never will.

While there are valid reasons not to use flash, there are plenty more reasons why you should, and the main one is that it can make your pictures **better**—you just need to start using it more creatively.

In this chapter you'll find all the lighting accessories you need to do just that. For only a few hours of your time you can quickly transform your portable flash from the least-used item in your camera bag to one that's guaranteed to help you create stunning photographs.

32 OFF-CAMERA FLASH

Flash is one of the most brilliant inventions that has come to photography, but it is also one of the most poorly used. Happy snappers with their point-and-shoot cameras have no choice but to use the pop-up flash on their cameras, which are always mounted too close to the lens and produce red-eye, even in daylight. When you own a digital SLR camera, though, and you start to learn about controlling the way your pictures look, you can think about the next step in flash photography.

The default position of a flash on any camera is directly above the lens, but this means your subject gets a direct blast of light that reduces its three-dimensional qualities. To avoid this, and start creating interesting flash pictures, you need to get the flash out of the hotshoe so it can deliver light from the side, from below, or even from behind. Off-camera flash is much better at showing the shape and form of your subject and it will make your pictures stand out from the crowd. It's also really useful if you want to start using some of the lighting accessories we'll be making in the rest of this chapter.

The good news is there are plenty of ways of getting the flash off the camera, and none of them is particularly complicated.

Holding the flash off-camera and balancing it with the ambient light can add a subtle, "fill" effect.

WHAT YOU NEED

- Built-in wireless flash system, flash cables, or slave units
- Hotshoe adaptor if your camera doesn't have a PC sync socket

DIFFICULTY **

MULTIPLE FLASH SETUPS

You can create sophisticatedlooking lighting very easily by using more than one flash unit. If you have a wireless flash system you have the added advantage that the camera will work out the exposure for you. Even if you don't, with a digital camera it is easy to see the results immediately, and flash positions and power can be adjusted to change the brightness. Don't be scared of flash—with your camera's LCD screen as a guide just experiment and you'll soon be producing excellent results. Most of all, get that flash away from your camera!

BUILT-IN WIRELESS SYSTEMS

Many modern digital SLR cameras have wireless flash control systems built-in—all you need to do is switch it on and use it. These systems are usually controlled by a built-in flash unit that communicates with a second flash placed within the line of sight. One built-in flash can control multiple off-camera units, dealing with the exposure calculations for you. This is the easiest way to handle off-camera flash lighting, but not all cameras have this facility.

CABLE CONNECTIONS

While wireless flash is the easiest system to use, the simplest and most secure way of triggering a multi-flash setup is by using cable connections. Any camera that has a hotshoe or a PC flash socket can accommodate a flash cable, and any flash unit can be triggered with a cable, even if an adaptor has to be used. If your camera and flash are from the same manufacturer, you can often buy a specific cable that allows the flash and camera to communicate as though the flash were in the hotshoe, so all exposure calculations will be handled automatically.

In the most basic setup, the cable just triggers the flash, with no other communication. This type of setup works perfectly well, but ideally you need to use the flash unit in its aperture priority mode. In aperture priority you can match the flash setting to the aperture set on your camera's lens, or dial in a smaller or larger aperture to put out slightly more or less light, depending on the effect you want.

The greatest benefit of cable connections is that they rarely fail, so you can be certain the flashes will fire every time. The disadvantage is that you are restricted in where you can place the flash by the length of the cables you have. Also, cables can get in the way when you are working. On the other hand, they are cheap and easy to use.

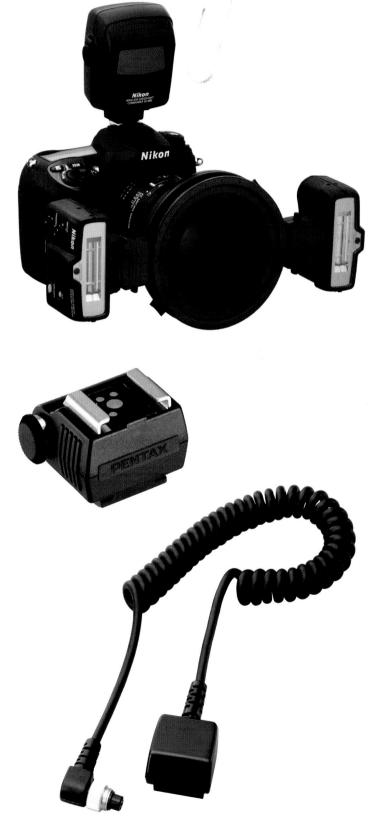

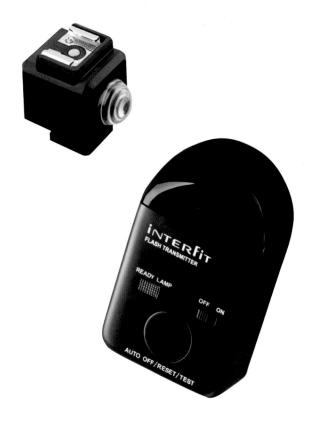

SLAVE UNITS

A neater way to connect flashes so they all fire at the same time is to use optical slave units. These are light-sensitive cells that connect to the trigger contact of the flash unit and fire the flash the instant they detect another flash firing. Indoors, where ambient lighting is low, optical slave units work really well, but they become less reliable outside in very bright conditions.

Radio slaves are much more effective as they rely on radio signals instead of light. These require a transmitter to be fitted to the hotshoe of the camera and each flash unit needs to have a receiver attached. This can work out to be quite expensive, but they are very good and generally have a much better range than optical slaves, in-camera systems, and cables. The transmitter and receivers also do not need to have "line of sight" to each other as the signal can pass through walls.

FLASH POSITIONING

Just getting your flash out of your camera's hotshoe is a great start, but now that you have a free hand you need to think about where you are going to position the flash. There are generally two principle lighting effects to choose between: natural-looking light and theatrical lighting. Broadly speaking, natural light comes from above (replicating the sun, or room lights), while theatrical light comes from below. The question to ask yourself is, "Do I want the flash to be a feature of the picture (theatrical), or do I want people to admire the lighting, but concentrate on the subject (natural)?"

Where the flash goes in relation to the subject can be broken down into three basic groups—in front, behind, and to the side. Obviously you can place the flash slightly behind *and* to one side, but for now we'll work on these three general principles.

Lighting a subject from the front works well with most subjects and, generally, if you keep the gun well away from the lens axis and higher than the camera you will achieve good results easily. This type of lighting shows detail, but can create a rather flat-looking image, so try holding the flash up high and aim it down onto the subject to re-create the appearance of sunlight for a more natural feel. If you are holding the flash in your hand and photographing a person you probably have no choice but to use frontal lighting—unless you have very long arms.

If you want to show the shape of a subject, side lighting is the way to go, although it can create deep shadows on the unlit side. On its own, side lighting creates dramatic effects, but if you balance the flash output with the ambient light (or use side lighting in conjunction with a second flash to the front, or oncamera) it can add shape to an evenly lit subject.

Finally, illuminating a subject from behind will show the shape of its outline and separate whatever you are photographing from its background. This is great for most subjects—whether people, food, or still life—but it nearly always needs to be used with either a reflector or an extra flash because the light obviously only lights the back of the subject, while the front will remain in darkness. A burst of built-in flash from a pop-up flash on your camera can be enough, as can daylight outside, or a large white surface such as a wall or a reflector that bounces light back onto the front of the subject. See Project 31 to find out how you can make your own reflectors.

Here, off-camera flash has been used from the side, with a second light on the background helping to make the subject stand out.

PORTABLE FLASH DIFFUSER

The light from a bare flash is fairly harsh, and the shadows it creates can be particularly unflattering for portrait photography. This is why so many people angle the head of a flash at a white ceiling, because bouncing the light back down onto the subject creates a more natural and evenly lit portrait.

The harsh light from a flash also explains why there are numerous devices available that will fit over your flash to help diffuse and soften it. But these can be surprisingly expensive to buy, and there's no reason why you can't make your own from a sheet of cardboard and some sort of diffusion material such as tracing paper or parchment/wax paper.

You will need to adapt the template depending on the particular model of flash you want to use the diffuser with (which is the difficult part), but the basic principal is easy to follow and modify.

WHAT YOU NEED

- · Portable flash
- Cardboard (a cereal box works well)
- Tracing paper or parchment/ wax paper
- Scissors
- Craft knife
- Ruler
- Glue
- Clear tape
- Black tape

DIFFICULTY *

The first thing you need to do is measure the height and width of your flash. Use these measurements to make a plan similar to the one shown. You can do this on paper and stick it to a sheet of cardboard, use a computer graphics program to draw the plan and print it out to scale, or draw it straight onto your sheet of cardboard. Then, cut it out, remembering to remove the window in the center for your diffusion material.

Tape your diffusion material (tracing paper or similar) over the window in the front of the diffuser. If you are using a cereal box, as I have here, stick the diffuser to the gray side of the box—this will be the inside of the diffuser.

Score the cardboard using a straightedge and the back of a craft knife, and fold the cardboard into shape. Use short pieces of clear tape to hold the diffuser together.

Now it's time to make your diffuser as light-tight as possible, and that means wrapping it in black tape. This will not only

make it light-tight, but will also strengthen the diffuser and make it look much neater.

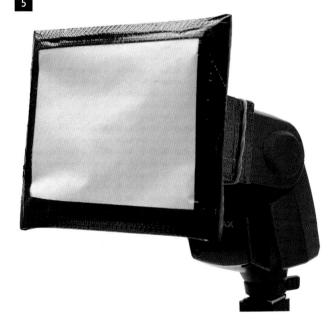

TIPS

To increase the spread of the light, make the front of the diffusion panel bigger. Be careful to avoid making it so big that it obstructs your lens!

To increase the diffusion effect, make the unit deeper, so the diffuser is further from the flash. Using several layers of diffusion material will also help soften the light.

the scene you are photographing. However, there will be occasions when you want to focus the light down to a much narrower spot—to highlight a particular area, create a spotlight effect on a background, or prevent light from falling on a background if you're taking a portrait. Professional photographers using studio strobes will achieve this using a reflector known as a "snoot," which is a type of reflector dish (usually a tube or cone) that fits to the front of the flash to physically restrict the beam of light from the flash to a smaller area. This is something you can easily make for your portable flash units as well, giving you studio-style control over your lighting.

WHAT YOU NEED

- Portable flash
- Cardboard
- Craft knife
- Ruler
- Glue
- Black duct tape (optional)

DIFFICULTY *

	Height of flash head	Width of flash head	Height of flash head	Width of flash head	
noot					
Length of snoot					TAB
_					

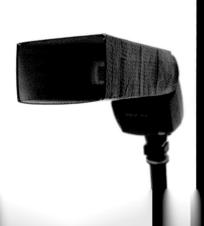

Far left: A flash fitted with a snoot and positioned behind a sheet of colored plexiglass can be used to create a spotlight effect on a background.

Opposite: The directional control of a snoot lets you concentrate light onto a very specific area of the image, as in this atmospheric portrait

The starting point for a snoot is a sheet of cardboard—the cardboard from a cereal box is ideal. Measure the width and height of your flash head, and transfer these measurements using the accompanying template as a guide. Essentially, you are making nothing more than a rectangular box that's open at both ends.

The length of your snoot will determine how small the pool of light from the flash will be; the longer the snoot, the smaller the pool of light. I'm making a snoot that's 6 inches (15cm) long, but note that you need to add an extra inch (2.5cm) to slide it onto the flash.

Cut out your template and use a ruler and the back of a craft knife to score the fold lines, not forgetting to fold the tab along the longer edge.

Apply glue to the tab and stick your snoot together. If you're using a cereal box, fold it so the printed side is outward, otherwise the print could introduce a color cast to your flash.

Once the glue is dry, wrap the snoot in duct tape to make it neater and stronger.

All you need to do now, is slide the snoot onto your flash head and use a small piece of tape to hold it in place.
When the flash fires, your snoot will funnel the light to create a narrow beam, or "spotlight" effect.

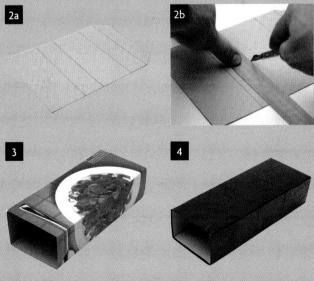

35 PORTABLE GRID SPOT

In this image the flower and vase have been lit using a soft box (see Project 40). To add depth, a grid spot has been placed to the left of the vase and aimed at the background to create a brighter spot directly behind the flower.

A useful, and incredibly simple lighting tool is a "grid," a device that looks like a honeycomb (or grid) and is positioned in front of a light. This grid pattern narrows the path of the light to create a concentrated, spotlight effect—a bit like a snoot, but in a far more compact device. Making a grid for your portable flash is easy and, because of its small size, it's perfect for carrying in your camera bag so you can convert your standard flash into a more directional light source.

WHAT YOU NEED

- Portable flash
- Snoot (see Project 34)
- Black drinking straws
- Ruler
- Scissors
- Black tape
- Glue

DIFFICULTY *

TIPS

The longer you have the lengths of the straws in your grid, the narrower the "spotlight" effect will be.

Your grid can be used in lots of ways, from putting a bright spot of light onto a background, to preventing light from spilling onto a background. Alternatively, use it to accentuate or add highlights to a portrait or even light an entire scene if you have multiple flash units.

Although the grid is similar to a snoot, the straws focus the light much better, so you can produce a similar effect with a more compact device.

The starting point for your grid spot is a basic, 3-inch-long (7.5cm) snoot, so follow steps 1–4 of the previous project so you've got a black snoot to transform into a portable grid spot attachment.

To convert the snoot into a grid, you need to fill the center of the snoot with straws, which will act as "guides" to focus the light. You need to leave about 1 inch (2.5cm) of the snoot to slide over your flash, so cut your straws down so you have a bundle of 2-inch (5cm) lengths.

Starting at one end of the snoot, align your straws with one open end and start sticking them inside the box. A handy timesaving tip is to tape 6–8 straws into a "bundle," then glue the bundles in place, using individual straws to fill the gaps—it's quicker than gluing the straws in one at a time! Keep gluing until you fill the box, and that's your finished grid spot.

Slide your new grid spot attachment onto your flash, using a small strip of tape to hold it in place. Now, when you fire your flash the light will be directed through the straws, creating a narrow beam of light that's perfect for highlighting small areas in an image.

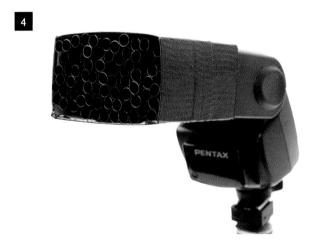

he "must have" piece of gear for any aspiring fashion photographer is a ringflash, with its—distinctive light quality. The circular shape of the flash—with the camera lens in its center—ets photographers get extremely close to a subject and create virtually shadowless images.

Originally designed for less glamorous uses—such as forensic, medical, and even dental photography—cutting-edge fashion photographers such as David LaChappelle and Nick Knight started to exploit ringflash lighting in their fashion and portrait photography in the late 1990s. The then-radical look quickly became very popular, inspiring a generation of ashion and portrait photographers.

Ringflash portraits are easily spotted, thanks to the tell-tale circular catchlight in the subject's eyes, as well as a shadow "halo" around the subject. A ringflash's even lighting also nakes it ideal as a fill light to soften harsher shadows from other light sources, but the cost of a studio ringflash often puts this particular light out of the reach of most photographers.

However, you can replicate the ringflash effect easily and cheaply using your existing ortable flash and a handmade diffuser—the biggest investment is a few hours of your time.

WHAT YOU NEED

- Portable flash (off-camera)
- · A large, shallow plastic bowl
- A smaller plastic bowl
- Aluminum foil
- Parchment/wax paper or tracing paper
- Black tape
- Glue (suitable for plastic)
- Scissors
- Craft knife
- Ruler
- Marker pen/Sharpie
- Flat black spray paint
- Thick cardstock

DIFFICULTY **

Ringflash photographs are typified by circular catchlights in the subject's eyes and a shadow "halo."

TIPS

If the light from your ringflash diffuser is uneven, or doesn't quite reflect all the way around the diffuser, lightly roughen the brighter area of the diffuser with sandpaper, or add an extra piece of your diffusion material to help even out the light.

Project 39 shows you how to create a larger ringflash diffuser for use in a home studio.

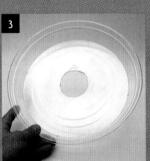

The first task is to cut the bottom out of the smaller bowl, leaving a narrow rim around the base. Depending on the type of plastic the container is made from, you might need a sharp pair of scissors, a craft knife, or a rotary tool.

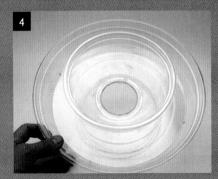

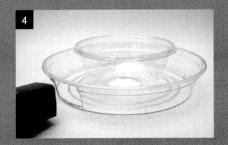

36 > > >

At this point you can paint the bowls flat black. This is optional, but recommended as it will make the finished diffuser look more professional and reduce any reflections that could cause lens flare.

To help support your flash, make a three-sided holder from thick cardstock, as shown. This should be the same width and depth as your flash, with flaps at the top of the holder to fit through the hole in the side of the large dish. Fold the flaps over so they are on the inside of the large bowl and glue or tape them into place.

Next, cover the area between the two bowls with aluminum foil. If you crush the foil, then flatten it out again, this will help reflect the light around the inside of the diffuser. Use glue and tape to secure the foil, and make sure you don't cover up the flash mounting hole.

To create an even spread, you need to add some diffusion material. Parchment/wax paper, or tracing paper are both good materials for this. Draw a circle that matches the diameter of the outer bowl, then a second circle inside that matches the size of the smaller bowl. For additional diffusion, you can use two diffusion rings.

Cut around the larger circle, remove the center disc, and use short pieces of clear tape to hold the circular diffusion ring in place.

To attach your flash to the ring adaptor, slide it into the card flash mount and secure it with a rubber band or tape. Now all you need to do is point your camera through the hole in the center of the ring adaptor and start shooting with the ringflash look!

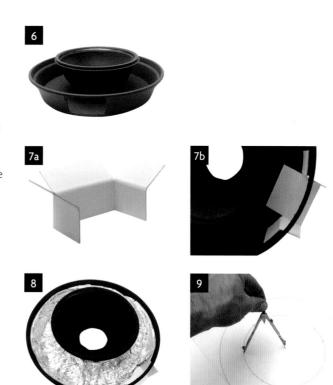

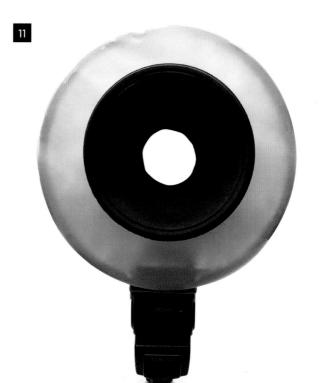

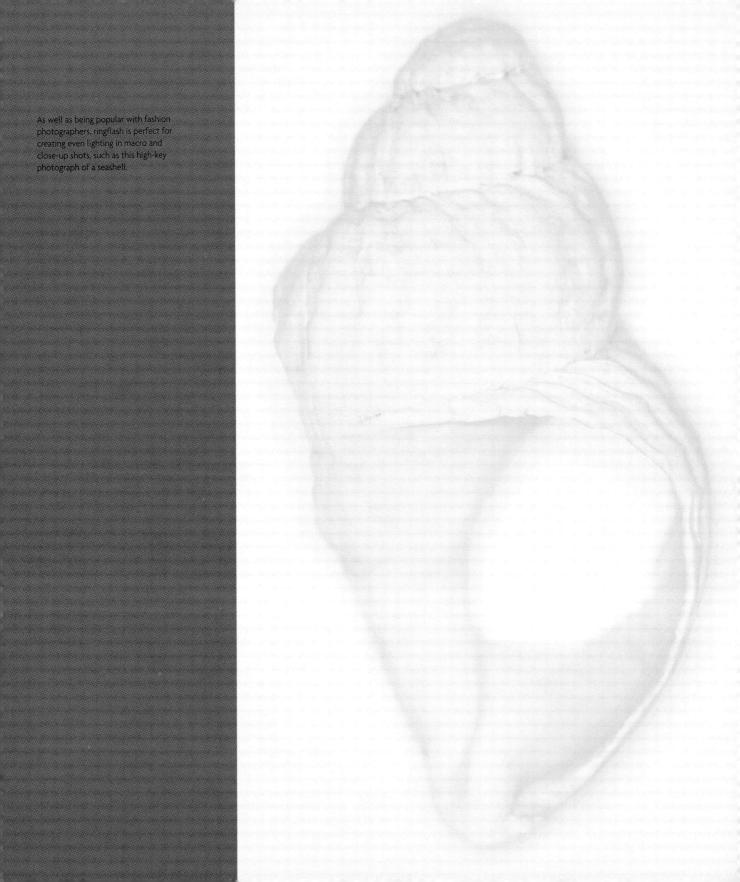

PORTABLE BEAUTY DISH

A beauty dish is one of the most commonly used light modifiers in portrait and fashion photography. The dish creates a circular, even light that produces soft shadows that gradually become darker. This is achieved by firing the flash directly at a small plate (usually silver) held a few inches in front of it. The light reflects off the plate, back into a larger dish, which bounces it back out to illuminate the subject. The light is diffused each time it get reflected, so the beauty dish's "double bounce" method is a great way of creating a larger spread of light using a very compact reflector.

Most commonly, a beauty dish is positioned above head height, quite close to a subject and at a 45-degree angle from their face. This adds definition to facial features, particularly cheek and jaw bones, but without introducing hard shadows. It's typical for a large reflector (see Project 31) to be placed below the subject to bounce light back up from the beauty dish to soften the shadows even more. Despite the soft shadows, the light itself is still direct, and can be quite hard, particularly if the dish is made of a silver reflective material. This adds definition and reveals fine detail, but can be unflattering if the subject has less-than-perfect skin—when a beauty dish is used for fashion photography it is used on models with immaculate skin, or at least a lot of make-up or post-production editing.

As with most studio flash equipment, a beauty dish can be expensive to buy—especially if you need to buy a studio strobe to go with it—but it is possible to make one for your portable flash using items that can be purchased for very little in most homeware stores.

WHAT YOU NEED

- Portable flash
- Large, clear plastic dish or bowl
- Small, clear plastic dish or bowl
- Scissors
- · Craft knife
- Double-sided tape
- Black tape
- Marker pen
- · Zip ties, string, or wire
- · Aluminum foil
- · White spray paint
- · Black spray paint
- Drill or rotary tool

DIFFICULTY **

Positioned above head height and quite close to the subject, a beauty dish can create well-defined features.

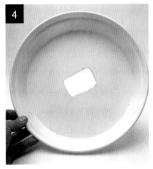

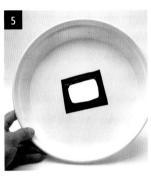

Like the ringflash adaptor in the previous project, the main ingredients of the beauty dish are two plastic bowls—a small one that you will fire your flash into to start with, and a larger one that will act as the main reflector.

Start by holding your flash in the center of the large bowl and drawing around the head to mark it on the bowl.

You will need to cut out the shape you have just marked to allow the flash head to fit through. Depending on the type of plastic the bowl is made from you may have to use scissors, a craft knife, or possibly even a rotary tool to do this.

Once you've cut the hole, use flat white spray paint to paint the inside of the bowl. This will help diffuse and soften the light.

When the paint is dry, stick strips of black tape around the hole you have cut to stop any sharp edges from scratching your flash when it is slid into place.

Take the smaller bowl and mark and cut around its circumference to reduce its height, to around 1½ inches (4cm). If your bowl is already quite shallow you can skip this stage.

- Crumple some aluminum foil and use glue or double-sided tape to stick it to the inside of the smaller bowl. Try to keep it as crumpled as possible, as this will help to reflect the light in different directions. If you want to, spray the outside of the smaller bowl black to make it neater.
- Next, mark three points on the small bowl at around the 12, 4, and 8 o'clock positions. Use a drill or rotary tool to make a small hole at each of these points, then drill holes in identical positions in the larger bowl.
- Position the smaller dish inside the larger one, with the aluminum-coated surface (the inside of the small bowl) facing the white interior of the larger bowl. Align the holes you drilled and thread wire or string through them so the smaller one is suspended in the middle of the larger bowl, directly over the hole that has been cut for the flash. Tie a knot in the string, or twist the wire so the small bowl is held in place.
- Finally, slide your flash through the hole at the back of the larger dish, using tape to hold the lightweight dish in place. When the flash is fired the light will hit the aluminum foil on the smaller dish, reflect into the larger bowl, and bounce off the white surface to produce a light that's perfect for portraits.

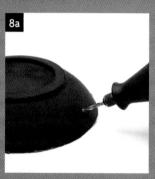

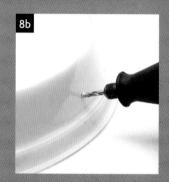

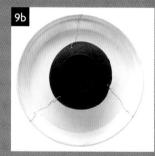

TIPS

By changing the type, or color of spray paint you use in the large dish you can vary the light your beauty dish will produce. Using silver or even a mirror finish spray paint instead of white will make the light harder, and add more contrast to your shots. Using a gold dish produces a similar level of contrast to silver, but the golden light will add a bronzed look to skintones.

You can also experiment with bowls of different depths and diameters—a wider dish will produce softer light. Alternatively, stick a sheet of parchment/wax paper or tracing paper to the front of the beauty dish to soften the light even more.

A beauty dish can be unflattering if your model has less-than-perfect skin, so consider makeup and image-editing as essential parts of the process.

30 STUDIO STRIPLIGHT

The previous projects have shown you how to create a range of useful accessories for your portable flash, with the emphasis being on portability. Some of them aren't that small, but they can be easily used on location, whereas the final three projects are designed to be used in the studio. First up is an easy way to make a studio striplight—the sort of light that usually houses a long, daylight-balanced fluorescent tube. However, here we'll use nothing more than your portable flash to create the distinctive striplight effect.

The main ingredient is a long, thin cardboard box. You might be able to find one that's a suitable size, or you could make one. There are no exact dimensions to follow, although a box that's around 2–3 inches (5–7.5cm) in depth, 6–8 inches (15–20cm) wide, and roughly 3–4 feet (90–120cm) long will work well. The one used here was a "found" box that originally contained a clothes rack. It has the added benefit of flaps at the front, and while these are optional they are very useful for controlling the light.

WHAT YOU NEED

- Portable flash (off-camera)
- Long, thin cardboard box (made or "found")
- Duct tape
- · Aluminum foil
- · Marker pen
- Spray glue
- Scissors
- Craft knife
- Diffusion material (white cotton, parchment/ wax paper, tracing paper, or similar)

DIFFICULTY *

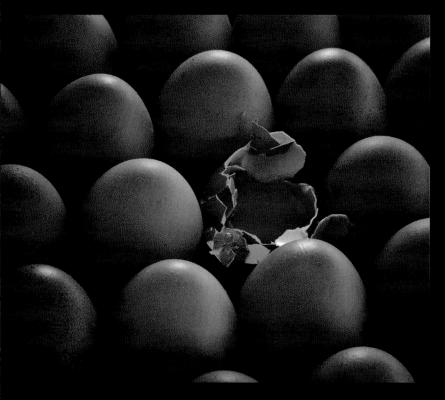

A simple still-life shot, lit using a single striplight and two reflectors.

A single striplight in front of the models and below the camera was used for this portrait shot.

The first step is to strengthen all of the joins and corners of the box with duct tape.

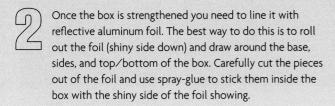

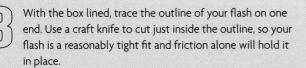

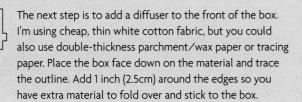

Cut out the front diffuser, and stick it to the box using tape, glue, or both. I stretched my fabric tight and glued the material to the flaps on either side of the box, holding it in place with clips while the glue dried. I then folded the edges over and taped them all the way around.

That's it, one striplight softbox for your portable flash! You can now push your flash in the hole at the top and start shooting. The design can be used without a stand—either on its side, or upright—and if it doesn't balance very well with the flash in place try adding a couple of cardboard feet to support it. Alternatively, add a hole at the bottom and/or one side and use a large, flat washer and a nut to mount it on a tripod or light stand (see Project 28).

TIP

Having flaps on the front of your striplight lets you modify the light, from a reasonably wide beam, to a narrow slit.

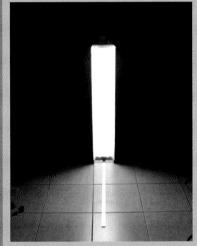

FLAPS OPEN

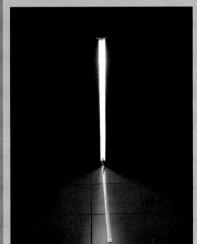

FLAPS CLOSED

For this striking picture, two strip lights and two "bare" flashes were used to build up the lighting.

39 STUDIO RINGLIGHT

As we saw in Project 36, ringflashes are incredibly popular with fashion and macro photographers, and making a portable ringflash adaptor for your flash isn't that difficult. This project shows you how to make a larger ringlight that's great in a small studio for shooting portraits or fashion pictures. There are no "hard and fast" rules when it comes to building the flash, so take the basic steps and experiment with different ring and box sizes—it will help give your pictures a slightly different look from anyone else's.

WHAT YOU NEED

- Portable flash (off-camera)
- Large, shallow box (such as a pizza box)
- Square box (made or "found")
- Aluminum foil
- Duct tape
- Aluminum tape (optional)
- Spray glue
- Marker pen
- Scissors
- Craft knife
- Compass
- Diffusion material (white cotton, parchment/wax paper, tracing paper, or similar)
- Black cardstock
- Thin strip of wood (around 1-inch (2.5cm) wide and ½ -inch (0.6cm) thick)

DIFFICULTY **

Mark out the section of the inner box that needs to be cut out. This needs to be the depth of the outer box, plus 1 inch (2.5cm) on each side to make flaps. You could easily make this piece from thick cardboard if you can't find a suitably sized box.

Use a craft knife to add flaps as shown, then stick aluminum foil around the outside of the box, but not on the flaps.

Instead of foil, you could use aluminum tape.

You now need to line the larger box with aluminum foil. Roll out the foil (shiny side down) and trace the outline of the box with a marker. Cut out the shapes and use spray glue to stick them shiny side out in the box. I used aluminum tape for the narrower edges as it's easier for covering smaller areas, but you could do this with foil.

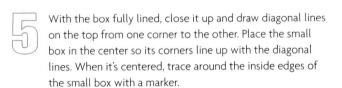

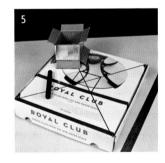

Carefully cut out the marked square with a craft knife and turn the box over. Repeat the process on the other side, using the piece you cut out as a template.

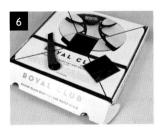

- Open the larger box and place the smaller box over the bottom hole. Use tape over the flaps to stick it in place, then cover the four cardboard flaps with aluminum foil or tape.
- Next, you need to mark out the ring on the top of the box, which basically means drawing one circle within another. The easy way to do this is to use a compass, but mine seems to be missing so I'm using a small plate for the inner circle, and a pan lid for the outer circle. The width of the ring isn't critical—2–3 inches (5–7.5cm) is a good start—but it's important that both circles are centered on the box.
- With the ring marked, cut along the outer circle. You need to use this piece as a template later on, so be careful. Next, cut out the inner circle, again taking care as you want both the inner section and the ring intact.
- The next step is to prepare the diffuser panel. I'm using a piece of cheap, white cotton fabric, but double-thickness parchment/wax paper or tracing paper will also work.

 Trace the outline of the main box onto your fabric or paper and cut it out. Here you can see the cut-out diffuser panel placed on top of the main box, but DO NOT stick it down at this stage.
- Place the inner section from the ring you cut out over the small, central box (and diffuser) and mark the outline of the square hole on your diffuser.
- Put the diffuser to one side and tape the inner ring cut-out to the inner box—aluminum tape is ideal.

You can now attach the diffuser panel, gluing and taping it to the front of the box. Make diagonal cuts in the center hole of the material to make flaps that you can tape to the inside of the inner box.

> To tidy up the flash, cover the front with black cardstock. The easiest way to do this is to use the cardboard ring you cut out earlier as a guide. Once your ring has been cut out, align the black cardstock with the ring on the front of the flash and trim the cardstock to size. Cut flaps in the center of the middle disc to fit in the central hole, then tape around all of the edges for added strength and neatness.

You now need to make a hole for the flash to sit in. Trace around your flash on one side of the box and cut out the shape, being careful to cut inside the line so the flash is a snug fit.

Finally, you need to be able to mount the ringflash on a lightstand or tripod. Because the cardboard might not be quite strong enough on its own, stick a thin strip of wood across the bottom of the box (the edge opposite the flash), with a hole in the middle for a bolt to pass through. You may need to space it away from the box slightly so you can put a nut behind the hole to tighten it on a tripod, or use a bolt through the wood to fit it to a lightstand. Then just shoot through the hole for the ringflash look!

TIP

Who said a ringflash has to be round? Instead of cutting out a circular ring, try making one that's square, hexagonal, or even triangular to add unexpected catchlights to your subject's eyes.

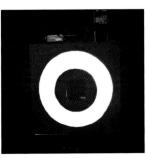

40 STUDIO SOFTBOX

Softboxes form the backbone of most pro photographers' studio lighting kits, whether it's for shooting portraits, still-life setups, or simple product shots. The beauty of a softbox is its ability to produce a large, diffuse spread of light that can be used for overall illumination and built on with other lights, such as the grids and ringflash we have already covered. This project shows you how to build your own softbox with a quick and easy way to mount a portable flash unit. Unlike the previous projects, the softbox uses a wood frame, but don't let this put you off—you don't need any carpentry skills to put it together. All the materials you need should be readily available at your local hardware store for only a fraction of the price you'd pay for a pro softbox—and the results are not that different!

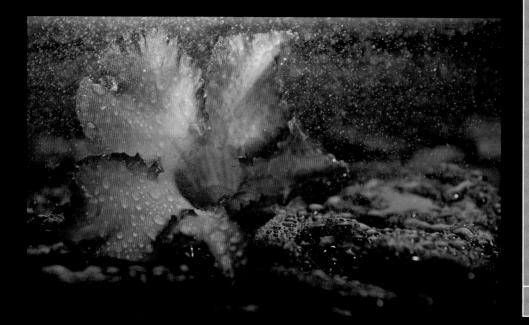

This flower was lit from behind with a homemade studio softbox, with two additional flashes adding the modeling.

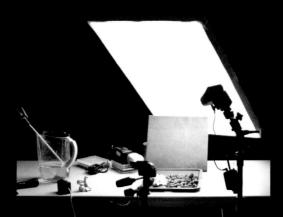

WHAT YOU NEED

- · Portable flash (off-camera)
- Wood for frame and flash cradle (approximately 15 feet/5m)
- Wood for support (approximately 3 feet/lm of thicker wood strip measuring 1½x¾ inches/38x19mm)
- Small L brackets (interior and flat brackets)
- Small screws (for L brackets)
- Small picture hangers
- Approximately 12 feet/4m thick wire
- 4 large sheets of cardstock
- Aluminum foil
- Aluminum tape
- Duct tape
- Bolt or nut (to hold mount softbox to tripod or lightstand)
- White cotton fabric (or similar) for diffuser
- Velcro
- Screwdriver
- Drill
- Saw
- Pliers
- Staple gun

DIFFICULTY **

This project is to make a softbox measuring 40x24 inches (100x60cm), which is a good size for portraits and more than adequate for still-life setups. The front frame is a simple rectangle made from thin wood strips measuring around 34x1/2 inch (19x10mm).

With the size of the softbox decided, cut out the lengths you need from the wood and use small L brackets to join the ends together, making a flat frame. Because the wood is quite thin it's a good idea to drill pilot holes to stop the wood from splitting.

Next, build a frame to hold your flash. There's no single way of doing this, but I decided to go with a cradle design so the flash can be easily removed. Mark out a few small sections of wood to build this, the key measurements being the width and depth of the flash. To join the sections together I used inside L brackets. There's no real science to this; just build the cradle a section at a time, holding the flash in place as you position each piece.

The cradle now needs to be attached to the front frame. A frame-to-flash distance of roughly 20 inches (50cm) works well for a softbox of this size—larger softboxes will require a greater distance, while smaller softboxes will work with a shorter distance between the flash and the frame. To make it easier to join the cradle to the frame (and keep the two parts the correct height and distance apart) I made a temporary stand for the cradle from two 20-inch (50cm) lengths of wood joined with an inner L bracket.

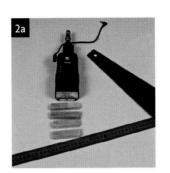

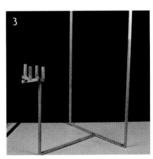

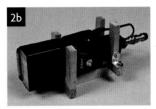

Two homemade softboxes were used to light this model car, with an additional two flashes fired through plain paper that acted as a diffuser and a reflector.

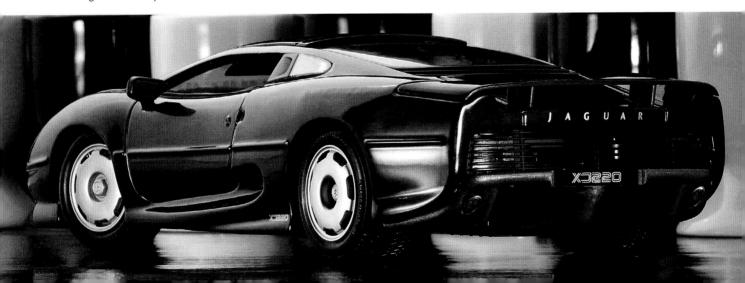

40 . . .

I used 20-gauge fencing wire and small picture hangers to attach the two parts together, but any strong wire that you can bend by hand (but doesn't flex on its own) will work. Start by cutting four 40-inch (100cm) lengths of wire and roughly straighten them out. Feed one end through a picture hanger and fold the wire back on itself so it's held in place. Then, screw the hanger to the front frame (drilling a pilot hole first). Repeat this on all four corners, and then attach the other end of the wire to the flash cradle in the same way.

Trim the excess wire off each end and remove your temporary support. Don't worry if it all seems a bit wobbly at this point, the next step is to add a brace that will also act as the mounting point for the whole softbox.

The brace is a length of wood that fits diagonally between the bottom of the frame and the camera cradle. Cut a length of wood that's a few inches longer than the gap between the cradle and frame and, with the softbox placed face down, hold the support brace in place and draw the join angle onto the edge of the wood—this will make sure the brace fits neatly.

Saw the ends at this angle and attach the brace using inner L brackets. Bend the brackets at a right angle using two pairs of pliers and screw the brace in place (after drilling pilot holes!).

The next task is to add a mounting bracket for a bolt that will attach the softbox to a lightstand. Use a slightly thicker piece of wood than used for the brace and draw a line on it that would be roughly parallel to the floor when mounted on the brace—it doesn't have to be totally accurate, but try to get the angle as close as you can.

Saw along this line, then determine the balance point of the softbox. This is the point where you can sit the brace in your hand and the softbox doesn't want to tip forward or back. Screw the mounting bracket to the brace at this point and your softbox "skeleton" is complete.

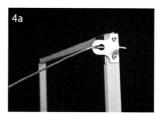

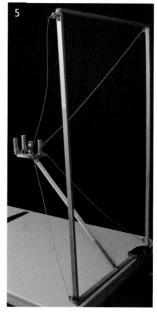

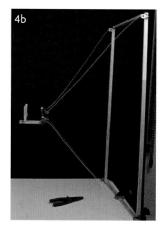

A simple studio still-life often needs nothing more than a single softbox to produce fantastic results.

Now it's time to add the softbox "skin," and the best material for this is thin cardstock. It's a good idea to number each side of the softbox at this point, so you can match your cardstock to the side.

To create your skins, lay the softbox on its side, on top of the cardstock, and trace the outline of the softbox so you have a triangular shape. Remove the softbox and expand your line by a couple of inches, so you have extra material to fold over and stick. Label the panel so you know which side it attaches to.

Repeat this process for each side of the softbox and cut out each of the panels.

Now you can attach the panels to the frame. Start with one of the larger side panels, and use a small piece of aluminum tape on the inside of the panel to attach it to the camera cradle and the wire. Use the extra material at the cradle end of the panel to create a tab and staple it to the wood. Then, tape the wide end of the panel to the softbox wire to hold it in place.

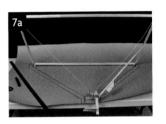

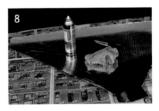

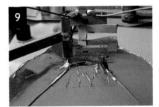

40 . . .

- Next, cut two lengths of aluminum tape the same length as the wires. Run this over the top of the wires to hold the panel in place on both sides. Tape beyond the edge of the panel so you are left with a long tape flap that you can attach the adjacent panel to. Finish up by stapling the panel to the front wood frame.
- Repeat the previous step with the other side panel so you have both sides in place, with tape flaps running the length of the four wires.
- Next, add the panel to the top of the softbox (the side without the brace). Start by stapling the front edge to the frame, making sure it is lined up properly. Then, turn the softbox upside down so the panel is at the bottom, and attach it to the side panels using the tape flaps.

Once that's done, trim off any excess cardstock on the outside of the panel, and strengthen the edges with duct tape.

Before adding the last panel, you need to add the lightstand mount. Lightstands vary, so if your lightstand doesn't have a "drop in" style mount (or you want to mount the softbox on a regular tripod) you might need to make a small hole to wedge/glue a nut into. I've fitted a bolt, with two nuts attached so the lightstand has something solid to clamp onto.

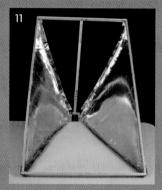

It's time to fit the last panel, but because of the brace, you will need to trim the panel to size before fitting it. Repeat the procedure outlined in steps 12 and 13, stapling the front edge of the panel to the frame, taping up the inside with aluminum tape, then strengthening the outside edges with duct tape.

The final stage is to add the diffuser panel to the front of the softbox, and a piece of white cotton fabric is perfect. Lay the softbox face-down on the fabric, trace around the outer edge, and add an inch all around so you have got material to fold around the frame.

The best way of attaching the diffuser is with Velcro, so you can remove the diffuser to wash it, replace it, or make any repairs to the inside of the softbox. A few short tabs are all that's needed, and you can add an extra tab to the corners to keep them neat.

And that's it—one large softbox for your portable flash. All you need to do is set it up on a lightstand or tripod and start shooting!

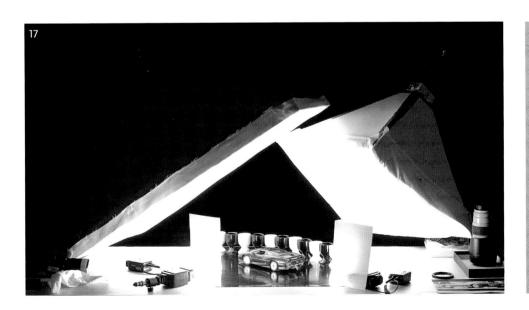

Your softbox doesn't have to match these dimensions—you can make it larger or smaller, or change the shape to a narrower rectangle, or a square. The important thing when you change the size is the flash-to-diffuser distance—if your flash is too close it won't light the diffusion panel evenly. To avoid this, make your softbox deeper, so the flash is further from the diffuser.

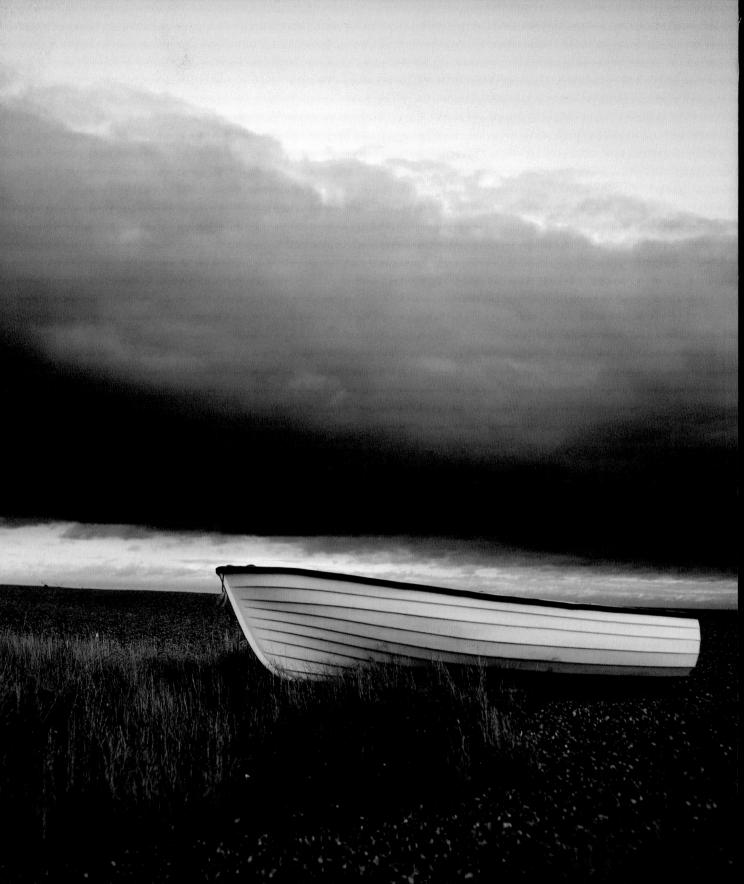

DIGITAL PROCESSING AND PRINTING

As we have seen, there are lots of ways that you can start making photographs that are more creative, but there are some things that just can't be done in-camera or by making your own lens and flash accessories. So, to round off our fifty-two projects, this chapter will show you twelve ways that you can transform your pictures on your computer, whether it's re-creating the look of vintage processes or films, or creating truly unique works of art using your home printer.

Most of these projects are demonstrated using Adobe Photoshop,

but this doesn't mean that's the only program you can use. Many of the projects can be accomplished just as easily using Photoshop Elements, Paint Shop Pro, or even Gimp, a free image-editing program for Windows and Mac computers that's available from www. gimp.org. The only thing to note is that the Photoshop tools might be called something different in other programs. Alternatively, if you want to follow these projects using Photoshop, you can download a free, thirty-day trial of the latest version from www.adobe.com.

DIGITAL POLAROID SX-70

Before

WHAT YOU NEED

 Image-editing program with Smudge tool (or similar)

DIFFICULTY *

TIPS

To emulate the "plastic" feel of a genuine Polaroid, use a high-gloss paper for images made using this technique. To take it a step further you could also add a Polaroid-esque frame made out of thin, matte white paper.

For the "ultimate" Polaroid finish, make your prints on inkjet transparency film, then mount the film ink-side down onto highgloss white media. Frame this in matte white paper and you will have a great "fake Polaroid."

After

When Polaroid abandoned production of its instant films, a range of unique materials and techniques were lost, from emulsion lifts to emulsion transfers. However, prior to this, another unique emulsion was sidelined—SX-70 (or Time Zero) film.

If you're unfamiliar with this particular film, it was designed for the "instant" camera of the same name, which became something of a cult classic. What made it unique—and exciting to creative photographers—was the way in which the film was made. The emulsion was sandwiched between the Polaroid backing and a clear plastic cover, and because the emulsion took a short while to "harden," there was a window of opportunity where the emerging image could be physically manipulated and pushed around to create impressionistic, painterly images. However, while the film is no longer produced, it is still possible to achieve a similar effect using your editing program.

SMUDGE TOOL

The key to re-creating the manipulated Polaroid look lies with the Smudge tool, which hides in Photoshop's toolbar alongside the Blur and Sharpen tools. While it might not have the most appealing name, it is perfect for re-creating the look of a manipulated Polaroid. Basically, the smudge tool works like a paintbrush, so you can set different brush sizes and change the hardness of the edges. However, instead of applying color to your image, the Smudge tool "smears" the information that's already there—exactly like pushing the emulsion around on Time Zero film. By changing the "strength" of the Smudge tool you can alter its effect, so it has a lesser or greater impact on your image.

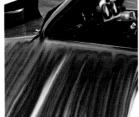

Strength 25%

Strength 100%

OUTLINES

Depending on how "dry" the emulsion was, and how hard you pressed, one of the properties of Time Zero film was that black or white lines could be added to the manipulation, creating outlines and fake "highlights" that didn't exist in the image to start with. The obvious way of replicating this digitally is to use the Pencil or Paintbrush tool to add thin black or white lines that you can blend into the picture using the Smudge tool.

DIFFERENT STROKES

With your image open and the Smudge tool selected, it's time to re-create the look of manipulated Time Zero emulsion. Experimentation is the key here, so play around with different brush sizes and vary the hardness of the brush to see what different effects can be achieved. Alter the strength of the smudging as well.

As the smudge tool is used freehand, different effects can be achieved by applying it in different directions. For example, to remove a background quickly, a large brush and high strength combined with a circular "smudging" action does the job well, whereas "straight" smudges can create a regular, abstract background.

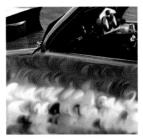

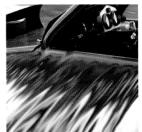

Round strokes

Straight strokes

CONVERGING VERTICALS AND SLOPING HORIZONS

Have you ever returned from vacation wondering whether one of your legs is shorter than the other because none of the horizons in your photos are straight? Or perhaps all of the dramatic skyscrapers that you were photographing have come out looking triangular? If this has happened to you then you're suffering from sloping horizons and converging verticals.

Converging verticals is the effect when parallel lines (like the sides of a tall building) appear to get closer together, the further they get from the camera. It is most severe with very tall buildings, but can also be noticeable when shooting any large, regularly shaped subject, especially when you're shooting from fairly close with a wide-angle focal length. The image I'm using here (see step 1) suffers from both problems—the horizon isn't straight, so the church looks like it's leaning to one side, and the walls are converging toward the top of the building. This is easily fixed with your editing program.

WHAT YOU NEED

· Image-editing program

DIFFICULTY *

TIP

To avoid sloping horizons when you're shooting, attach a small spirit level to your camera's hotshoe. These are available from most camera stores and if your camera is on a tripod they make it easy to keep your horizons straight.

Before tackling the converging verticals, I want to correct the sloping horizon. Choose the Ruler tool from the toolbar (it's nested with the Eyedropper tool) and draw a line across an edge in the image that should be straight. Choose Image>Image Rotation>Rotate Arbitrary and the correct angle to make this edge straight will automatically appear in the dialogue window. Press OK.

With the horizon straightened it's time to correct the converging walls of the church. It's easier to do this if you turn on Photoshop's grid (View>Show>Grid), which places a grid over the picture.

I'm going to make the correction using the Perspective adjustment tool (Edit>Transform>Perspective), so I need to double click on the Background layer in the Layers palette to convert it into an editable layer (Layer 0). It is then a case of pulling the uppermost adjustment points until the walls of the church are parallel, using the grid as a guide.

The perspective adjustment has corrected the converging walls, but the church looks guite "dumpy." To make it appear more natural I've chosen Edit>Transform>Scale, without clicking the tick icon to apply the perspective correction. I can now pull the top and bottom adjustment points to stretch the church back into a more realisticlooking shape before clicking the tick icon to apply the perspective correction.

As a result of the adjustments I've made, an empty space has appeared in the bottom left corner, so I need to crop the image using the Crop tool. Once that's done, it's just a case of tweaking the Levels to boost the contrast and the picture's ready to print.

TIP

Rather than correct converging verticals, why not emphasize them for creative effect? Rather than "stretching" the walls to make them parallel, "squeeze" them together to increase the sense of towering buildings stretching into the sky.

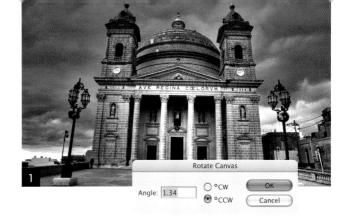

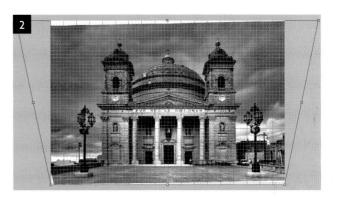

43 HDR IMAGING

Over the past few years a new trend has appeared in digital photography; it's called HDR (which stands for "High Dynamic Range") and it's become hugely popular because it allows you to bring out a massive amount of detail in your photographs.

The problem with digital photography is that your camera is limited in what it can capture, in terms of the lightest and darkest areas of a scene. You'll know this if you've ever photographed a sunset and found that while the sky is clear, the beach, landscape, or buildings turn black and become silhouettes. While you can probably see detail in these areas with your eyes, your camera just can't capture the full brightness, or contrast range.

In the most basic sense, HDR (and a process called "tone mapping") takes a sequence of images that have been exposed for the different levels of brightness within a scene, merges them together, and then "squashes" the wide brightness range into a single, usable picture. There are several ways to make an HDR image, but we're going to look at the most straightforward, which is to use a single Raw file.

WHAT YOU NEED

- A digital camera that captures Raw files
- Raw converter software
- HDR generation software (such as Photomatix Pro)

DIFFICULTY **

Before

Afte

The key to a good HDR image is to have at least three identical pictures to work with: one that retains detail in the highlights, one with detail in the shadows, and a third well-exposed image in-between. So, the first step is to open a Raw file in your Raw converter and produce these three images.

Start by dropping the exposure down by 2 stops in your Raw converter, and save the image; this will be the image with the highlight detail in it.

Next, adjust the exposure to 0 to create your "normal" exposure and save this, giving it a different name.

Finally, drag the exposure slider to +2 (to bring out detail in the shadows) and save it again so you have three files that you can use to generate your HDR image.

To convert the three files into a single HDR image I'm using Photomatix Pro. Go to File>Open, and use the browser to find the three files you created. Photomatix knows these are from the same Raw file, so you need to "verify the bracketing." This is basically telling the program how many stops apart the images are. As they were set at 2 stops apart, select "2" from the drop-down menu. The brightest should now be listed as 2, the middle exposure as 0, and the darkest at -2.

The next dialogue offers a number of options, but because you've used the same Raw file to produce our three files you can leave most of them unchecked or at their default settings. The only one you might want to change is Reduce Noise. Now you're ready to click *Generate HDR*.

Generating an HDR image isn't an immediate process, and when Photomatix reveals your HDR image it will look terrible. Highlights will have become featureless white spaces and shadows will have turned solid black—the exact opposite of a "detail-packed" image!

The reason for this is because you are looking at a "true" HDR image, and your computer screen's contrast ratio is much lower than the contrast ratio of the image. So some processing is needed.

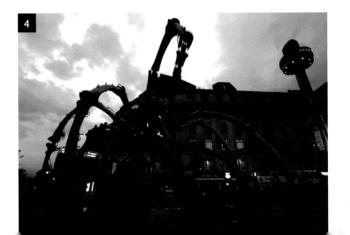

43

5

To process the image, select *HDR>Tone Mapping* from the menu. This is the part where you "squash" the brightness range in the HDR image.

When the tone-mapping interface opens you will see a more normal-looking picture in the preview window. It may still need work, but it will definitely look better than it did in the previous step.

The tone mapping dialogue offers two main options: "Details Enhancer" and "Tone Compressor." The Details Enhancer often produces better results (and is easier to use), but there are no rules to follow when it comes to the settings—every image is different, and everyone likes different effects. So just play with the sliders until you get a preview image that looks right to you!

Once you're happy with your tone-mapped image click *Process* and it will be fully rendered. Choose *File>Save* from the menu to save your HDR image as either a TIFF or JPEG file, and that's it—six simple steps to HDR!

DETAILS ENHANCER STARTER SETTINGS

I use the following settings as a starting point when I use the Details Enhancer:

Strength: 70% Color Saturation: 60% Luminosity: +5 Light Smoothing: "very high"

This will bring out lots of detail in a sky and shadow areas, for example. If you find you're getting a lot of noise in the image, try increasing the micro-smoothing or reducing the strength.

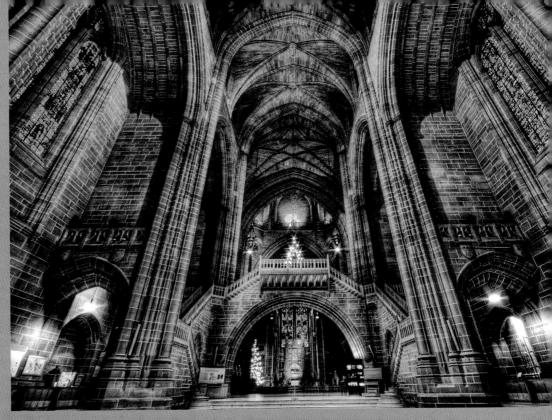

DIGITAL CROSS PROCESSING

Cross processing was popular with certain film photographers for the unique look it gave. The technique basically involves developing film in the wrong type of chemistry, and the most common type of cross processing is to develop print (negative) film using the process designed for positive (slide) film. This produces some fairly odd results, but with a lot of trial and error, the pictures can look really cool, with dramatically increased contrast and wildly oversaturated, inaccurate colors.

The downside to "traditional" cross processing is that it's both expensive and unpredictable. Depending on the film used, and the development parameters, you're equally likely to get a roll of complete duds as you are to get a roll of killer images. Fortunately, if you shoot digitally it is possible to re-create the classic cross-processed "look" using your image-editing software.

This project is intended for more advanced photographers, and you will need the full version of Photoshop (or a similar program that features RGB Curves control and Adjustment Layers) so it is possible to take maximum control and produce the most striking images.

WHAT YOU NEED

 Image-editing program with RGB Curves control and Adjustment Layers (Photoshop CS or similar)

DIFFICULTY **

TIP

The settings given are a good starting point, but they are only a starting point—experiment with them to create an individual look.

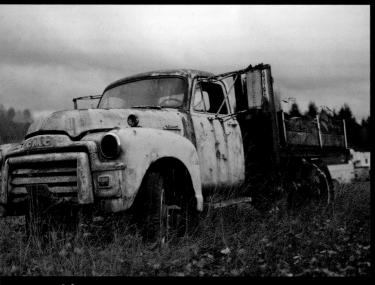

Before

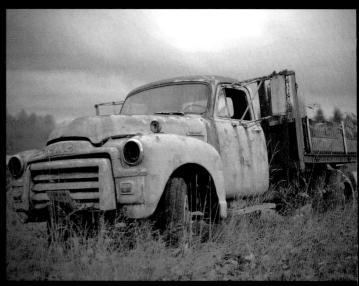

After

With your image open in Photoshop, go to Layers>New Adjustment Layer>Curves. When the Curves adjustment dialogue opens, select Red from the channels dropdown list and move the curve into the "S" shape shown here. The image should take on a pinkish tint.

Next, select the green channel, and pull the curve into roughly the same shape as the red curve in step 1. Since most of the data in digital images is contained in the green channel, this adjustment will increase the overall contrast, especially in highlight areas.

The final curves adjustment is to the blue channel, and with this adjustment we want to remove blue from the highlights and add it to shadow areas. Pull the top right point down a little, and the bottom left point up, as shown here. Then pull the curve into a gentle "reverse S" shape. This will give the image an overall yellow cast, but add a lovely rich blue to the shadows.

4

This step is optional, but if you find that your curves adjustments have increased the contrast and tonal balance of your image too far, change the curves adjustment layer's Blending Mode to *Color*. Don't worry if your image suddenly looks a little flat and unnatural after changing the blending mode—we will correct this in the next step.

44 >>>

New Layer	
Name: Color Fill 1	ОК
Use Previous Layer to Create Clipping Mask	Cancel
Color: Blue	
Mode: Color • Opacity: 10 • %	

The image is almost finished, but I want to add slightly more blue, especially to the shadows and midtones. To do this, choose *Layer>New Fill Layer>Solid Color*, select your color, and then set the opacity—I chose blue as my color, and reduced the opacity to 10%.

When you click *OK*, a color selector appears, and from here you can choose the precise tone that you want to add. Once this is done, change the layer's Blending Mode to *Color*. To finish this image off, I applied a slight vignette using the Lens Correction option from the Filter menu.

TIP

As in traditional, film-based cross processing, fashion and portrait images work well for this technique, but don't be afraid to experiment with other subjects.

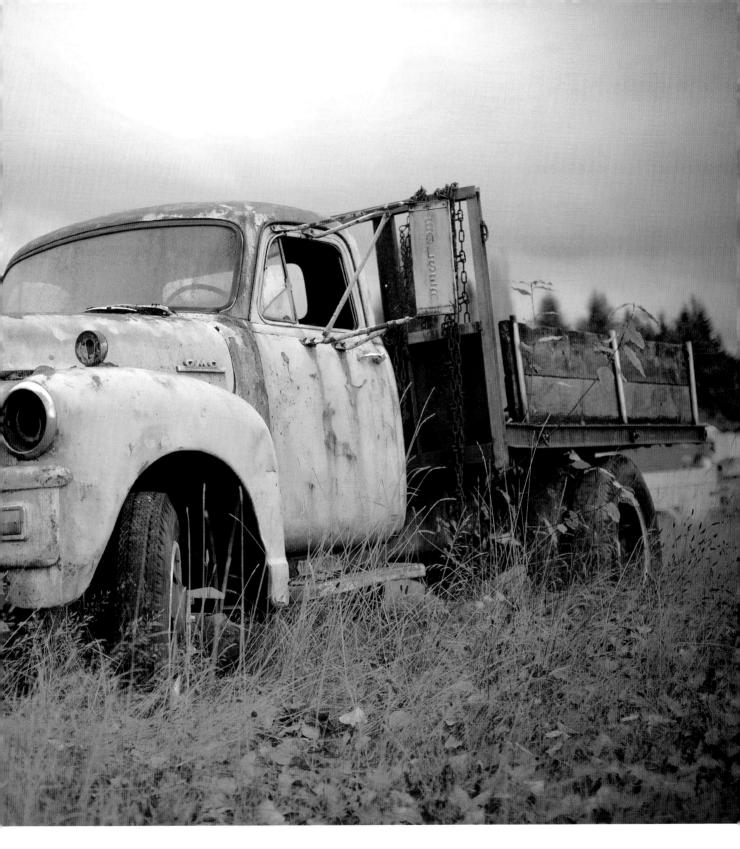

45 DIGITAL CYANOTYPES

As photography has progressed over the last century and a half there have been hundreds of different processes for making prints, and many of these can be emulated using basic image-editing software. The trick to accurately re-creating an old process is to understand a bit about how that process worked. While this is not essential for creating an original and pleasing picture, it will help you produce something that looks believable and authentic.

The cyanotype process was invented in the 1840s as a cheap and easy way of making prints from large format negatives. It used a mixture of potassium ferricyanide and ferric ammonium citrate that was usually coated onto a piece of paper that would be sandwiched with a negative and exposed to UV light (sunlight). After the exposure, it would simply be washed in water, which would "wash out" the unexposed highlight areas, with the image drying down to a deep blue color.

When it comes to re-creating this effect you should remember that traditionally, the dark areas of the scene would end up the most blue, while lighter areas would be less well-colored, although even the brightest parts of a picture would not be pure white. So a "true" cyanotype should contain subtle tones and be fairly low contrast. As the cyanotype solution would also be coated onto a heavy art paper or watercolor stock, we would expect texture as well—all of which is easy to emulate in your editing software.

WHAT YOU NEED

 Image-editing program with layers, blending modes, and curves

DIFFICULTY *

TIP

Use a different color than blue to create alternative toned images. They won't look like "proper" cyanotypes, but you can produce some great-looking images.

Before

After

Start by converting your color image to black and white. I recommend using the Channel Mixer in Photoshop and applying settings that give equal weight to the blue and green channels. As traditional glass plates had no sensitivity to red, excluding it will deliver a more authentic feel. If your software doesn't feature a Channel Mixer, don't worry—simply choose the Desaturate option instead.

Next, create a new layer and choose Layer>New Fill Layer>Solid Color from the menu. Click OK and you will be asked to pick a color in the Color Picker window. As a good starting point, enter values of R: 5, G: 65, and B: 125 into the RGB boxes at the bottom left of the window. Choose OK and your picture will disappear behind a solid blue curtain.

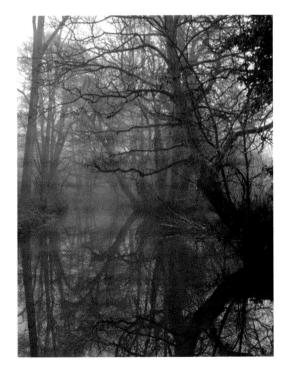

55

To make the picture show through, change the fill layer's Blending Mode to *Overlay* from the dropdown menu at the top of the Layers palette.

You might find the blue is too strong, as the colors take differently to every picture, so reduce the strength of the color using the opacity slider.

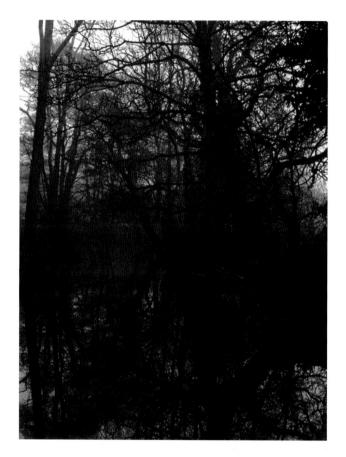

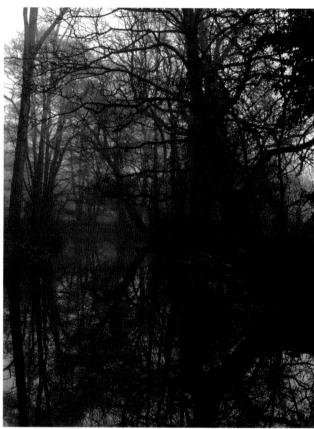

5

Some contrast adjustment will probably be necessary now, so click on the Background layer and open the Levels dialogue (Image>Adjustment>Levels). Move the black (shadow) Input Levels slider to the right to darken the shadows. Shift the white (highlight) Output Levels slider at the bottom of the dialogue window to the left to slightly darken the highlights and add a subtle tone to them.

Finally, Photoshop's Texturizer filter (*Filters*-Texture> Texturizer) is great for adding a subtle paperlike texture to the image—the Sandstone texture looks best. Keep the Relief set to a value of 2–5, but experiment with the Scaling and Light settings as the effect of these will depend on the image size.

Instead of using Photoshop's Texturizer filter to add the appearance of textured paper, try printing on heavy art paper for a more realistic look.

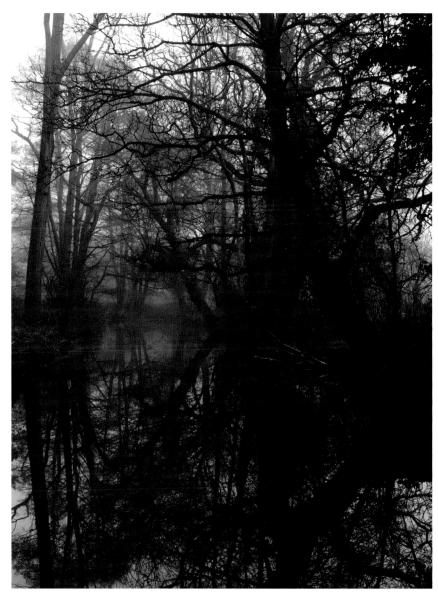

raditional that printing is a very specialized type of black and write printing, but its a process that can turn mediocre shots into great pictures, and make good images look tunning. A lot of photographers have experimented with lith prints, and perhaps one of the most notable names in recent years has been Anton Corbijn with his portraits of people like—Nicholas Cage, Johnny Depp, Michael Stipe of R.E.M., and the band U2.

But while Corbijn's photographs are fantastic, the problem with lith printing is that it's an incredibly time-consuming exercise that requires access to a "wet" darkroom. Even if you have the facilities, you'll end up going through a lot of expensive paper and chemistry before you master the art. Thankfully we don't have to retreat into a darkroom and spend a fortune on materials to create lithlike pictures of our own—similar results can be created with your image-editing software, and it's far more controllable for photographers looking to give their images a lith twist.

WHAT YOU NEED

 Image-editing software with layers, blending modes, and curves

DIFFICULTY * *

TIP

Portraits work particularly well with a lith treatment, but almost any subject has the potential to look good.

After

- The first step in the lith conversion is to get rid of the color. You can do this by simply choosing Image Adjustments Desaturate from the menu bar—there's no need for a more complex conversion. Your image is now in black and white, but the RGB channels are still in place so you can color it.
- To increase the contrast, duplicate the Background layer and choose Curves (*Image*>Adjustments>Curves), adding a classic "S" curve as shown. This will darken the shadows and brighten the highlights, without affecting the midtones.
- Now it's time to add the classic, warm lith tone. Select your background layer and make another duplicate, this time calling it "Tone." Drag the Tone layer to the top of the stack in the Layers palette.
- Open the Levels dialogue (Image>Adjustments>Levels) and slide the middle (gray) slider to the right. This will lighten the shadow areas, and give you a low contrast image to apply color to.
- To add the color, I'm using Photoshop's Variations tool (Image>Adjustments>Variations), using a mix of yellow and red to create a sepia tone with a slightly pink tint.

TIP

If your editing program doesn't have the exact same tools as Photoshop, it will have something equally appropriate. The three basic elements of a lith image are the high contrast, the warm tone, and the intense grain.

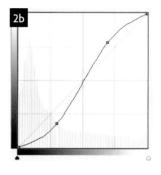

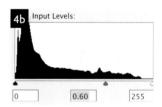

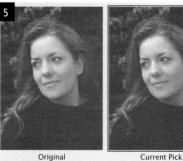

With the color set, change the Tone layer's blending mode from Normal to Multiply. Immediately, the strong blacks will return to the image, while the lighter areas have the lith tone. Reduce the layer's opacity to around 80% to lighten the highlights and reduce the intensity of the color, then flatten the layers down (Layer>Flatten Image).

The image could do with a touch more contrast, so open the Levels dialogue again. Move the black slider to the right to darken the shadows, then slide the middle (gray) slider to the left to lighten the midtones.

Duplicate your Background layer and apply another gentle "S" curve using the Curves tool. Set the duplicate layer's Blending Mode to Overlay, and reduce the opacity to around 20%. You've really got a strong lith feel now, so flatten the image down.

The final step in making this look like a true lith image is to add grain. Hold down the Option/Alt key and click on the New Layer icon at the bottom of the Layers palette. Call this layer "Grain," and set the Blending Mode to Overlay. Check the "Fill with Overlay—neutral color (50% gray)" box at the bottom of the dialogue.

New Layer	
Grain	ОК
Use Previous Layer to Create Clipping Mask	Cancel
None	
Overlay Opacity: 100 🔻 %	
	Grain Use Previous Layer to Create Clipping Mask None

I'm going to create the grain using a two-step process, rather than an unconvincing "film grain" filter, and the first step is to add some noise with the Noise filter (Filter>Noise>Add Noise). An amount of 30-50 works well. Choose Gaussian noise and check the Monochromatic box at the bottom. Then click OK.

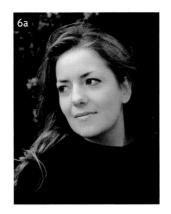

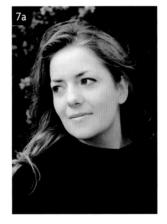

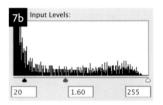

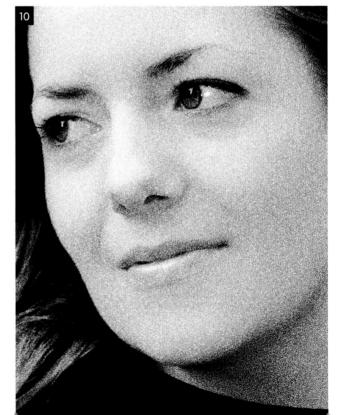

Because noise is quite "hard," you will need to soften it a little to make it look more like film grain. I'm going to use Photoshop's Gaussian Blur filter (Filter>Blur>Gaussian Blur), but don't be too heavy-handed—a Radius of less than 1 pixel works well.

You now have a uniform grain across the image, but lith prints have the grain limited to the shadows. Double-click the Grain layer to open the Layer Style dialogue window. Drag the Underlying Layer white slider at the bottom of the window to the left to "clean" the grain from the highlights. Then, hold down the Option/Alt key and drag the left half of the slider further to the left. This splits the white slider in two, creating a softer transition between the areas with and without grain.

The lith treatment is done, so you can flatten your layers and print the picture. Here I made a further adjustment to the Levels to darken the shadows, then added a border to add an "authentic" film camera look.

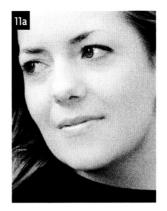

47 DIGITAL INFRARED

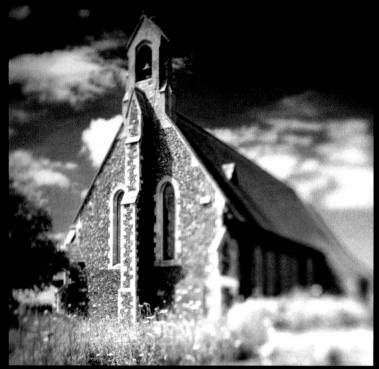

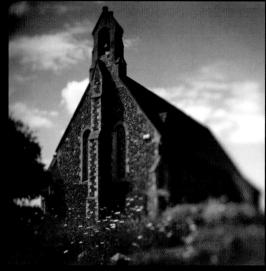

Before

Infrared (IR) photography is a classic technique that lets photographers take pictures that are way beyond human vision. This is because infrared wavelengths of light are invisible to the naked eye, and most digital cameras can't see them either.

However, what was once a very specialist, expensive, and unpredictable area of photography has become much easier thanks to image-editing software. Many programs now offer a simple "convert to infrared" option, but while they're great starting points, just pushing a button isn't enough—you need to make a few changes to get the best results.

There are several things that typify an infrared photograph, and if you want to produce the best IR pictures you need to know what to look for. Typically, foliage transmits and reflects high amounts of infrared light, so elements like grass and trees take on a light, often white appearance. At the same time, blue skies don't contain a lot of infrared, so they tend to come out almost black. This can look really dramatic when the sky is punctured by brilliant white clouds. Editing programs are quite good at re-creating the tones, but fall down when it comes to re-creating the unique look of the film itself, which produces "glowing" highlights and obvious grain. So let's look at how it's done properly.

WHAT YOU NEED

· Image-editing software with black-and-white infrared feature

DIFFICULTY *

TIP

Because infrared light has the greatest impact on blue skies and foliage, landscape images are a classic for the infrared treatment. However, don't let this stop you trying out other subjects as well.

Start by creating a Black & White adjustment layer, either by clicking on the Create Adjustment Layer icon at the bottom of the Layers palette or choosing Layer>New Adjustment Layer>Black & White from the main menu.

Select the default Infrared option from the Preset dropdown as your starting point. The result hints at infrared, but the sky is way too light, and the highlights at the bottom of the image have been blown out.

You need to make some radical changes to the basic IR settings to create a more convincing result. Starting from the top of the dialogue, the Reds are set to 129% (not -40%) to create the infrared "glow," the Yellows are decreased to 164%, and Greens increased to 196% to lighten the grass, while trying not to let the grass bleach out too much. At the bottom end of the dialogue window the Cyans and Blues are both heavily reduced to darken the sky.

Already the image looks more infrared than Photoshop's default setting, with glowing grass that isn't as burned out, and a dark, brooding sky that typifies IR photography. However, it's still missing the "glowing highlights" and grain that typify infrared film.

To add the glow, duplicate the Background layer (Layer>Duplicate Layer) and set the duplicate layer's Blending Mode to Lighten. Open the Gaussian Blur filter (Filter>Blur>Gaussian Blur) and apply a small blur radius. With this image a radius of 1.3 pixels was all that was needed to add a subtle glow to the highlights.

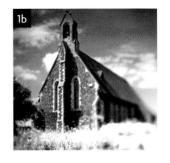

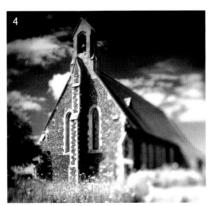

Now you can combine the Background and Background Copy layers. You just want to combine the two color layers, not the Black & White adjustment layer, so turn the Black & White layer's visibility off by clicking the eye icon in the Layers palette. Then choose *Layers>Merge Visible* to blend the two background layers.

Use the eye icon to make the Black & White layer visible again, but make sure the color Background layer is highlighted in the Layers palette. To add grain we'll start with some noise (Filter>Noise>Add Noise). The amount you add entirely depends on taste. I like my grain to be noticeable, so for this image the Amount was set to 7%, the Distribution to Gaussian, and I made sure the Monochromatic box was checked.

To transform the noise into "grain," soften it slightly using the Gaussian Blur filter. You only need a very small amount of blur—the aim is to take the edge off the "hard" noise, not to overly soften the picture. A 0.4 pixel radius was all that was used here.

Because adding noise tends to reduce the apparent contrast of a picture, boost the blacks and whites with a quick Levels tweak (*Image>Adjustments>Levels*). Setting the black point (left slider) to 5 and the white point (right slider) to 250 bumps up the contrast a touch. If this clips the highlights or shadows it isn't a problem—it adds to the contrasty, infrared look of your finished image.

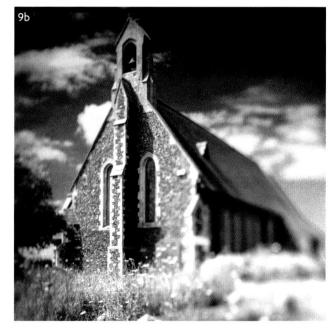

Landscape photographs with clear blue skies and green foliage make great infrared pictures, as the skies turn nearblack and the foliage glows white.

48 MODEL WORLD

In Project 23 you saw how to make a tilt lens that will let you take some really cool shots with a narrow band of focus. Making your own lens is great, but it's not something you will always carry around with you, and you need to have an SLR camera to start with—it's not much use if you use a digital point-and-shoot camera.

That doesn't mean that you can't play around with selective focus in your pictures though, and this project will show you how you can re-create the effect using your image-editing software. I'm going to be using Photoshop CS4 here, but you can just as easily use earlier versions of Photoshop, Photoshop Elements, Gimp, or Paint Shop Pro—most have the tools you need, they might just be called something else.

WHAT YOU NEED

 Image-editing program with gradient tool and lens blur filter

DIFFICULTY * *

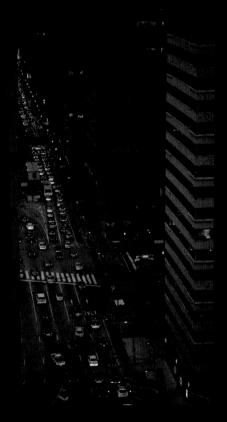

Before

After

Start by to selecting the area you want to keep in focus. In Photoshop, you'll do this using the Quick Mask mode and the Gradient tool. You can toggle between Standard Editing and Quick Mask mode using the toolbar, or by pressing *Q* on the keyboard.

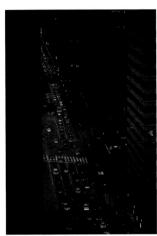

5

To select the zone of focus, click on the image in the center of the area you want to remain sharp, and drag the cursor upward. If you hold down the Shift key while you do this it will lock the selection so it's perfectly straight.

When you release the mouse, the gradient will be shown as a semi-opaque red mask (the default Quick Mask color). The red mask shows the area you've selected that will remain in focus. Return to the Standard Editing mode (Q) and the familiar "marching ants" will outline the unselected area that you will blur.

To create the focus fall-off, use Photoshop's Lens Blur filter (Filter>Blur>Lens Blur). The Lens Blur filter has quite a few settings to play with (and feel free to experiment with them), but I'm only changing two of them here—the Iris and the Radius, which I've set to Octagon and 56 respectively. Click OK when you are done.

It takes a while for the filter to be applied—maybe a minute or more depending on the size of your image and the speed of your computer. Once the filter has been applied, the focus effect is fairly obvious. You could finish at this point if you wanted to, but there are a few more things I want to do with this image.

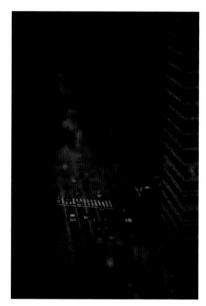

I want to give this image more of a "model" feel, so it looks slightly more like a constructed, small-scale set. To enhance the "plastic" appearance of the picture I'm going to adjust the saturation and the contrast. Call up the Hue/Saturation dialogue (Image>Adjustments>Hue/Saturation) and slide the saturation slider to the right to increase the color—10–25 is normally enough.

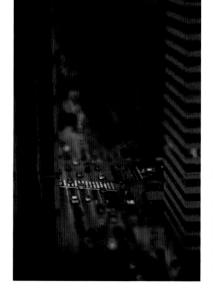

Finally, I'm going to use Curves (Image Adjustments Curves) to bump up the contrast. This will also make the color "pop" a little more. Add a point toward the top right of the curve and drag it slightly upward to lighten the highlights. Add another point at the opposite end of the curve and lower the bottom left to darken the shadows. And that's it—a straight city scene has been transformed into a small-scale model town.

TIP

This technique is especially effective when your starting picture is taken from a high viewpoint. If the scene is quite contrasty, that's even better—both of these things will add to the illusion that the viewer is looking down on a small-scale model that has been lit by a single, close light source.

TIP

Your focus doesn't have to run horizontally across the picture—a tilt lens will let you change the direction of the zone of focus (also known as the "plane of focus"). So, instead of having a horizontal plane of focus, try creating one that runs diagonally—or even near-vertically—through the picture by making the gradient in steps 3 and 4 go in a different direction.

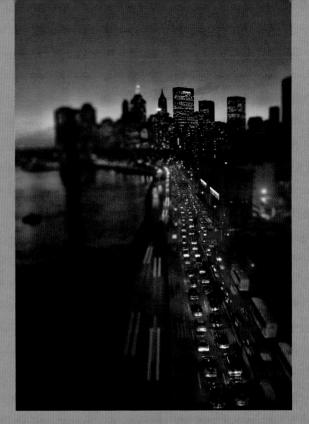

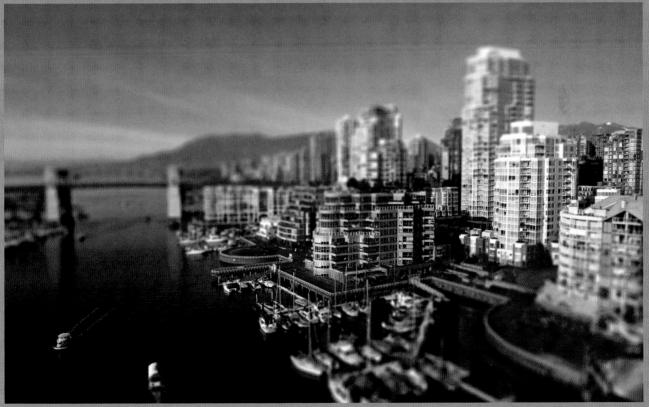

49 PANORAMAS

There are times when you will find that even the widest zoom setting or focal length on your point-and-shoot camera or digital SLR just isn't wide enough to record the scene in front of you. When this happens, the answer is to create a panoramic image. This is a two-stage process that starts with shooting a sequence of shots to create the panorama—basically taking several pictures to photograph your subject from one end to the other. Back at your computer you can use your image-editing program to merge all of these pictures together and produce a single panoramic photograph.

WHAT YOU NEED

- Tripod (to align images when shooting)
- Remote release (optional)
- Image-editing program with "photo merge" feature

DIFFICULTY * *

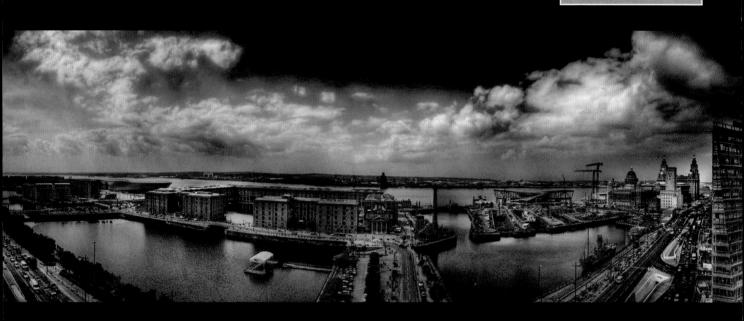

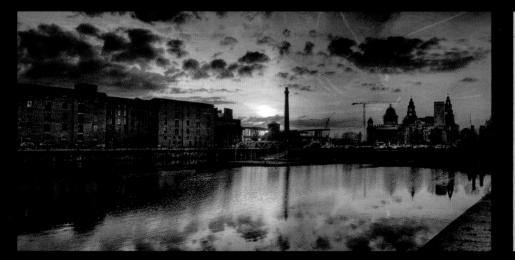

TIP

Shoot in portrait (upright) orientation to get a more detailed image, though you will have to take more shots and the result will be a much bigger file. If you use a 10-megapixel camera, for example, you might end up with a panoramic image of around 30 megapixels shooting in landscape format, versus a massive 90-megapixel picture if you shot upright images!

SHOOTING

A tripod is a great idea because it will help you align your images as you shoot them. A remote shutter release cable may be useful as well, but it's not absolutely necessary.

Start by finding a suitable scene: something that's nice and wide, with lots of amazing detail to capture—like a distant cityscape, or landscape view. Set your camera up on your tripod, and make sure the tripod is level—if it isn't, your panorama will be sloping when you join your sequence of images together.

Line your camera up at one end of the scene you want to photograph (most photographers start at the left). It's a good idea to set your camera to its Manual shooting mode to take your pictures, and set an aperture of f/8–f/16 for a good depth of field. Next, set an appropriate shutter speed. Because you're in Manual

mode each picture in the sequence should receive the same exposure so it will match the one next to it.

Now, take your first shot. Then, turn the camera slightly to the right—so you're looking at the next bit of the scene—and take a second shot. The trick with a panorama is to overlap the images in your sequence slightly so the software can find elements that are common to both of the pieces it's joining, and automatically align them for you. An overlap of roughly 1/3 of the frame is enough for most software, although some compacts have a brilliant panoramic shooting mode that shows you the previous image so you can easily align the next one in the sequence.

Continue shooting until you have covered the full width of the scene, from left to right, overlapping your images as you go.

EDITING

Once you've shot a sequence of images you need to combine them into a single panoramic photograph. I'm going to use Photoshop here, but most editing programs will allow you to merge—or "stitch"—images together.

Open Photoshop, and choose File>Automate>Photomerge from the menu. Use the Browser to find all your images. At the left of the Photomerge dialogue are four Layout options, but I suggest you leave this set to Auto. If you have overlapped your sequence of images correctly, Photoshop can do an excellent job on its own, and will use several of the other tools to achieve the best result. Check the Blend Images Together option at the bottom of the dialogue for

better blending across the panorama. Then press OK.

49 . . .

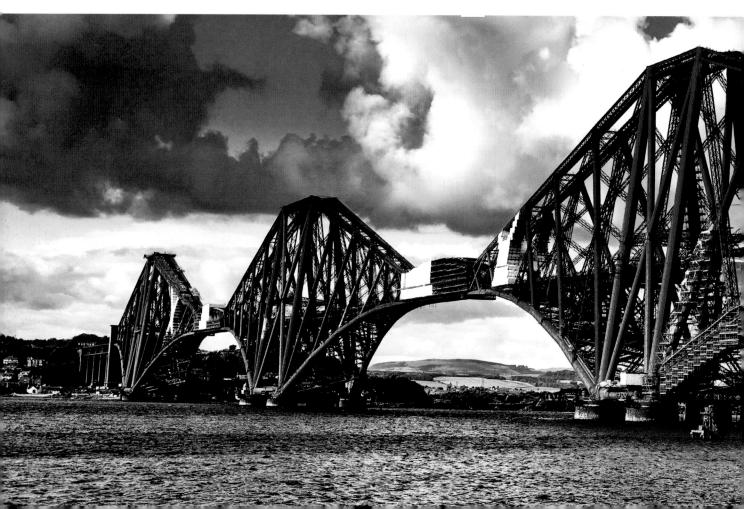

2

Once Photomerge has run its course, you will be presented with your panorama, which should have no visible joins. However, the different images will be on different layers, so you will need to flatten the layers (*Layer>Flatten Image*).

55

You will probably find that parts of the sequence have been cropped in places, resulting in a few gaps at the top and bottom of the photograph. To remove these empty areas, choose the Crop tool from the toolbar and drag a crop box around the good areas so you remove the empty space. Click on the check box or press *Enter* to crop the image.

After you have cropped your image you can process it like any other picture—converting it to black and white, increasing the levels to add punch, or whatever else you want to do. Here, I tonemapped the image using Photomatix Pro to create an HDR-style image.

50 SMALL WORLD

If you thought planet-building was something best left to deities, think again—Photoshop, Photoshop Elements, and many other editing programs give you the power to turn a panoramic photograph into a perfect celestial orb with just a few clicks of the mouse. The result is a singularly intriguing image, which might represent your perfect planet, or something a little more abstract.

While you can apply this technique to any panoramic photo, it works best with a picture that looks very similar at the left and right hand ends. If the ends are a close match (in terms of color and content) you can get an almost seamless join when the picture is twisted round and they meet in the middle. This means minimal retouching later on. It's also good if the lower 25% of the panorama contains little detail—like the sea in this example—and similarly, the sky should be evenly toned. Once you have chosen a suitable picture, it's time to start creating your small world.

After

WHAT YOU NEED

- Image-editing program with Polar Coordinates filter (or similar)
- Panoramic picture

DIFFICULTY *

Before

It's vital that your picture has a completely level horizon, as the left- and right-hand edges of the picture will be joined up when you create your sphere. Any slight misalignment will become glaringly obvious. To check that your picture is level, open the Ruler tool and draw a line from the lefthand edge of the horizon to the right-hand edge.

To make sure the horizon is perfectly straight, choose Image Image Rotation Arbitrary from the main menu. If your horizon isn't already perfectly straight, the angle needed to correct it will be shown automatically. Just click OK and the change will be applied.

You need to crop your picture to a panoramic format (if it isn't already), with proportions of at least 2:1 (twice as long as it is tall). Some parts of the final image will be distorted, but with a wider panorama, the area furthest from the center of the planet will appear better proportioned, which might make your world a more inviting place.

Once your picture is cropped to a panorama, you need to make it square—this conversion from panorama to square is important, so don't just think you can start with a square image. Open the Image Size dialogue (Image>Image Size) and uncheck the Constrain Proportions box. Copy the pixel value from the Pixel Dimensions Width field into the Height field, and then click OK. Your picture will appear bizarrely stretched but, crucially, it will be square.

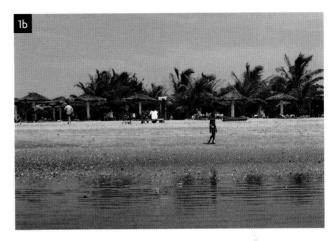

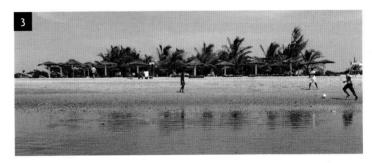

Now it's time to convert the upside-down, squashed, square image into a small world. This sounds harder than it is—simply choose *Filter>Distort>Polar Coordinates*, using the default Rectangular to Polar setting. Click *OK* and the transformation from flat photo to miniature world will be complete.

Unless the lighting in your image was unnaturally favorable, it's likely there will be some degree of discrepancy between the left and right ends of the image that is made more obvious when they are joined together. This is something you can correct using the Healing Brush and Clone Stamp tools, carefully editing the join to make it less obvious.

Finally, duplicate your new planet layer and apply the Unsharp Mask filter (Filter>Sharpen>Unsharp Mask) to bring out the detail. Make sure that the radius setting is low, and preview the picture at 100% so you can see the effect the setting has before you apply it. Flatten the layers down, and that's it—a humble panoramic picture has been transformed into a small world!

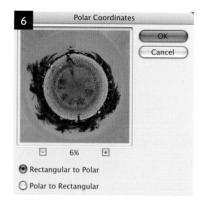

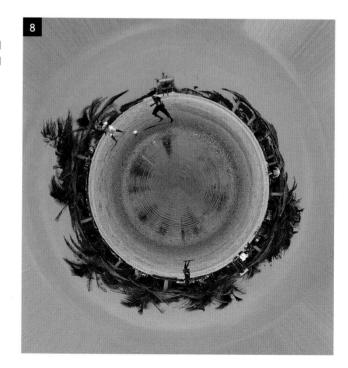

TIP

If your lens is prone to vignetting, the small world effect will exaggerate the darkened corners. Try using the Lens Correction tool in Photoshop's filter menu to correct this before you start.

TIP

An alternative to creating small worlds is "the world in a bubble." Simply skip step 5 (rotating the square image) before you use the Polar Coordinates filter and your world will turn in on itself!

evelyone has a rayonce picture that they want to blow up big and hang on their wall to impress riends and family, and getting a poster-sized print made is definitely the way to go.

But before you head to your local processor, or upload your pictures to get some expensive poster-prints made, why not try creating fantastic poster-sized prints using your existing desktop printer? All you need to do is print your image across more pages, like advertising companies do for billboards, and this is where PosteRazor steps in.

Most image-editing programs will let you resize and "tile" your images for multipage printing, but it's not a straightforward process. However, PosteRazor uses an incredibly
imple 5-step process to create super-enlarged pictures from your original, converting your
mage into a series of individual pages, or "tiles," that you can print out and stick together.

Best of all, PosteRazor will run on Windows and Mac computers and it's completely free!

WHAT YOU NEED

- · Inkjet printer
- PosteRazor software (http://posterazor. sourceforge.net/)
- Adobe Reader 4 (or higher)

DIFFICULTY *

ASSEMBLING YOUR WALL ART

There are two ways to assemble your wall-sized image. The easiest option is to stick the pieces onto a large sheet of foamcore or thick cardstock, carefully lining up each one to create your poster in the same way that billboards are put together.

LOAD AN IMAGE

Use the browser to find the picture you want to transform.

SET THE PRINTER'S PAPER SIZE

You need to tell PosteRazor what paper you are using in your printer; choose from the standard paper sizes, or enter a custom size. You can also choose whether you want the tiles that make up your enlargement printed horizontally (landscape), or vertically (portrait). You can even add a white border to each tile if you want.

SET THE OVERLAP

If you want to stick your multi-page prints together precisely, you will need to set a slight overlap— $\frac{1}{2}$ inch (1.25cm) works well.

SET THE POSTER SIZE

In this dialogue you set the size of your final poster. You can do this using precise measurements (inches/cm), or by telling PosteRazor how many sheets of paper you want it to print your super-size image across, or by using a percentage increase.

SAVE THE POSTER

Your final poster will be saved as a multi-page PDF document that you can open and print using Adobe Reader. Just open the PDF (or ask PosteRazor to do this automatically after it has saved it), print all the pages, and you're ready to piece your art together.

printers will give you fantastic photo prints that are packed with detail. If you're printing out your vacation or holiday photos this is all you could ask for, but if you want to get more creative, why not use your printer as the starting point for a great project—inkjet transfers.

Making inkjet transfers requires a couple of steps beyond just pressing the print outton, but it isn't difficult and can transform your pictures into truly unique works of art, as no two transfers are ever the same. What we're going to do here is transfer the image oroduced by your inkjet printer onto another surface, such as watercolor paper, heavy ardstock, wood—in fact almost anything you want to experiment with. The results are just as varied, and can range from bold, stencil-like "street art" images to delicate pictures that take on the soft feel of a watercolor painting. It all depends on the original image you use.

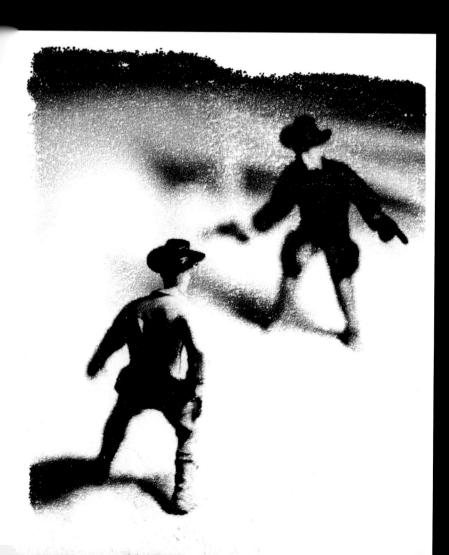

WHAT YOU NEED

- Inkjet printer
- Shiny backing paper from adhesive labels
- Watercolor paper or similar to transfer the image onto
- Rubber roller (optional)

DIFFICULTY *

TIPS

Instead of using the shiny backing paper, you can use transparency film (acetate) instead. Make sure the film you use is NOT designed for inkjet printers because inkjet film is designed to absorb the ink, which you don't want it to do.

Experiment with different receiving surfaces—some respond to inkjet transfers better than others. In general, naturally absorbent surfaces work best as they allow the transferred ink to soak into them.

Your transfered image will appear reversed, so what is on the left of your computer screen will be on the right of your transfer. If you don't want this, flip the image horizontally before printing it.

THE TRANSFER PROCESS

The starting point is to print onto a non-absorbent surface such as the shiny backing paper you get with adhesive labels (the sheet that's left when all the labels have been removed).

Open up the image you want to transfer on your computer, load your printer with a sheet of your shiny backing paper, and open your printer settings by clicking *Print*. You want to get plenty of ink onto the paper for the transfer, so set your Media or Paper Type to Glossy Photo Paper to do exactly that. Then print your image onto the *shiny* side of the backing paper.

Now comes the crucial bit. Take your print out of the printer, being very careful not to smudge the wet image—it won't dry like a regular print. Position the print ink-side down onto your "receiving surface" (your watercolor paper, cardstock, wood, or whatever), making sure you don't move either the print or the surface underneath.

To transfer the image, apply pressure across the back of the print using the side of your hand or a rubber roller. This will transfer the ink from the backing paper into your receiving surface. Again, don't let the backing paper or the surface underneath move around or it will smear the image, although this can add to the effect.

Finally, peel off the backing paper and your image will have been "magically" transferred to your receiving media!

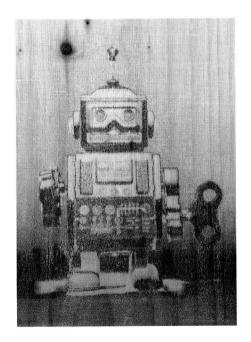

Images can be transfered onto a range of surfaces, from a variety of papers and cardstocks (right) to wood (left). The clarity of the image will depend on the surface you are using.

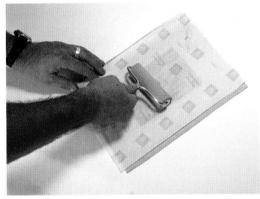

REFERENCE

PHOTOGRAPHY CREDITS

INTRODUCTION

© Chris Gatcum www.cgphoto.co.uk

CREATIVE SHOOTING

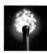

© Kit Hung www.flickr.com/photos/phohe

01

© Angela Nicholson www.angelanicholson.com

02

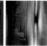

© Chris Gatcum www.cgphoto.co.uk

03

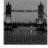

© Chris Gatcum www.cgphoto.co.uk

© Peter Adams iStockphoto.com www.padamsphoto.co.uk

© Timothy J. Vogel www.flickr.com/photos/vogelium

04

© Damien Demolder www.damiendemolder.com

© Amanda Rohde iStockphoto.com www.designtangents.com.au

05

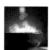

*

© Kit Hung www.flickr.com/photos/phohe

© Isabel Bloedwater
www.flickr.com/photos/polanaked

06

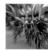

© Steve Corey
www.flickr.com/photos/stevecorey

© **Jeffrey L. Reed**, Atlanta GA www.flickr.com/photos/zandir

© **Derryn Vranch** www.flickr.com/photos/derrynv

07

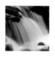

© ooyoo iStockphoto.com

© Gerad Coles iStockphoto.com www.flickr.com/photos/gcoles

08

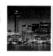

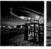

© Pete Carr www.petecarr.net

© Sean Goebel iStockphoto.com www.flickr.com/photos/7687009@n02

© Stephan Messner iStockphoto.com

09

© Francisco Fernandez www.flickr.com/photos/16940890@n07

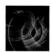

© David Hull www.flickr.com/photos/mtnrockdhh

10

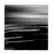

© Darin Kim www.flickr.com/photos/darin11111

©

© Ken Douglas www.flickr.com/photos/good_day

© Sebastien Ettinger

www.flickr.com/photos/s e b (Creative Commons)

© Emilia Stasiak

iStockphoto.com www.dreamstime.com/emielcia info

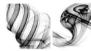

© David Nightingale www.chromasia.comuk

© Slobo Mitic

iStockphoto.com

13

© Chaval Brasil

www.flickr.com/photos/chavals

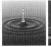

© konradlew

iStockphoto.com

© Nicolas Chateau

www.flickr.com/photos/nchateau

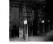

© Jeff Morris

www.flickr.com/photos/ineeddadrink

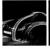

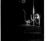

© Ben Parry

www.flickr.com/photos/dialedout

© Dave Arthur

www.flickr.com/photos/davearthur

15

@ Aline Smithson

www.alinesmithson.com

© Bruce Berrien

www.flickr.com/photos/bruceberrien

© Mark Ilford

www.flickr.com/photos/mark_ilford_photography

16

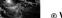

© Wallace Billingham

www.thoumyvision.com

© Patrick Schmidt

www.flickr.com/photos/p tumbleweed\

© Michael Barnes

www.toycamera.com

© Venus Campos

www.flickr.com/photos/appleheartz/

18

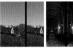

© Kees van den Aker

www.flickr.com/photos/biokees

Library of Congress

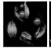

© Damien Demolder

www.damiendemolder.comk

LENSES AND ACCESSORIES

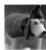

© Chris Gatcum

www.cgphoto.co.uk

20

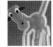

© Chris Gatcum

www.cgphoto.co.uk

© Damien Demolder

www.damiendemolder.com

PHOTOGRAPHY CREDITS

22

© Elena Erda www.flickr.com/photos/elenaerda

LAIN

© Chris Gatcum www.cgphoto.co.uk

23 🖟

© Sabrina Dei Nobili iStockphoto.com

© Chris Gatcum www.cgphoto.co.uk

© Linda & Colin McKie iStockphoto.com www.travelling-light.net

24

© Damien Demolder www.damiendemolder.com

27

Michael Barnes
 www.toycamera.com

© Chris Gatcum www.cgphoto.co.uk

28

© Amanda Rohde iStockphoto.com www.designtangents.com.au

29

© Vika Valter iStockphoto.com www.vikavalter.com

30

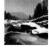

© Andrew Penner iStockphoto.com

31

© Damien Demolder www.damiendemolder.com LIGHTING

© Joseph Jean Rolland Dubé iStockphoto.com

32

© Damien Demolder www.damiendemolder.com

© Wolfgang Lienbacher iStockphoto.com www.lienbacher.com

33

© Chris Gatcum www.cgphoto.co.uk

34

© Tracy Hebden iStockphoto.com www.quaysidegraphics.co.uk

5

© Thomas Stange iStockphoto.com www.tstange.de/foto

35

© Richard Sibley www.richardsibleyphotography.co.uk

36

© Richard Sibley www.richardsibleyphotography.co.uk

(A)

© Chris Gatcum www.cgphoto.co.uk

37

© **Richard Sibley** www.richardsibleyphotography.co.uk

E

© Kateryna Govorushchenko iStockphoto.com www.iconogenic.com

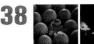

® Nick Wheeler www.flickr.com/ photos/nickwheeleroz

© Nick Wheeler ww.flickr.com/ photos/nickwheeleroz

© Nick Wheeler www.flickr.com/ photos/nickwheeleroz

DIGITAL PROCESSING AND PRINTING

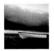

© Damien Demolder www.damiendemolder.com

© Chris Gatcum www.cgphoto.co.uk

© Barney Britton www.barneybritton.com

© Pete Carr www.petecarr.net

© Barney Britton www.barneybritton.com

© Damien Demolder www.damiendemolder.com

© Chris Gatcum www.cgphoto.co.uk

© Chris Gatcum www.cgphoto.co.uk

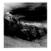

© Adam Juniper www.adamjuniper.com

48

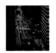

© Terry Wilson iStockphoto.com www.terryfic.com

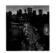

© John W. DeFeo iStockphoto.com www.johnwdefeo.com

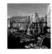

© Benjamin Goode iStockphoto.com www.kwestdigital.com.au

© Pete Carr www.petecarr.net

© Adam Juniper www.adamjuniper.com

© David Nightingale www.chromasia.com

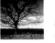

© Chris Gatcum www.cgphoto.co.uk

© Chris Gatcum www.cgphoto.co.uk

© Chris Gatcum www.cgphoto.co.uk

© Chris Gatcum www.cgphoto.co.uk

INDEX

		Condition and 152
A	D	Gradient tool 153
abstract shots 11, 20–21, 34, 36, 41, 129, 160	3D 60–62, 90, 94	grain 146–50
acetate 166	dark frames 25	gray card 11
Adjustment Layer 136–37, 149–50	daylight 11, 26, 49, 84, 94, 96, 112	gray filters 22 Grid tool 131
Adobe Photoshop 36, 127, 129, 136–37,	depth of field 16, 18, 20, 23, 36, 40, 61, 63,	grids 102–3, 120
141, 143, 145, 147, 149, 152–54, 157, 160, 163	66–67, 72, 157	grids 102–3, 120
Adobe Photoshop Elements 127, 152, 160	Desaturate 141, 145	н
Adobe Reader 165	detail 11, 16, 62, 68, 90–91, 96, 132–33, 135,	halo effect 104
Aperture Priority 14, 23–24, 33, 49, 95	156, 160, 162, 166	hand-holding 21, 24, 67
architecture 72	Details Enhancer 134–35	
Argus 75 54	dew chasers 27	HDR (High Dynamic Range) images 24–25, 132–35, 159
automatic white balance 10–11	Diana/Diana+ toy camera 46–49	Healing Brush tool 162 highlights 133, 137, 140, 143, 145–50, 154
В	diffraction 14	Holga toy camera 46–53
	diffusers 98–99, 104–9, 113–14, 118–20, 125	hotshoes 51, 86, 93–96, 130
B (Bulb) 26, 42–44, 46-47, 49, 53	diffusion material 98–99, 106	hotspots 43–44
batteries 27, 43	Dodge tool 36	110tsp0ts 45-44
beam splitters 38	E	1
beanbags 24, 80–81	emulsions 128–29	improvised lenses 70–71
beauty dishes 108–11 bellows 67, 73	enlargements 164–65	infrared 44, 148–51
birefringence 12	EV (Exposure Value) 13, 84	inkjet transfers 166–67
Blending Mode 137–38, 142, 146	exposure 9, 21–23, 25–26, 30, 33, 36, 39–40,	inkjet transparency film 128
blur 9, 16, 18, 20–21, 23–24, 29–30, 41, 46, 75, 150, 153	43–44, 46, 48–49, 53, 58, 67–68, 75–76, 79,	intervalometers 32–33
Blur tool 129	95, 133, 140	ISO settings 21, 23–26, 36, 40, 43, 49, 76, 79, 84
body caps 76–78	Exposure Guide 76, 79	130 300011183 21, 23 20, 30, 10, 13, 17, 70, 77, 01
bokeh filters 18–19	extension tubes 39, 67	J
bounce flash 98	Eyedropper tool 131	JPEG files 134
brightness 132, 134	eyeglass lenses 70-71	
brush sizes 129	0) 0,000 10.1000 10 11	К
Burn tool 36	F	Knight, Nick 104
	fashion shots 104, 108, 116, 136, 138	Kodak Duaflex 54
С	file size 156	
cable connections 95–96	fill light 104	L
camera shake 13, 21, 49-50, 53, 75, 81, 84	filters 89	LaChappelle, David 104
Canon 67	fisheyes 71, 89	landscapes 11, 16, 48, 132, 148, 156-57, 165
catadioptric (mirror) lenses 18	fixed subjects 30–31	Layers palette 131, 141-42, 145-47, 150
catchlights 104, 119	flange depth 73	Layout tools 157
Channel Mixer 141	flash 35-36, 38, 40, 42-44, 83, 86, 93-101, 104-6,	LCDs 12-14, 36
Clone Stamp tool 162	108-9, 112-14, 116, 119-21, 125, 127	LEDs 42, 63
close-ups 12, 39, 58, 67–68, 71	flashlights 44	legacy lenses 66–69
color casts 10–11, 22	flash-to-diffuser distance 125	Lens Blur 154
Color Picker 141	floating platforms 84	Lens Correction 138, 163
continuous shooting mode 40, 75	flocking 53	lens flare 67, 106
contraption 54–58	focus 9, 13, 18, 23, 26, 35–36, 39–41, 51, 56, 58,	LensBaby 72
converging verticals 130–31	66-69, 71-72, 75-76, 152-55	Levels 36, 130, 143, 145–47, 150
cookies 88	fog 11	light leaks 50, 53, 74
Corbijn, Anton 144	FourThirds system 67	light streaks 44
Crop tool 131, 159	frame-to-flash distance 121	lightcubes 82–85
cross polarizing 12–13	framing 9, 13, 33	light meters 26
cross processing 49, 136–39	frontal lighting 96	lightstands 86–87, 114, 119, 124–25
Curves 36, 136–37, 145–46, 154		lith printing 144–47
cyanotypes 140–43	G	Lomography 46
	Gaussian Blur 147, 149–50	low light 14, 21–22, 24, 49, 67, 96

gels 89 Gimp 127, 152

м PosteRazor 164-65 spirit levels 130 macro 12, 38-39, 66-69, 71-72, 116 posters 164-65 sports 22 ppi (pixels per inch) 63 Macs 127, 146-47, 164 spotlight effect 100-103 magnifying glasses 71 presets 11, 149 star filters 14-15 primes 67 star trails 24, 26-27 manual exposure 33, 35, 39, 76 memory cards 33 product shots 42, 82, 84, 120 stereo shots 60-61 metering 58, 68 Program 33 still life 16, 90-91, 96, 120-21 midtones 138, 145-46 stitching 33, 157 Minolta 67 stop frame animation 33 Quick Mask tool 153 mirrors 91 stringpod 81 modifications 50-53 striplights 112-15 monocle lenses 70 sunsets 10-11 radio slaves 96 motion blur 30 moving subjects 21, 23, 30, 36, 43, 49 Raw files 10, 34, 132-33 red-eye 94 multiple exposures 49 templates 98, 100-101 reflectors 90-91, 96, 100, 108-9 texture 140, 143 remote release 13, 23, 40, 49, 157 Ν theatrical light 96 resolution 63 natural light 96 TIFF files 134 ND (Neutral Density) filters 21-23 reverse lens macro 68-69 tiles 164-65 night shots 14, 21-22, 24-27, 42-43, 49 RGB 136, 141, 145 tilt lenses 72-75, 79, 152, 155 ringflash 109, 116, 120 Nikon 67 Time Zero film 128-29 ringflash diffusers 104-7 noise 24-26, 36, 84, 135, 146-47, 150 time-lapse sequences 32-33 ringlights 116-19 nylons 16-17 TLR (Twin Lens Reflex) 54-56, 58 Rotate View tool 162 Tone Compressor 134 0 Ruler tool 131, 161 tone mapping 132, 134, 159 Olympus 67 toy cameras 46-53, 70 S OM system 67 trails 24, 26-27, 44 Samsung 67 transfers 166-67 P saturation 24-25, 135-36, 154 transparency film 166 Paint Shop Pro 127, 152 scanners 62-63 tripod 13, 21, 23-24, 26, 30, 33, 35, 39, 43-44, 46, self-timer 13, 23, 29, 84, 87 Paintbrush tool 129 49, 53, 58, 80-81, 84, 86-87, 114, 119, 124-25, sepia tone 145 painting with light 42-45 130, 157 shadows 133, 135, 137-38, 143, 145-47, 150, 154 panning 30-31 TTV (Through The Viewfinder) shots 54-59 panoramas 48-49, 156-62 Sharpen tool 129 tungsten light 11 sharpness 14, 17, 35, 67, 70, 72, 81 PDF files 165 shift lenses 72 U peephole fish-eyes 71 shuffling 48 Unsharp Mask 162 Pencil tool 129 Shutter Priority 21, 29-30, 33 Pentax 67 UV filters 17, 89 Perspective tool 130 side lighting 96 petroleum jelly 17 silhouettes 132 skin tones 91, 111 Variations tool 145 Photomatix Pro 133, 159 skylight filters 17, 89 Photomerge 157, 159 video editing program 33 slave units 96 Photoshop 36, 127, 129-30, 136-37, 141, 143, 145, vignetting 46, 70, 138, 163 147, 149, 152-54, 157, 160, 163 sleep mode 33 Photoshop Elements 127, 152, 160 sloping horizons 130-31, 161 SLRs 11, 14, 20, 32, 39, 44, 49, 54-55, 66-68, 70-71, wall art 20, 33, 164-65 pinhole lenses 76-79 73-76, 79, 81, 86, 93-95, 152, 156 pivoting 48 water shots 22, 38-41, 49 smoke shots 34-37 point-and-shoot cameras 11, 54, 61, 70-71, 81, 86, websites 73, 127 94, 152, 156 Smudge tool 129 white balance 10-11, 22 snoots 100-103 Polar Coordinates tool 162 Windows 127, 164 polarizing filters 12-13 soft focus 16-17, 46, 70 wireless flash 95 Polaroids 128-29 softboxes 98-99, 120-25 software 28, 32, 49, 63, 71, 136, 140-41, 144, 148, 7 portraits 11, 16-18, 42, 66, 90-91, 98, 100, 102, 104, 108, 110, 116, 120-21, 138, 144, 156, 165 152, 157 zoom-burst 20-21

Sony 67

Zuiko 67

post-processing 33, 36, 55, 108

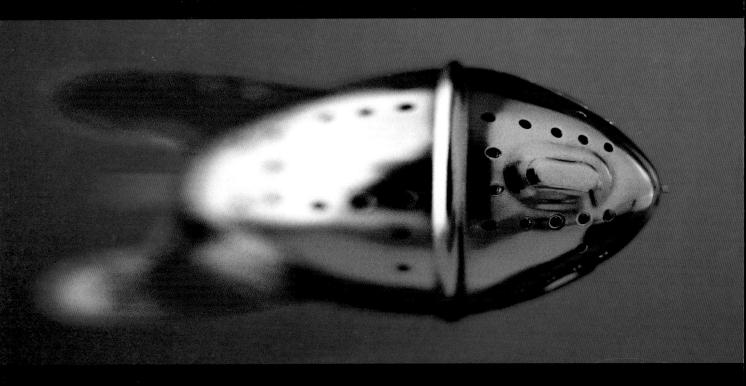

ACKNOWLEDGMENTS

This book wouldn't have been possible without an outstanding team of contributors, so in addition to the photographers already credited, a big thank-you has to go to the following people for sharing their techniques and wisdom: Damien Demolder, Angela Nicholson, Barney Britton, and Richard Sibley from Amateur Photographer magazine, Adam Juniper, Peter Carr, Michael Barnes, Nick Wheeler, and NK Guy.

Thanks also to Julie Mazur at Amphoto for having (and keeping!) faith in me, and Emily for putting up with my last-minute design tweaks.

Finally, apologies to Rosie for all the "lost" evenings and weekends while I was working on this, and a great big hug for being so understanding and supportive.